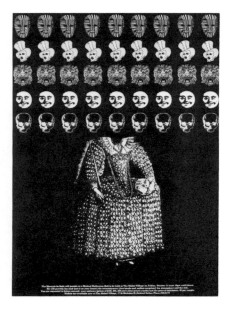

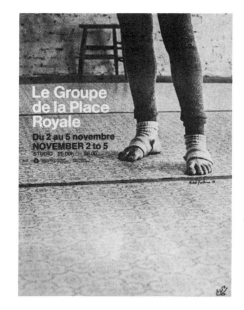

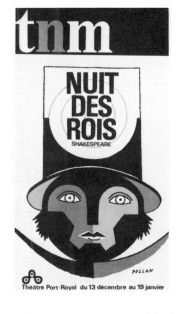

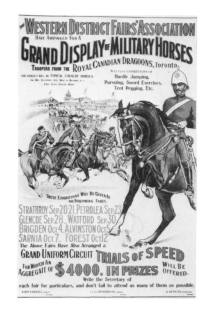

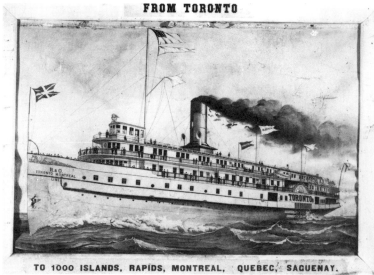

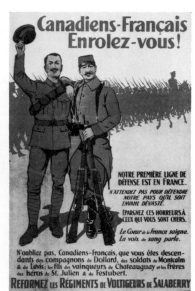

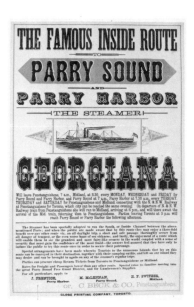

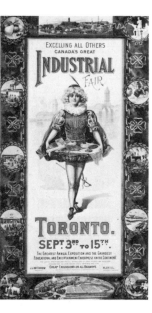

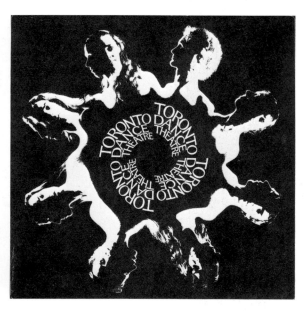

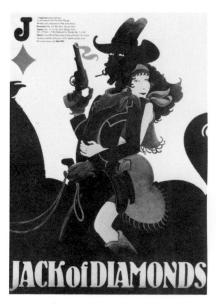

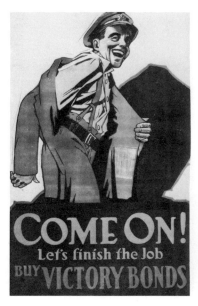

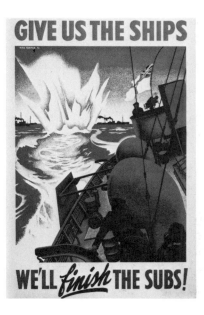

The CANADIAN Poster Book

100 YEARS OF THE POSTER IN CANADA
Robert Stacey

n METHUEN
Toronto New York London Sydney

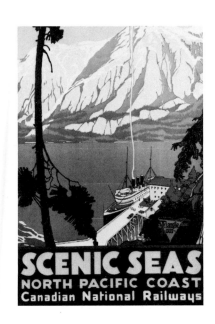

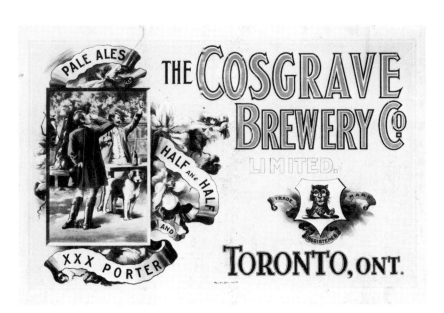

Canadian Cataloguing in Publication Data

Stacey, Robert H., 1949-
 The Canadian poster book

Bibliography: p.
Includes index.

ISBN 0-458-93850-5

1. Posters, Canadian. I. Title.

NC1807.C3S83 769'.5 C79-094212-7

Printed and bound in Canada

1 2 3 4 5 79 80 81 82

Contents

Key to Abbreviations

A: Artist
D: Designer
D/A: Designer and Artist
C: Writer and/or Copywriter
Ph: Photographer
AD: Art Director
S: Studio
Ag: Agency
S/A: Studio and/or Agency
C/A: Client/Advertiser
P: Printer and/or Publisher
T: Typesetter
M: Medium
Dim: Dimensions
Note: Where data is not given as above, information was not available to the author. Ideally, dimensions should be included; however, since many posters were reproduced from photographs in which length and width are not indicated, it was decided to eliminate these figures. At any rate, posters often were and are printed in several different sizes and formats.

Preface

"I Want All the Scraps I Can Collect" is the caption of an early nineteenth-century print by T. Dighton. This lithograph depicts a man putting new posters on a wall while a distinguished-looking, well-dressed gentleman is reaching down to pick up from the sidewalk the discarded and out-of-date notices.

Methuen's splendid selection of Canadian posters of the last hundred years marks the first significant recognition in Canada of the importance of printed ephemera, or "scraps," which when collected and organized provide a penetrating insight into our social and cultural history.

The Canadian Poster Book: 100 Years of the Poster in Canada is important because it illustrates and documents the combined creative endeavours of well-known and unknown artists as well as of businessmen and others who are involved in shaping our society. The book also allows the viewer to gain knowledge and find nostalgia in the events it records, revealing in convincing measure the healthy awareness which people in this country are quickly developing with regard to their culture, past and present.

This book is a major contribution to the long history of the poster and its antecedents; it offers a new dimension to make us conscious of what people in the nineteenth and twentieth centuries were planning, perfecting and producing. This is all the proof that is required, if indeed it ever was needed, to convince us that the poster, often no more than an elegant piece of printed ephemera, is part of our artistic heritage.

Although posters came into prominence in the nineteenth century, especially in Europe and America (the word itself began to be used in England in the 1830s), they had their forerunners; we know that since the very beginnings of printing in the fifteenth century Gutenberg and his contemporaries made and sold broadsides, typeset public announcements of events to be posted, even before the publication of the Gutenberg Bible. The broadside sheet as the poor cousin of the poster still lives on and, in a modest fashion, continues to fulfil the poster's function.

The poster is of today, of tomorrow and of yesterday. It is very much a part of our society's way of life because it records that "way." Posters are all around us. We see them on crowded notice boards, on walls of buildings and nailed to telephone poles. They remind us of the political and propagandistic roles they play, especially in present-day China where they conceivably originated following the invention of printing in the Far East.

The examples reproduced in this book reveal many styles and many ways of how to approach the very real art of the poster. Brought together and supported by an informative text written by a knowledgeable author, they reflect many things. They represent our social history, as well as part of the history of printing, graphic art, typography, design and all those other art forms which, when used in this manner, provide us with a dramatic and dependable diary of events as they happen day by day.

Here then is our past spanning the last hundred years. This book convincingly stresses the need to preserve such ephemeral but vital information, and it is hoped that it will inspire individuals, libraries, museums, archives and art galleries to conserve posters for the future.

Thanks be to those who collect and publish such evidence.

Douglas Lochhead
Davidson Professor of Canadian Studies
Mount Allison University
Sackville, New Brunswick.

Acknowledgments

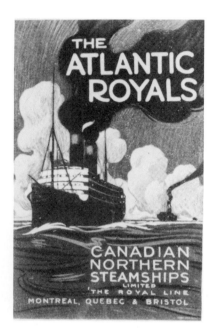

I have been assisted in this project by persons too numerous to mention, and so for reasons of space alone am forced to offer a blanket acknowledgment to all the graphic designers, illustrators, art directors, collectors, curators, librarians, archivists, and interested friends across Canada without whose advice and assistance this book could never have been contemplated, much less completed. Without their services I should not have begun to untangle the web of inference and misinformation, of false leads and stray clues, which constitutes the yet-unchronicled history of the applied graphic arts—and especially that of the poster—in Canada. I trust that credit-lines given to institutions, private collectors, designers, illustrators, photographers, art directors, advertising agencies, and printers will substitute for the comprehensive list of helpers and informants that is required.

This said, I should nevertheless express special gratitude to the following individuals, whose encouragement anabled me to put my passion for the art of the poster into concrete form. Dr. Douglas Chambers, to whom this book is dedicated, fostered my earliest interest in posters by hiring me to manage his new experimental graphics gallery, Pan, in 1973. For three years we toiled to make the first serious Toronto gallery exclusively dedicated to foreign and Canadian posters and fine-press printed ephemera a critical if not commercial success, mounting in all eighteen special exhibitions. The Pan collection in some ways is the core around which *The Canadian Poster Book*, and the Art Gallery of Ontario Extension Services exhibition which occasioned it, *100 Years of the Poster in Canada*, gradually grew. The latter show opened in the AGO's Education Gallery in January 1979, and subsequently toured Ontario. The idea for *100 Years of the Poster in Canada* was originally suggested to me by Nancy Hushion, the Head of Extension Services, and was realized by Exhibition Producer Mela Constantinidi. Nothing, of course, could have been accomplished without the full collaboration of the AGO's curatorial, Extension, media services, photographic services, restoration and library staffs. Both book and exhibition were also given impetus and direction by Ewa Bednarska of the Public Archives of Canada's Picture Division, who is responsible for cataloguing the PAC's enormous broadside and poster collection.

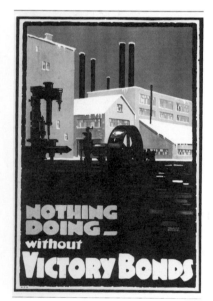

Finally, to all those at Methuen Publications who have been involved in *The Canadian Poster Book* from the outset and who have seen it through, my thanks—and my sympathies.

Introduction

I am not sure that future opinion of the contemporary art of our day will not consider the advertising poster, the window and counter card as most representative. I rarely pass a drugstore that I do not pause to examine and admire the sheer strength and attractiveness of their design and the beauty of their colouring. A hundred or two hundred years hence such work, I venture to predict, may be deemed more typical of the art of our time than some of the more pretentious paintings which hang in our public galleries and museums.

—Charles William Jefferys, quoted by William Colgate in *C. W. Jefferys* (Toronto: Ryerson Press, 1945; p. 28).

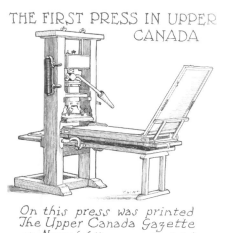

THE FIRST PRESS IN UPPER CANADA

On this press was printed The Upper Canada Gazette at Newark, (Niagara-on-the-Lake), in 1793.

1. **The First Press in Upper Canada** 1793. Drawing by T.W. McLean.

Of all the arts that flourish in Canada, few have received so little critical or scholarly attention as applied graphics. Other nations may also have been slow to recognize the achievements of their illustrators, graphic designers, typographers, and poster artists, but in the last decade there has been a considerable upsurge of interest in the hidden history of the commercial, editorial, and industrial arts and crafts. Canadian connoisseurs of the medium may be moderately aware that our contemporary designers have produced work deemed worthy of inclusion in such prestigious international surveys as *Graphis, Graphis posters*, and the Warsaw and Brno Biennales of poster art. Most, however, would likely be surprised to learn that the poster craze which spread from France to Britain and thence to the United States in the 1880s and '90s infected Canadian cities at about the same time.

Because there is so little literature on the graphic arts in Canada, and because galleries, museums, archives, and other public institutions have ignored and continue to ignore Canada's contribution to poster art over the past century, the very considerable accomplishments of our best designers, illustrators, and typographers remain unappreciated and obscure. Nevertheless, posters have been published in Canada in numbers amazing for so small a population. What is even more startling is the high quality of a fair percentage of this material. Conditions here are, admittedly, far from ideal for fostering a poster industry on a large scale. The obstacles, seemingly innumerable, extend from the inclemency of the weather to the nature of our architecture, from proscriptive local bylaws to the domination of billboards over other forms of pictorial advertising. All the more reason, then, to cheer the fact that the "art of the streets" has not only survived but in some cases hearteningly thrives.

As revealed in the first chapter of this historical survey, the ancestors of modern posters were the engraved or letterpress broadsides which began to

2. Trade-label engraving. Montreal, late 18th century.

3. Exhibition poster of 1967 demonstrating nineteenth century letterpress technology used in printing broadsides: the "forme" of metal type with ornaments locked up for imposition in a "chase".

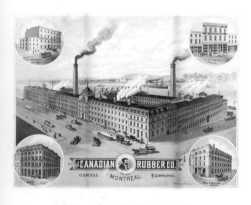

4. **Canadian Rubber Co.** Framed lithograph printed by A. Sabiston and Co. Lith., Montreal, late 19th century.

appear in Canada in the latter half of the eighteenth century and remained in use throughout the nineteenth. As these proclamations, notices, and advertisements demonstrate, the relative inflexibility of the format, it's lack of colour and essentially typographic character, ultimately drove printers and their markets to seek other forms of pictorial promotion. By the middle of the nineteenth century advertisers began to turn to the lithographic poster, a new medium with unexampled versatility which allowed not only for a whole rainbow of colour effects but also for a depth of perspective and a degree of detail never before obtainable. There are several claimants to the invention of lithography, but credit is customarily given to Aloys Senefelder, who published the *Complete course of lithography* in 1818. At first the medium was treated as a novelty, but after Brisset introduced the rotary lithographic press in 1833 and Engelmann had perfected his chromo-lithographic process in 1837, the practical application of Senefelder's accidental discovery became feasible. Auto-lithography involves the drawing of a design on a porous limestone block or grained zinc plate, or on transfer-paper; chromo-lithography is the re-drawing of an artist's work in colour by a professional copyist. Photo-lithography, which began to replace the hand-lithographer about the same time as photo-engraving supplanted the woodblock engraver, signifies the photographing of an image on a sensitized plate or stone. The process is planographic and based on the antipathy of water for grease (i.e., the ink, chalk, or crayon used to produce the picture and lettering), and of grease for water. Among the first litho'd advertisements were small trade-cards, the format of which gradually expanded in size as larger and faster presses appeared on the market. Most early lithographs were produced by expatriate German or British craftsmen who prided themselves on their painstakingly literal reproductions of figures and objects. Charming as much of their work was, it also tended to stiffly mechanical over-elaboration.

The modern "art" poster dates back to the introduction from England to Paris in 1869 of hand-drawn colour lithography by Jules Chéret (1836–1933). Chéret drew his designs for theatrical, concert, dance hall, and advertising posters directly on the stone, and, by means of over-printing four or five basic colours, created an array of brilliant hues and swirling forms evocative of the enchantingly frivolous bohemian sub-culture he celebrated. Art historian Alan Gowans believes that "from Chéret there are three lines of descent": the "workaday poster," "art in advertising" (which is designed to "elevate the tone"), and "the 'Art' poster." Posters became Fine Art, in Gowan's view, "because they were technologically obsolete" by the 1890s, when "the great bulk of advertising was shifting from outdoor forms like posters to the indoor form of newspapers and magazine advertisements. . . ." Newer and quicker forms of cylinder-printing and the invention of wood-pulp newsprint in the 1880s made newspaper advertising economical, at the expense of the poster. The more competition there was for public attention, the greater the sensory assault on the audience, and the harder the sell to win over the growing mass of consumers. The poster's punch, forceful as it could be, lacked the impact of volume advertising in the periodical media. It was deemed too "arty" by the practical-minded, for the more artistically satisfactory the poster was, the more it drew the observer's eye to itself rather than to the message it was designed to put forward.

The far-reaching results of Chéret's "revolution" should not, however, be denied merely because they came too late—or too soon. The technology which robbed posters of their dominant position in the realm of advertising at the same time expanded the medium's possibilities. Although, by 1848, cylindrical presses could print posters at a rate of 10,000 sheets per hour, these presses were not perfected until the 1860s. Up to that time, most lithographic work was done on small flatbed scraper presses. With the introduction of the large steam-driven rotary machines, artists such as Chéret and Henri de Toulouse-Lautrec were able to design posters three metres and more in height. Before the fanaticism of collectors rendered the enjoyment of the artist's *affiche* an avocation restricted to wealthy connoisseurs, outsize wall-posters changed the face of Paris, bringing art—of a kind—to the "gallery of the streets." In recognition of his achievements, Chéret was awarded the *Légion d'honneur* in 1890—an event which did not escape the notice of an editorialist of Toronto's *The Week*, who wrote that "all artists and persons of artistic taste will rejoice

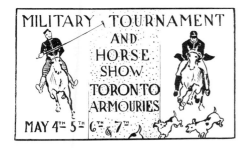

5. **Military Tournament.** Poster by John Innes, Toronto, 1898.

6. Sketch by Oscar Wilde of series of billboards promoting his May, 1882 lecture in Montreal.

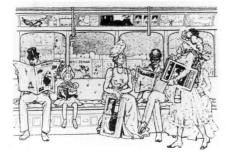

7. Interior of Toronto streetcar, turn-of-the-century, as depicted by an artist on the staff of Grip Ltd., for a promotional brochure.

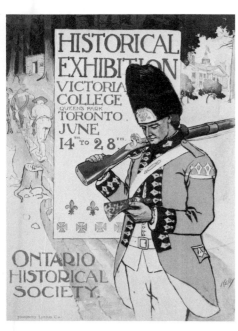

8. **Historical Exhibition.** Poster by J.D. Kelly (lithograph), printed by Toronto Litho. Co., 1899.

that encouragement is shown at least in one country to an artist who subdues to his skill and taste those hideous placards that disfigure so many places. This at least is making art practical and as such the knighting of M. Chéret will commend itself to our worthy Minister of Education." It did not do so, of course, but it did help to convince respectable painters and printmakers to teach themselves the art. What is now known as the "Golden Age of the Poster" saw the papering of the newly widened boulevards of Baron Haussmann's reconstructed Paris. It simultaneously witnessed the public apotheosis of such early masters of the *affiche* as Henri de Toulouse-Lautrec, T. A. Steinlen, Paul Berthon, Georges de Faure, T. Privat-Livemont, Pierre Bonnard, Lionetto Cappiello, and dozens of others of near if not equal renown. Poster cults blossomed almost simultaneously in Italy, Austria, Belgium, Spain, England, and America. The vogue of *art nouveau* was largely inspired by the popularity of Alphonse Mucha, Sarah Bernhardt's favourite poster-artist; in England, the Arts and Crafts and Decorative movements achieved similar feats of sensuous elaboration, and disciples of William Morris and Aubrey Beardsley brought the floridly ornate style of the *fin-de-siècle* to the New World.

It was with the design of converting philistine North America to the aesthetic gospel of Morris and his followers that Oscar Wilde undertook his highly publicized lecture tour of 1882. Wilde's vanity was seduced by the sight of billboards announcing his appearance in Montreal. In a letter to Norman Forbes-Robertson dated 12 May 1882 he crowed, "I am now six feet high (my name on the placards), printed it is true in those primary colours against which I pass my life protesting, but still it is fame, and anything is better than virtuous obscurity, even one's own name in alternate colours of Albert blue and magenta and six feet high. This is my view at present from the Windsor Hotel, Montreal. I feel I have not lived in vain."

Posters of those dimensions did not in fact become common in Canada until the early twentieth century, as the poster fever which spread to America manifested itself in miniature rather than in giant format. The "art" poster was occasioned here, not as in Paris, by the music hall, the cabaret, the *café dansant*, or by the *estampe*-publishers and gallery-owners, but by the proprietors of newspapers and magazines, who sought to increase subscriptions and circulation by issuing illustrated news agents' cards and window-bills in large editions to advertise special numbers. Following the lead of the Swiss artist Eugène Grasset, who was first invited to design a magazine cover for a New York periodical in 1882, a North American school of imitators of Beardsley, Toulouse-Lautrec, and other favourites quickly emerged. Formats remained small, as if in recognition of the fact that such posters had their origins in pictorial covers and frontispieces. Size was also determined by such factors as the narrowness of our city streets, the lack of outdoor posting facilities, and the nature of the market, which increasingly consisted of dealers and collectors. Advertising was the agent, not the end. Canada was not far behind the United States in this field, but never managed to produce a Will Bradley, an Edward Penfield, a Frank Hazenplug, an Ethel Reed, a Maxfield Parrish, a J. C. Leyendecker, or a Robert Wildhack. Two Canadians who did make something of a mark in the 1890s were C. W. Jefferys, then an illustrator for the *New York Herald*, and his friend Jay Hambidge (inventor of the compositional theory of "dynamic symmetry"), who did several posters in a realistic vein for *The Century Magazine*. We can detect the influence not only of *art nouveau* graphics but also the elegant yet vigorous style of pen-draughtsmanship popularized by Charles Dana Gibson, C. S. Reinhart, and A. B. Frost.

In Toronto, awareness of the progress made by the modern poster was registered by such forward-looking organizations as the Ontario Society of Artists and the Toronto Art Student's League. The League's members were, for the most part, professional illustrators and lithographers, or art students who realized that to make their livings they would have to join commercial art studios, the staffs of newspapers and magazines, or printing companies. From the date of its inception in 1886 the League's primary objective was the awakening of artists and the public to the possibilities of using the Canadian landscape as subject matter, but its leaders were also strongly affected by such contemporary trends as French Impressionism, the modern Scandinavian landscape school, and *art nouveau*. Traces of the latter style can be detected in the lettering and decorations which graced the League's annual calendars

9. Typical billboards and hoarding-posters, early 20th century, on south side of College St. just east of Bathurst St., Toronto.

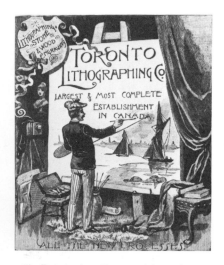

10. Print advertisement (wood engraving) for Toronto Litho. Co., late 1890s.

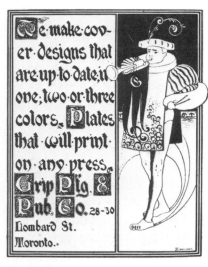

11. Print advertisement for Grip Printing and Publishing Co., Toronto, by John Conacher, turn-of-the-century.

published between 1893 and 1904. When it was dissolved in 1904, its aims were perpetuated in such reincarnations as the Graphic Arts Club (which became the Canadian Society of Graphic Art on the occasion of its first public exhibition in 1924), and the Canadian Society of Applied Arts. The CSAA was founded in 1903 by G. A. Reid and a number of other front-rank artists and designers for "the encouragement of original design and original expression" according to the example of William Morris, whether in crafts, furniture, or posters.

In the last decades of the nineteenth century, many Canadian artists were forced to chose or to leave the country, either to study abroad or to seek employment in the United States. Those who returned to Canada brought with them new ideas and styles, and so influenced their colleagues at home. The process has continued up to our own time and its consequences have been both productive and deleterious. While it may have impeded the development of an indigenous Canadian style, it rescued our artists and designers and their sponsors from chronic isolation, informing them of methods and approaches current in the world's centres of innovation.

The original poster vogue lasted only a few years, but at its peak, in 1896, *The Poster* reported that there were some six thousand poster collectors in the United States and, amazingly, another one thousand in Canada.

The fact that some modern-style posters were beginning to appear in Canada in the 1890s should not mislead the reader into believing that the majority of pictorial advertisements were couched in the simplified, suggestive mode preferred by artists who adapted the flat, flowing patterns of the Japanese woodblock print to the lithographic poster. Most posters took the form either of typographic broadsides or of "paper-under-glass"—that is, framed chromos issued to retailers, publicans, etc., by manufacturers and distributors. Tobacco, alcoholic beverages, foodstuffs, thread, cloth, soap, rubber, and flour were advertised by this medium, as were the services of insurance and trust companies. When a company's product itself could not be depicted with photographic realism, a genre scene or an aerial view of its head office or manufacturing plant was featured instead. The printers of such poster-prints fulfilled their advertisers' wishes not to alter pictorial styles or contents for fear of creating public confusion; certain images and slogans were reproduced year after year, long after the graphic technique, lettering, and costumes had gone out of fashion.

Gradually, variations on the basic format of the poster appeared with the growth of cities and the development of transportation systems required by swelling urban populations. A turn-of-the-century depiction of the interior of a Toronto streetcar by a Grip Printing and Publishing Co. employee indicates the range of visual media available to the advertiser, from car-cards to dress-boxes, from magazines and newspapers to hoarding posters for plays and other attractions. The mildly *art-nouveau*ish character of the designs suggests that the style had been sufficiently domesticated to be acceptable to Toronto's conservative burghers. More typical, however, were the cramped, cluttered advertising sheets which by the first decades of this century were covering every available surface, including the huge billboard stands that arose at the city's major intersections. One searches in vain for posters exhibiting the economy, sophistication, and sense of frivolous, naughty fun that typify French, Belgian, and even English entertainment posters of the day. The puritanical cast of our city fathers and moral arbiters must have been partially to blame, as was the paucity of cultural occasions for posters. Endeavours to reconcile the stripped-down, dynamic stylistics of the contemporary French poster with an historical Canadian theme give J. D. Kelly's exhibition announcement of 1899 its peculiar tension.

By no means did all the engravers and lithographic draughtsmen of the late nineteenth century have ambitions to be academic painters, but a significant number of them were involved in both professions. J. D. Kelly, C. W. Jefferys, F. H. Bridgen, F. S. Challener, and J. E. H. MacDonald went so far as to credit their practical training with teaching them a sense of discipline and dextral facility which would have been otherwise unobtainable. At the time of their indentures, firms such as Toronto Lithographing Co., the Toronto Engraving Co., and Grip Ltd. were adding to their printing facilities the services of illustrators and designers capable of producing artwork in the

12. Unfinished calendar design by a Rous and Mann artist—possibly Tom Thomson, c. 1912.

styles of their customers' choice. The idea of the modern commercial art studio housing under one roof draftsmen, photographers, plate-makers, layout-artists, copywriters, and advertising salesmen was imported to Great Britain in 1902 by four members of the Toronto Art League and former employees of Grip Ltd.: A. A. Martin, W. T. Wallace, T. G. Greene and Norman Price, who all became co-founders of London's Carlton Studios; other Canadians, including J. E. H. MacDonald, later briefly also joined the firm. Carlton's philosophy was the desire to apply the ideals of William Morris and the Beggerstaffe brothers to commercial printing and advertising. Its success can be gauged by the fact that within a few decades Carlton was considered to be the largest advertising house in the world. Several of their alumni attempted to introduce Carlton's methods and theories to Canada, and in so doing fostered the cause of the poster revolution on soil that remained inimical to modernism of any kind.

The federal election of 1891—the first to be fought in Canada with the aid of posters in colour—proved to the victorious Conservative party that public opinion could be swayed by cleverly calculated propaganda. A quarter of a century later, the recruiting and bond drive campaigns of World War I convinced advertisers and government agencies that the poster and the billboard could be effective means of reaching a widely scattered public. Although billboards were introduced in the 1870s to promote travelling circuses, fairs, and similar attractions, they had not had much impact on the population until a regulatory body, the Poster Advertising Association (ancestor of today's Outdoor Advertising Association) was set up in 1912. Millions of dollars were raised through the poster advertising of Victory Bonds; the hortatory hard-sell exemplified by variations of the "I Want You!" pointing soldier motif became the standard technique of promotion in the decades following the Armistice.

Canadian artists were not quick to adapt to the various modernist reforms in graphic design and typography proposed by the Purists, the Objectivists, and the De Stijl and Bauhaus functionalists. The Russian, German, French, Italian and Swiss design revolutions influenced North America only in a diluted and belated form, partly because of poor communication, and partly because of the nature of the market itself.

The innate conservatism of Canadian advertisers forced designers and illustrators to opt for less extreme solutions than those propounded by the Europeans who experimented with *sans serif*, and asymmetric typography, photograms, and the "symbolist" mode. This mode sought to make simplified or abstracted images conjoin with letterforms to convey the *idea* of a product or service, at the same time reducing the text to a more or less supportive role. The new science of streamlining was borrowed from automobile designers to give illustrations and captions a feeling of speed, urgency, and gracefulness. In Canada, the car's impact was seen more definitely by the enlargement and radical simplification of images and texts in order that they might be taken in at a glance by passing motorists. Posters by Stanley Turner and Arthur Keelor are good examples of the best domestic work of the twenties.

The French and Anglo-American leaders of the symbolist revolt, A. M. Cassandre and E. McKnight Kauffer, had Montreal's Raoul Bonin and Allan Harrison as their Canadian disciples in the 1930s. Bonin travelled to Paris to study under his master, and Harrison fled to London in search of work with Shell Oil, London Transport, and other firms which displayed progressive notions about advertising art. Bonin's and Harrison's attempts to transplant the advanced European techniques to Canada were thwarted by the Depression and also by the cautious and often reactionary outlook of advertising agencies and the companies they served. By the late 1940s their efforts, combined with those of Clair Stewart, Eric Aldwinkle, Leslie Trevor, Charles Fainmel, Henry Eveleigh, and Carl Dair, eventually helped to push the Canadian poster out of its infancy and into belated adolescence.

While some Canadian posters of the twenties, thirties, and forties reflect the *art déco* fashion which ironic nostalgia elevated to cult status in the 1970s—just as the poster revivalists of the psychedelic sixties had turned to *art nouveau* for subjects worthy of imitation,—a more direct and more lasting influence was the landscapes painted by the Group of Seven. The Group's collective style, with its bold, raw colours and massive, vigorously outlined undular forms, has often been accused of appearing "posterish." This is hardly surprising, considering how many of the Seven and their associates (including

13. Unfinished poster design by Stanley F. Turner, included in Canadian poster show, Empire Exhibition, Wembley, 1924.

14. **Save** by Stanley F. Turner, c. 1924.

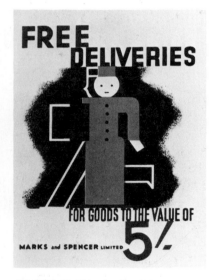

15. **Free Deliveries** by Allan Harrison, 1935.

Tom Thomson) were originally employed as designers and illustrators. MacDonald, Thomson, Lismer, Varley, Johnston and Carmichael began to develop their shared attitudes and approaches while working first for Grip Ltd., and, after 1912, for Rous and Mann. The tradition was carried on commercially by Frank Carmichael and his successor, A. J. Casson at Sampson-Matthews, probably Canada's leading silkscreen poster-printing establishment between the wars. All these artists tried to accommodate certain modernist ideas to the geography of Canada itself, not only on their canvases but also in their illustrations and travel posters.

When World War II broke out it took some time to get into the act of mounting a poster campaign to apprise the public of the urgency of the situation. Finally, the Department of Public Information (later named the Wartime Information Board) was established by the Ministry of War Services, and commercial and "fine" artists were enlisted to create powerful images that would inspire, exhort and inform. But it was not until 1942 when Harry Mayerovitch ("Mayo") took over the design department of the National Film Board that a consistent program of poster production got underway. Another war posterist, Charles Fainmel, complained in 1947 that the Canadian government had not maintained the momentum gained during the war years to educate the public and to broadcast the vital message of peace and reconstruction through concerted nationwide poster campaigns. Henry Eveleigh demonstrated what could be achieved in the category of "social" posters when he designed an inspirational photo-montage which won him the first United Nations poster contest in 1947.

Despite idealistic attempts to elevate the poster to a public art form, the medium was once more returned to commercial advertisers, who by now were increasingly influenced by their American counterparts. Slick illustrative or photographic posters with crassly calculated sexual or "human interest" themes were the norm, and the decisions of individual artists were increasingly overruled by the meddling of art directors, committees, efficiency experts and market analysts. In the late forties and fifties typography became a secondary consideration in most posters; too often, texts and images contradicted rather than harmonized with one another, and the new film and acetate typefaces frequently lacked integrity or taste. Television and radio, meanwhile, were claiming the attention of consumers and sapping the budgets of advertisers; the post-war building boom was producing brutally geometric glass-and-concrete structures which left little room for posters. Even the new subways made few provisions for the posting of placards and posters in their stations. Billboards remained ubiquitous and mostly bad, but a few designers, among them Ted Bethune, showed inventiveness by cleverly manipulating words-as-images and images-as-words.

The Art Directors' Club of Toronto was founded in 1949. Similar organizations soon sprang up in Montreal, Vancouver and Winnipeg, and although they all began to falter by the late sixties, they did succeed in awakening a public and professional awareness of quality in advertising in all its forms, including that of the poster. In 1956 Typographic Designers of Canada was established in Toronto, an association primarily intended to reform commercial and editorial typography standards; however, the changing of the society's name to Graphic Designers of Canada in 1968 does indicate a shift in emphasis, as it now takes in all types of advertising and publication design.

The rebirth of interest in illustration in the United States had an effect on Canadian commercial artists and on the studios to which they were attached. The best designers managed to tread the narrow line between glib flashiness and cold impersonality, and emerged, by the end of the decade, with a style which seemed to integrate the qualities of a number of imported modes in an idiom that was nevertheless unmistakably Canadian. The major advertising centres each had their individual approaches, but the refined eclecticism of three of Toronto's finest designers of this period, Allan Fleming, Theo Dimson, and Jim Donoahue, may be cited as representing the era at its peak. Compromise is a peculiar Canadian talent, and the ability to reconcile modernist precision with nostalgic revisionism set these craftsmen apart from their less adaptable contemporaries.

Curiously enough, Franco-Canadian designers have, on the whole, been

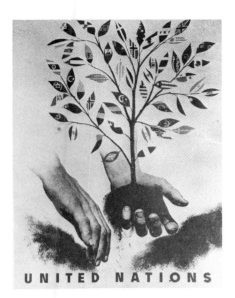

16. **United Nations** by Henry Eveleigh, 1948.

more receptive to the Bauhaus-influenced European style than their anglophone counterparts. This is perhaps due to the fact that so many of them studied at continental art colleges, and also because several expatriate Europeans had settled in Montreal and Quebec City, where some took up teaching positions or founded trend-setting studios. Their domination of the scene can be detected in the posters commissioned for Expo 67 and the 1976 Montreal Olympics. By the mid-seventies the style had, in some eyes, exhausted itself; the ethos of form-follows-functionality is, after all, sometimes merely an excuse for lack of imagination. As early as 1964 Allan Fleming had begun to protest against the omnipresence of the "international style." Although he praised the contribution made by such recent arrivals as Rolf Harder, Ernst Roch and Gerhard Doerrie, Fleming complained that their "reward" for having "fed and nurtured us" was the "knowledge that they had completely taken over. . . ." Fleming's objections to "one-world designing" included the fact that "a world culture was not good because it implied the loss of exotic cultures."

At the time when these remarks were published in the catalogue of the 1964 Society of Typographic Designers' exhibition, poster art in America was beginning to divide into four separate streams, much as it had during the epoch of Chéret. The fine-art poster continued to survive, if precariously, with the help of grants supplied to theatres, galleries, and other cultural bodies. The institutional and advertising poster also stayed alive, and in some areas even thrived on the optimism that attended the celebration of Canada's centennial. The new entry was the psychedelic or "rock" poster which did not last long. Like its cousins, the "personality poster" and the "poster-poster," the underground poster was an import, this time from San Francisco and "swinging" London, which certain nonconformist Canadian freelancers strove to make their own. Da-glo colours, barely legible "organic" lettering, erotic or hallucinatory imagery, and a modicum of revolutionary rhetoric were the constants of many of these posters. Ephemeral and often cheaply produced, as much as it was, such work had the beneficial effect of reviving interest in *art nouveau* and its German equivalent, *Jugendstil*. In so doing, it affected a poster craze comparable in volume and enthusiasm to that of the 1890s. Although Canada's contribution to the genre was minor, it indicated that the poster had not been completely consumed by conventional advertising interests. Our dependence on American models was, however, distressing.

Since 1968, cooler and less self-indulgent styles have become prominent. The *art déco* rage showed no signs of abating by 1979, but the latter half of the decade has also seen a sudden and praiseworthy rebirth of support for poster illustration, which again had an important effect on design.

The poster faces serious obstacles as it enters the last twenty years of the century. Soaring printing and paper costs, inflation, and the freezing of grants have caused arts groups and government agencies to turn away from poster publicity, despite its relatively low cost compared to that of other promotional media. Where previously the poster artist's freedom of invention was limited by advertisers' reliance on successful formulae, today the most basic economic and social factors combine to restrict expression and eliminate outlets. Civic reaction against the intrusiveness of "ugly" billboards has unfortunately extended to wall-posters and flybills, the posting of which becomes a more clandestine activity every day. Various other forms of censorship—of which Quebec's language legislation prohibiting signs in English only is but one example—also threaten the poster's livelihood. Yet somehow one cannot despair for its future. It has confronted opposition and indifference before and has triumphed, often emerging from the encounter with a greater sense of purpose and determination. It will either fend for itself—in the streets and markets of our cities, not in galleries or museums—or it will perish. Certain forms of assistance, however, could and should be introduced to encourage cultural organizations to commission original designs. The success of the List Art Poster Program in the United States, whereby arts institutions can receive funds to commission and print posters in large enough runs for public sale, should provide a model for Canadian benefactors or entrepreneurs. Private business and government might be encouraged to resort once more to poster advertising if they could be guaranteed that publications would be properly mounted and maintained, as in certain European countries where renters of

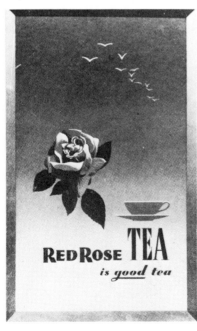

17. **Red Rose Tea.** Toronto subway-placard by Eric Aldwinkle, c. 1953-54.

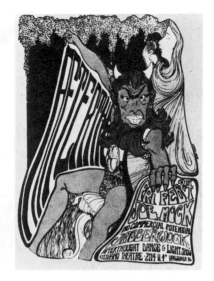

18. Poster by Bob Masse for Kitsilano Theatre, Vancouver, 1968.

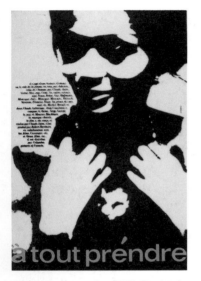

19. **A tout prendre** 1963. Poster by Vittorio Fiorucci for a film by Claude Jutra. **M:** Silkscreen.

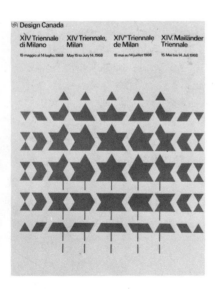

20. **Design Canada XIV triennale di Milano** by Rolf Harder, 1968.

poster boards and kiosks offer reliable and economical services. Before such facilities can become available, standard poster sizes have to be agreed upon, so that frames and boards can be built and posters can be printed to universally accepted dimensions. With the adoption of the metric system some degree of uniformity may at last come to the poster design industry.

Harold Innis, Marshall McLuhan, and their disciples have made us conscious of the influence of advertising on our lives. This increasing awareness has caused many people to examine the priorities and principles of those who seek to claim our hearts, our minds and our dollars. The refusal of art galleries, museums, archives, and libraries to take applied arts more seriously has in the past resulted in public indifference to the *quality* of the visual-verbal message. Unless examples of advertising and other types of graphic announcement and persuasion are preserved and exhibited, the achievements (and failings) of the present cannot be measured. Printers and commercial art studios must keep copies of their productions and their original artwork, so that physical records can be maintained for consultation. There must be a concept of where they have come from or where they are going; without this perspective, there can be little sense of history, direction, or proportion in the graphic arts.

The Public Archives of Canada must be commended for at last deciding to catalogue and photograph its enormous collection of broadsides and posters and for instituting a national poster registry and archive—a significant first step in reclaiming Canada's buried graphic heritage. That the Art Gallery of Ontario should have undertaken to mount and tour throughout 1979 an exhibition showcasing one hundred years of the poster in Canada is also an encouraging sign. Earlier in its history the AGO demonstrated its concern for the medium by sponsoring exhibits of French posters (April 1923), English posters (November 1923), international posters (December 1924), English, American and Canadian posters (December 1926), another one of modern international posters (1927), modern European posters (May 1928), and still another of English railway posters. It has also periodically held poster competitions. The National Gallery of Canada and the art galleries of Vancouver and Winnipeg also have taken cognizance of the poster.

In Canada the poster has been a source of pleasure, amusement, inspiration, and information to millions. It has helped to finance the careers of painters and graphic artists, and has brought the messages of educational and cultural facilities to areas of the population which other media could not reach with similar efficiency or length of retention. It is time that Canadians began to pay homage to the talents of their artists, designers, photographers, art directors, and printers who have brightened our streets and public transit systems, our stores and shopping malls, dwelling- and working-places. The poster's one hundred years of slow and unsteady progress should be celebrated in a manner befitting the medium itself: directly, happily, unpretentiously, but with feeling.

If the consumers of advertising—which are all of us—show that they care about the aesthetic merits as well as the honesty of the graphics that daily address them, our designers and those who employ them will respond in kind. The advent of the age of instantaneous electronic communication may well have doomed the poster to obsolescence, along with all other forms of printed material, barely a century after its emergence as a distinct art form. But look around you, and you will still see posters wherever people congregate. Look harder, and you will discover that some of the best that can be found in Canada today have been produced by its own unsung masters of this elusive, perishable, neglected, but enormously rewarding medium.

1/ *Broadsides*

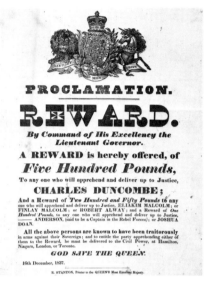

1. Proclamation. Reward. 1837;
P: R. Stanton, Toronto.

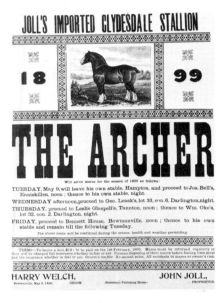

2. The Archer 1899; **P:** Statesman
Publishing House, Bowmanville,
Ontario.

3. Menagerie Annexioniste. 1850(?);
A: William Leggo (Woodcut anti-
annexationist cartoon-broadside,
attacking ex-rebel Joseph Legaré,
since raised to respectability as
member of Quebec legislative
assembly).

The earliest use of the term "broadside" cited by *The Oxford English Dictionary*
is 1575. A broadside, according to Webster's dictionary, is a large sheet of paper
printed on one side. Its style and contents provide an index of the political,
social, economic and artistic climate of the times.

Broadsides serve as valuable reminders of many significant historical events,
and the earliest Canadian ones date back to the beginning of printing in North
American colonies—in Halifax around 1764 and in Montreal in 1776. Except for
some commercial advertisements, the majority of them were proclamations and
bills. The King's Printer was responsible for official publications and issued
licences to job printers. The government's patronage frequently helped printers to
finance their operations but often restricted them in what they could print. In times
of political unrest more and more privately owned, independent presses were
established, and the number of news agents and broadside-mongers grew propor-
tionately. By 1890, over two thousand people derived their livelihoods by working
in Toronto's seventy-four printing establishments.

Election posters and government proclamations altered their styles
slowly, and traditional layout and type faces were retained until well into the
1930s. Even though typesetting and printing methods had changed, the
physical appearance of these documents remained constant for over one
hundred and fifty years.

Broadsides were not regularly illustrated until the middle of the nine-
teenth century. Before that time crests and seals, usually at the head of the
opening paragraph of a proclamation, were the only decoration.

A curious example of a mid-nineteenth century illustrated broadside is
Quebec printer William Leggo's satirical "*Ménagerie annexioniste*," which
combines crude caricature with letterpress isolated in speech-bubbles. Now
virtually incomprehensible, this lampoon on painter-politician Joseph Légaré,
a former supporter of Joseph Papineau during the 1837–38 rebellion in Lower
Canada, is intriguing because of its use of Québecois dialect. In August 1863
Leggo applied for a patent in Quebec City for "a new improvement in pans for
backing electrotypes." Three years later, when the first patents for halftone

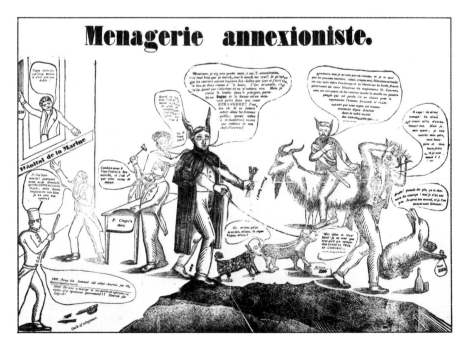

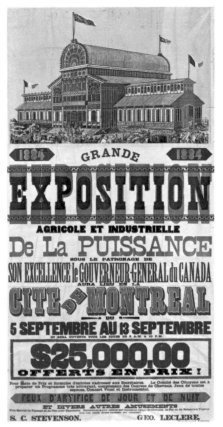

7. Grande Exposition Agricole et Industrielle... 1884; **C/A:** Cité de Montréal (?); **M:** Letterpress (wood type) and woodcut; **Dim:** 213.4 x 108.6 cm.

8. Second Biennial Perth County Slumgullion Festival 1976; **D/A:** William Rueter (b. 1940); **C/A:** Laurie Lewis and Amanda West Lewis.

Vancouver, where the Alcuin Society was set up to preserve and promote an old but still vital art form. Among leading proponents of the medium in the mid- and late-1960s in Montreal were McGill University Press's Robert Reid (an alumnus of the University of Toronto's special course in typography) and his young cohorts Ib Kristensen and Beverly Leach, two transplanted Vancouverites. Together they produced numerous broadsides (some of which were collected into expensive portfolios) using nineteenth-century wooden type fonts printed on a large press installed in the basement of the Redpath Library in Montreal. Their glory-days were short-lived but memorable, and the spirit which informed their compositions survives today in the posters and broadsides of Toronto's Will Rueter, operator of the Aliquando Press. The criteria of excellence he pursues in his private projects are uncompromisingly reflected in his book-design assignments for the University of Toronto Press.

Tim Inkster, co-proprietor of Porcupine's Quill, in Erin, Ontario, is also a poet whose interest in the appearance of the text on the page led him to investigate the history and techniques of hand-printing. He was assisted in his pursuit of discovering the typographic roots in rural Ontario by Doug Brown, then editor of *Copperfield* magazine, who in September 1972 learned that the archive of late-nineteenth century wood and lead type owned by the *Bowmanville Statesman* was up for sale. He insisted that Inkster buy the lot—consisting of thirty drawers—and restore it. Thus the very type used in broadsides printed by the *Statesman* a century earlier was returned to active service. Inkster proofs his broadside posters (such as the set issued in 1975 to advertise the national tour of the NDWT theatre company's production of James Reaney's *Donnellys* trilogy) on a Vandercook flatbed press formerly owned by Reaney, who in the sixties had printed his excellent little magazine *Alphabet* on it.

Allan Fleming, the distinguished Canadian designer, wrote shortly before his death in 1977 that, "In this age of high-speed reproduction, I find myself clinging desperately to the rapidly disappearing craft of letterpress printing. . . . In a sense I am a sort of classical dinosaur in my approach to typography. I feel like a Brontosaurus struggling in the tar pits, trying vainly to do my own thing but sensing, with my mini-brain, that the end is near."[2] Despite his pessimism, Fleming's legacy lives on in the work of a growing number of back-to-the-hand pressmen and women. These revivalists recognize that the purely typographic poster or broadside is still a challenge to the inventiveness and taste of the designer and to the typesetter's skill. They acknowledge that their craft provides a vital link between the pre-computer past and the post-industrial present.

Ironically, broadsides printed before 1866, when wood pulp was first used in Canada for paper manufacturing, will likely outlast posters printed after that date, because the sulphuric acid employed in pulp-making ensures the deterioration of non-rag paper. The most expensive coated bond stock has a circumscribed life expectancy compared to rag stock; consequently, it may be that our descendents will judge our commercial printing efforts by the early broadsides rather than by the posters we manufacture today.

[2]Fleming, Allan. "Typographic Design," *Graphicaids* (Montreal: Domtar Fine Paper), Vol. 1, No. 1, 1977.

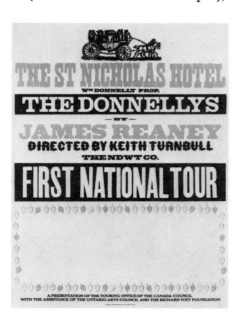

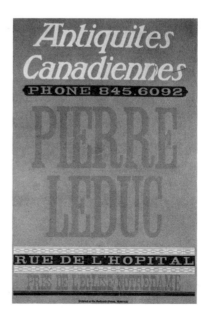

9. The St. Nicholas Hotel . . . The Donnellys 1975; **D:** Tim Inkster (b. 1949); **C/A:** The NDWT Co., Toronto; **P:** Tim Inkster, The Porcupine's Quill, Erin, Ontario.

10. Antiquites canadiennes c. 1965(?); **D/A:** Ib Kristensen; **C/A:** Pierre Leduc; **P:** Redpath Press, Montreal.

2/ *Fairs, Expositions and Shows*

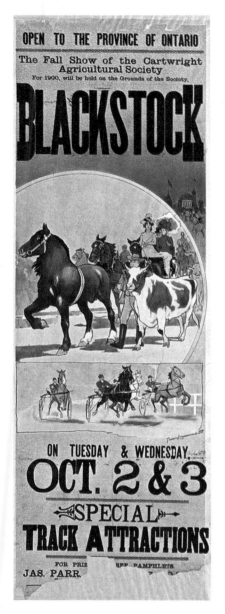

1. **Blackstock** 1900; C/A: Cartwright Agricultural Society; P: Toronto Lithographing Co., M: Colour lithograph.

The posters and souvenir program covers advertising Canada's many seasonal fairs, expositions and indoor and outdoor shows provide an archive of images which indicates not only where we have been, but where, at various times in our history, we have imagined we were going.

Each province introduced fairs and expositions at different periods and in different ways; the movement began in Ontario and spread to the West and to the East. John Graves Simcoe, Upper Canada's first governor, established the Niagara Agricultural Society in 1792 to foster the development of farming in the colony. Various local societies formed thereafter throughout Upper Canada were hampered by lack of funds and patronage, political unrest and economic instability. In 1830, the Legislature decided to pass an "Act to encourage the establishment of Agricultural Societies in the Several Districts of the Province." The first Provincial Exhibition was held in Toronto in October 1846 under the auspices of the newly formed Agricultural Association and Board of Canada West. Each year an Exhibition was held in a different centre—in Toronto, Ottawa, London or Kingston. In 1877, when Toronto's civic leaders decided that an exhibition should be settled permanently in the provincial capital, they acquired fifty-two acres of lakeshore property, yet in 1879 the exhibition was held in Ottawa. The disgruntled Toronto city council then created its own annual fair, the Industrial Exhibition Association of Toronto, which was incorporated on 11 March 1879. As the exposition committees were strongly influenced by the success of the 1850 British Great Exhibition held in London's Crystal Palace, a large number of imitations appeared—most notably Toronto's ill-fated copy of Sir Joseph Paxton's original design. In 1912 the Toronto Industrial Exhibition changed its name to the Canadian National Exhibition, which celebrated its centenary, if somewhat prematurely, in 1978.

Almost from the beginning the organizers of the "Ex" realized the value of pictorial publicity. Doubtlessly they had before them a model of large wood-type letterpress fair and auction announcements so familiar to collectors of nineteenth century printed ephemera. By 1883, the date of the magnificent "Grande Exposition," a super-broadside printed in Montreal, the topographic notice was being supplanted by the more colourful lithographic poster. Nevertheless, publicity committees still continued to resist the notion that a picture could tell a story better than a plethora of minute and hyperbolic copy. Part of the problem stemmed from the fact that broadsides and posters advertising fairs, carnivals, and exhibitions often had to double as programs of forthcoming events. Many of these posters tried not so much to attract people as to inform the public of what it would be able to see and hear at the fair it would be visiting. Only much later did artists attempt to convey an idea or a feeling for the forthcoming event through illustrations, photographs and slogans that fairly commanded potential spectators to race to the scene of the attraction. The early rosters of daily doings at the Toronto Industrial Exhibition were bound in bright, heavily decorated mini-lithos printed by Howell Litho. Co., Brigden's Ltd. and Stone Litho. Co. Some of these were enlarged for use as wall-posters, a practice which continued until recently. The colour-lithographer also had the opportunity to display his skills in posters announcing

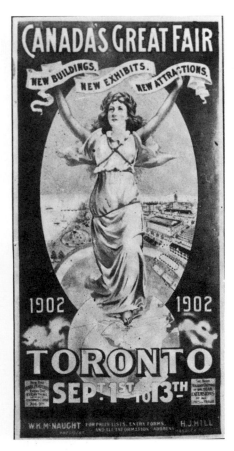

2. **Canada's Great Fair** 1902;
C/A: Toronto Industrial Exhibition.

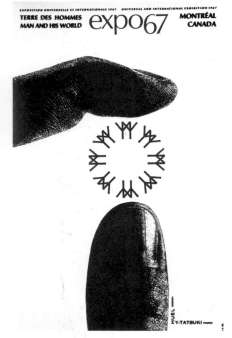

3. **Terre des Hommes Expo 67** . . .
1967; **D:** Georges Huel; **Symbol:**
Julien Hébert Tatsuki; **C/A:** La
Compagnie canadienne de l'Expos-
ition universelle de 1967, Montréal/
The Canadian Corporation for the
1967 World Exhibition.

Opposite

4. **Dominion Exhibition Calgary
Alberta** 1908; **C/A:** Dominion
Exhibition, Calgary; **P:** The
Hammond Litho. Co., Calgary.

the Ex's spectacular *son et lumière* stage shows. With the aid of special
lighting effects, these shows could recreate fireworks, music, backdrops and
sets, as well as the florid pageantry of great battles and disasters of history
such as the Siege of Sebastopol during the Crimean War.

In 1902 the T.I.E., with a budget of $4,000 for newspaper campaigns in
large American cities, the Maritimes and Manitoba, was commended for its
efforts in *The Printer and Publisher* (Toronto): "As for the handsome posters . . .,
they are put forth in vast numbers and are to be seen on every billboard in the
country. This year they are the work of the Toronto Lithographing Company,
and are quite as effective as any that have ever advertised an exhibition."[1] One
of the posters in question is a typical concoction of the symbolic (classical
figure astride a globe) and the factual (panoramic view of the grandstand, fair
buildings and Toronto Harbour in the distance). In 1923 the *Toronto Star
Weekly* praised the CNE posters, which were then the work of Rous and Mann
illustrator Stanley F. Turner. In other years competition winners or appointees
included A. H. Hider, a renowned "portraitist" of horses; J. E. H. MacDonald;
Franklin Carmichael; F. R. Halliday; N. K. McKechnie; Jules Laget; Fred
Finley; Eric Aldwinkle; and Grant MacDonald, whose 1941 poster "Canada's
Answer" signified the closing of the Ex for the duration of the War. The artist's
style was in keeping with the mode and mood of the moment: determined, grim,
self-consciously heroic. Earlier posters were almost unfailingly optimistic,
even when war or depression had darkened the horizon. "Commercial Awaken-
ing 1915," for instance, depicts the angel of prosperity symbolically leading
Toronto out of the clouds. Such messengers of hope were not always decorously
garbed: A. H. Hider's variation had originally appeared in the nude, but a
censorious board of governors then insisted that subjects be shown wearing
modest draperies.

The CNE posters began to decline in quality after World War II, although
there were exceptions, especially when the artwork was entrusted to such
forward-looking designers as Clair Stewart and Tom Hodgson. Most program
covers and wall-posters of the forties and fifties relied on combinations of
standard icons—beavers, maple leaves, or the CNE's Princes' Gates. These
posters arranged in cluttered layouts were further uglified by incongruities of
typefaces. Bucking this trend, Clair Stewart attempted in 1950 to convey
abstractly, through painted letterforms and arrows, a sense of movement and
direction *toward* the event.

Problems with recent Exhibition posters can be traced to entrusting
advertising to committees of businessmen and commercial agencies who are
influenced by the bland, slick style of American magazine illustration. As
James Lorimer observed in *The Ex*, the subject of the 1962 program-cover and
poster was "the ad-man's ideal Canadian family of the 1960s, Mr. and Mrs.
Consumer. . . ." The CNE's sister show, the Royal Agricultural Winter Fair, has
recently adopted a policy of commissioning first-rate poster-artists such as
Willi Mitschka, Heather Cooper, and Roger Hill to interpret the event in a
fashion which pays homage to the past without slighting the present; this is
precisely the function of fairs and expositions themselves.

A curious feature of many of the expositions and fall fair posters in the
first decades of this century—especially those advertising the Alberta Provin-
cial Exhibition and the Calgary Stampede—is that they convey a sense of
time's flight and the swift passage of the old free-range cowboy way of life.
This impression was frequently enforced by the use of chronological image
sequences depicting past, present and future; other posters represent the
decline of the west as in the nostalgic "Another Trail Cut Off." "Visit Alberta,"
we are advised by the proprietors of Calgary's Dominion Exposition, "before
the golden opportunities, picturesque rides and Indians are gone. Write for
rates." The irony implicit in a poster promoting the very cause of the destruc-
tion of the wonders being advertised obviously escaped the artist and his copy-
writer. To cry "See it before it goes!" is of course to ensure the disappearance of
the vaunted attraction.

The openness and exuberance of these long-ago souvenirs of the future-
as-seen-by-the-past are in refreshing contrast to the chilly sobriety that

DOMINION EXHIBITION

CALGARY ALBERTA.

VISIT BANFF CANADA'S FAMOUS MOUNTAIN RESORT

JUNE 29 TO JULY 9 1908.

$140,000. TO BE EXPENDED. VISIT ALBERTA BEFORE THE GOLDEN OPPORTUNITIES PICTURESQUE RIDERS AND INDIANS ARE GONE WRITE FOR RATES

"ANOTHER TRAIL CUT OFF"

WESTERN CANADA'S GREATEST FAIR

THE HAMMOND LITHO Co CALGARY ALTA.

I.S.G. VAN WART, PRESIDENT. E.L. RICHARDSON, MANAGER.

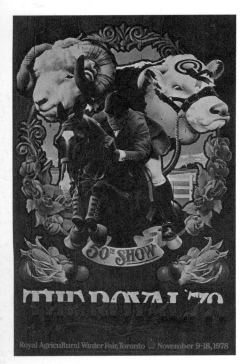

5. **The Royal '78** 1978; **D/A:** Roger Hill (b. 1943); **AD:** Myron Lasko; **S/A:** Foster Advertising, Toronto; **C/A:** Royal Agricultural Winter Fair, Toronto.

informs most of the posters commissioned by *La Compagnie de l'Exposition de 1967*. In charge of Expo 67's graphics and signage program was Montreal's capable Georges Huel, who, with photographer Y-Tatsuki, produced one of the few first-rate posters to come out of that overblown celebration. The majority of the poster commissions were of course awarded to Montreal designers, whose European training or bias is revealed in their overwhelming preference for the austerities of Bauhaus-influenced Swiss and German standards of typography and layout. The adoption of Adrian Frutiger's versatile but impersonal *sans serif*, "Univers," as the official Expo typeface, conditioned the style of the posters for the cultural pavilions designed by Montreal's Guy Lalumière et Associés. Lalumière was not always successful in tackling the problem of complementing strong images with quantities of small type in both official languages, but the combination works well in his poster for the "International Exhibition of Fine Arts." Elsewhere the designer tried too hard to instil a "universal" flavour supposedly in keeping with the nature of the World's Fair itself. Something more typically Canadian might, however, have presented the host nation in a more memorable light. The photographic images selected to represent or symbolize various artistic attractions were too abstract to be compelling, and probably confused the casual visitor instead of exciting curiosity.

Un-Canadian in character, but admirably suited to the spirit of entertainment in evidence at Expo, were Vancouver-born illustrator Ted Larson's posters for La Ronde. They project alternately a feeling of the swinging sixties (psychedelic lettering, Da-glo colours, flowing patterns, more than a hint of *nouveau art nouveau*) and of the naughty dance-hall nineties. Other designers employed by the Canadian Government Exhibition Commission on Expo projects were Burton Kramer, a recent arrival from the United States, and Frank Mayrs and Neville Smith, who both served on the team responsible for the interior of the Canadian Pavilion at the 1970 Osaka World's Fair.

If Expo 67 was something of a graphic disappointment to some, it did have the beneficial effect of stimulating Montreal's design and commercial art community. It was a proving-ground and a seed-bed; unfortunately the mistakes made by its under-funded design bureau were perpetuated at the Olympic Games nine years later.

6. **Expo 67 Design** copyright 1963; **D:** Guy Lalumière (b. 1930); **AD:** Guy Lalumière; **S/A:** Studio Guy Lalumière, Montreal; **C/A:** La Compagnie canadienne de l'Exposition de 1967.

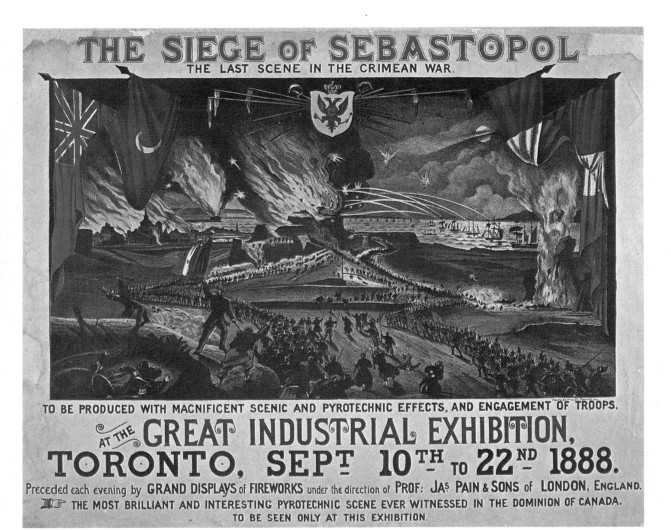

7. **The Siege of Sebastopol** . . . 1888; **C/A:** Toronto Industrial Exhibition, Toronto; **P:** Rolph, Smith & Co., Toronto; **M:** colour lithograph.

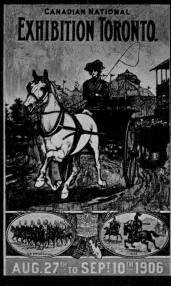

a

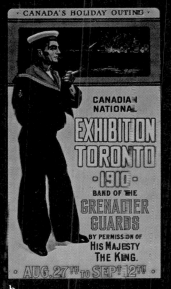

b

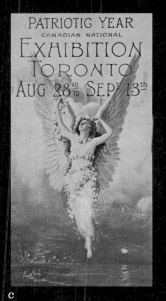

c

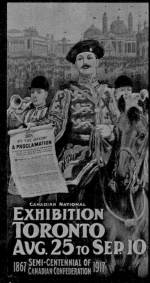

d

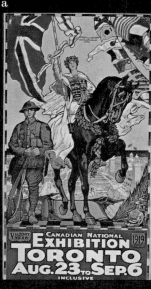

e

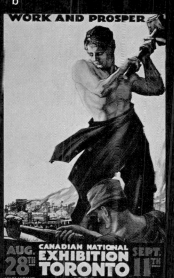

f

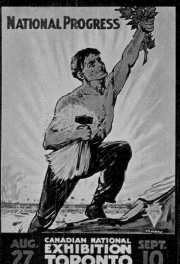

g

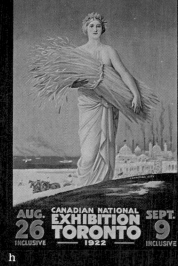

h

i

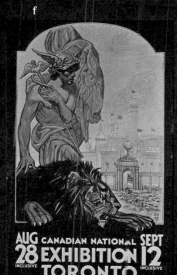

j

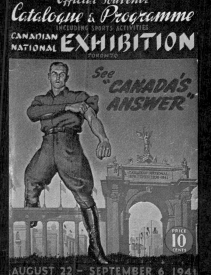

k

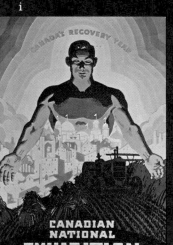

l

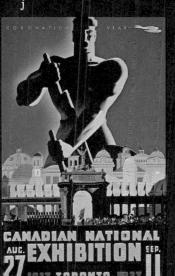

m

n

8. **Toronto Industrial/Canadian National Exhibition Posters**
A selection of souvenir programme-covers which were issued simultaneously as posters. All are colour lithographs.

a. **Canadian National Exhibition Toronto 1906; A:** A.H. Hider (1870-1952)
b. **Canada's Holiday Outing 1910**
c. **Patriotic Year 1915**
d. **Semi-Centennial of Canadian Confederation 1917; A:** A.H. Hider
e. **Victory Year 1919; A:** J.E.H. MacDonald (1873-1932)
f. **Work and Prosper 1920; A:** Franklin Carmichael (1890-1945)
g. **National Progress 1921; A:** Francis Robert Halliday (b. 1884)
h. **Industry-Thrift-Prosperity 1922; A:** N.K. McKechnie
i. **The Show-Window of Nations 1924; A:** Stanley R. Turner (1885-1953)
j. **Canadian National Exhibition Toronto 1931; A:** Jules Laget
k. **Canadian National Exhibition Toronto 1935**
l. **Canada's Recovery Year 1936; A:** Fred Finley (1894-1968)
m. **Coronation Year 1937; A:** Eric Aldwinkle (b. 1909)
n. **Canada's Answer 1941; A:** Grant MacDonald (b. 1909)

3/ Travel, Emigration and Tourism Posters

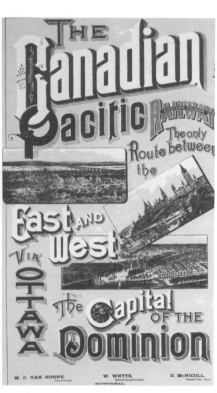

1. The New and Elegant Steam-Packet St. Lawrence. . . 1828; P: The Montreal *Gazette* Office.

The development of integrated transportation systems in some ways instigated, and occurred simultaneously, with Canada's development as a nation. Because of the horrendous conditions faced by those who availed themselves of the primitive facilities of our early travel services, advertising had to be defensive. The state of roads from the late seventeenth to the early nineteenth centuries in Upper and Lower Canada was so uniformly deplorable, especially during the fall and spring, that it inspired a whole popular literature and oral tradition. To counter the sometimes exaggerated accounts of writers and balladeers who had suffered the bone-jarring roughness, swampy miasmas, wintry chills and summer doldrums as they had journeyed over unmetalled tracks and bumpy corduroy roads, hostlers, hoteliers, innkeepers and stagecoach line operators first promoted their services through newspaper advertisements and subsequently through handbills and illustrated trade-cards.

The advent of the railways spelled the death of the long-distance stage companies. After 1870 Pullman service became available in eastern Canada, and the railway companies began to advertise in earnest to lure the tourist and the business traveller. Among the first travel posters were broadside-type bills announcing excursions, picnics, celebrations and other events which became increasingly popular in the late seventies and eighties. Posters for such outings were usually printed by the groups sponsoring them, rather than by the railways themselves. They encouraged this type of business by consigning special cars and even whole trains for the purpose. Early railway posters often feature wood-engraved vignettes of engines and cars. The type was usually wooden, although the 1856 "Railroad Celebration" poster is composed of a combination of wood and metal faces and printers' ornaments.

By the time Donald Smith drove in the last spike at Craigellachie, British Columbia, on the seventh of December, 1885, the CPR had already begun to stoke its publicity fireboxes in preparation for a nationwide run to lure passengers and encourage colonization and settlement along the line. Prominent Canadian landscape painters such as Lucius R. O'Brien, John Hammond, John A. Fraser and Marmaduke Matthews were invited to depict scenes along what was boasted in a transcontinental timetable to be "the longest continuous railroad in the world under one management." Many of these panoramic views were used to decorate CPR hotels and offices.

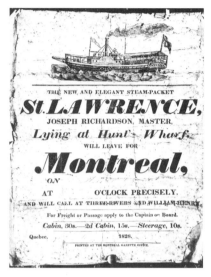

2. The Canadian Pacific Railway c. 1880s(?); **C/A:** Canadian Pacific Railway Co. (Eastern Division), Montreal.

Although by the 1890s the CPR had switched to lithographic posters for its major campaigns, the use of wooden typefaces set in broadside format did not disappear until well into the twentieth century. Train timetables changed little between the 1880s and the 1930s and, even later notices announcing unexpected alterations in times and rates resorted to this economical and seemingly expeditious method.

Since the CPR initially faced no competition, advertising was restricted to the dissemination of basic information, and selling the "Golden Northwest" became its biggest campaign. The scheme involved the printing and distribution of multilingual posters, space ads in newspapers, pamphlets, and touring exhibitions at home and in Europe. The Department of the Interior commissioned many large posters which were displayed in the windows of emigration

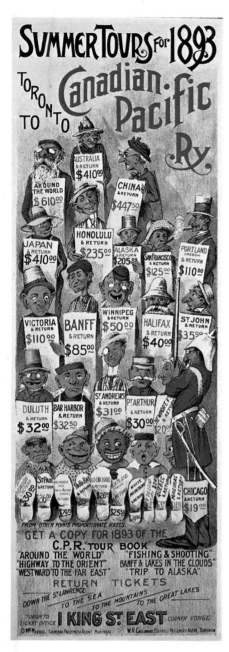

3. Summer Tours for 1893 1893;
C/A: Canadian Pacific Railway,
Toronto; M: colour lithograph.

Overleaf

4. Sun Tan West Indies Cruises c.
1920s or '30s; C/A: Canadian Pacific;
M: silkscreen.

5. St. Andrews By-the-Sea c.
1920s(?); A: F. ;
C/A: Canadian Pacific; M: silk-
screen.

6. Quebec Ski Centre-Lac Beauport
c. 1920s(?); C/A: Canadian Pacific;
M: silkscreen.

7. Sky Line Trail Hikers 1937;
C/A: Canadian Pacific; M: silk-
screen.

offices abroad to illustrate the wealth of opportunities which awaited the prospective colonist.

The CPR abandoned the idea of large, showy railway-travel posters after the 1890s, when emphasis was shifted to advertising its expanding steamship services.

By this time colour lithography had become *de rigueur*, as Australia, the United States, South Africa, and various South American countries, all vying for immigrants, employed every available device to convince the undecided. Many if not most of the emigration posters published during the 1910s and '20s can be credited to British artists, as the London and Liverpool offices of the steamship companies recruited advertising staffs from each city's commercial art labour-pools. Frank Newbould was a brilliant contributor to the golden age of the travel poster in Britain; he was an individualistic stylist whose visions of a fast-passing pastoral England defined a whole decade of the poster. His poster for the Cunard Steamship Company, entitled "A welcome awaits you" represents the typical Canadian prairie-farmer as perceived in the imagination of an Englishman.

The style of Frank Newbould's Cunard poster focuses on a human figure openly offering friendship, possibly to deny rumours of the terrible isolation suffered by new settlers in the west. The use of human figures was relatively rare in the early posters advertising steamship services. The usual subject was a realistically depicted vessel at sea. A number of CP steamship posters were painted by Norman Wilkinson, a renowned English marine artist who also worked for the White Star Line and the London, Midland and Scottish Railway. In 1924 Wilkinson suggested to the LMS that a series of posters by leading Royal Academicians and associates be commissioned to depict typical English and Scottish scenes along the system's line. Kenneth D. Shoesmith, a sailor by training, was another Canadian Pacific recruit, as were P. A. Staynes and Leonard Richmond. An earlier artist who painted posters for the CPR was Cyrus Cuneo, a San Francisco-born naturalized Englishman (1878–1916). His posters showed exotic places in the Orient to which CP steamships sailed.

Perhaps the most appealing CP liner and cruise-ship posters are those of Tom Purvis, one of the most popular commercial artists in England during the 1920s and '30s. His style is a peculiarly British modification of *art déco*, at once elegant and cheerful, sophisticated and naive. He made little or no attempt to adapt his familiar manner to suit the Canadian market.

As with the railway posters of that period, it is sometimes difficult to determine whether the unsigned steamship posters were produced in Canada by Canadian artists, in London or New York by English or American artists, or whether the CPR's Exhibits Branch had printed the work of English or American artists in Canada.

It is equally difficult to accredit posters produced by the Canadian National Railways' inland and marine advertising offices. The fact that the CNR arose out of its independent rival's failure may explain why the crown corporation's publicity was so haphzard and inconsistent from the start. In the 1920s or '30s some appealing posters to promote tourism at Quebec and Ontario resorts were published by the amazingly versatile and prolific J. E. Sampson.

A. C. Leighton, who came to Canada in 1929 to work for the CPR, fell in love with the prairies and painted in the west until his death in 1965. His poster advertising CP's "All Red Route" follows a familiar formula in incorporating a map, ships, a train and hotels in inserts. Leighton's "For your holidays see Canada by Canadian Pacific" exploits the equally stereotypical image of the onrushing locomotive. It was discovered that the notion of speed could be conveyed by a number of tricks, including the use of an airbrush to suggest the blur of motion, *art-déco* streamlining, and the setting of letters at an acute angle. As we can see from the silkscreen posters of British Columbia's Peter Ewart, this approach to the problem of how to inject into an inert medium the energy of the vehicles it displays has survived long enough to link the eras of steam and diesel locomotion.

Some indication of the state of the travel and tourism poster in Canada in the early 1950s is given by an account of the contest held in 1950–51 by *Les Amis de l'Art* of Montreal "to stimulate the appreciation of the beauties of Canada and to attract the tourist." The competition was open to Canadians between the ages of sixteen and thirty; judges included designer-illustrator Albert Cloutier

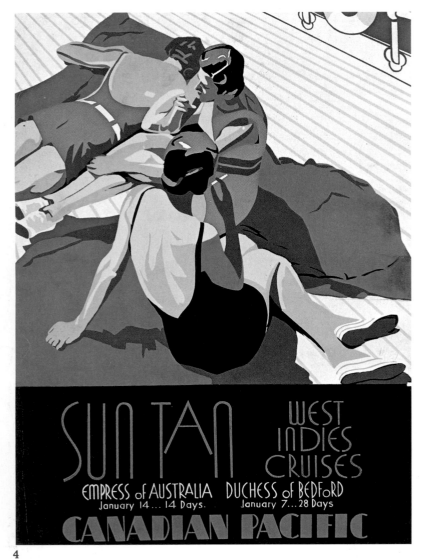

4

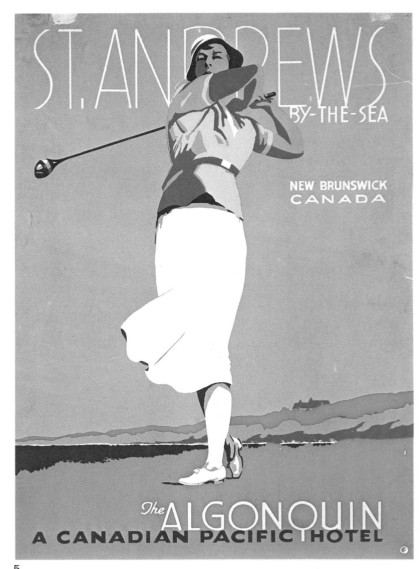

5

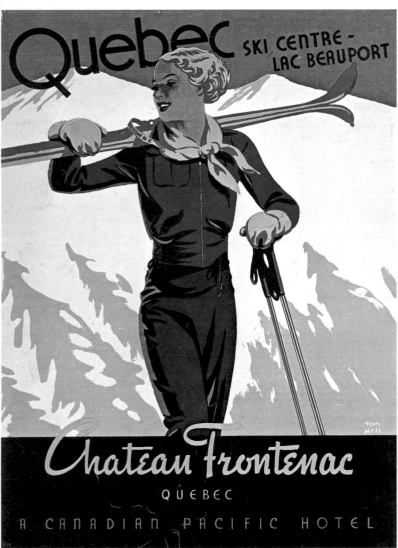

6

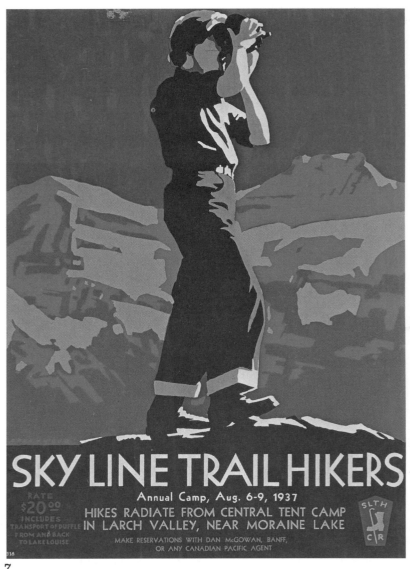

7

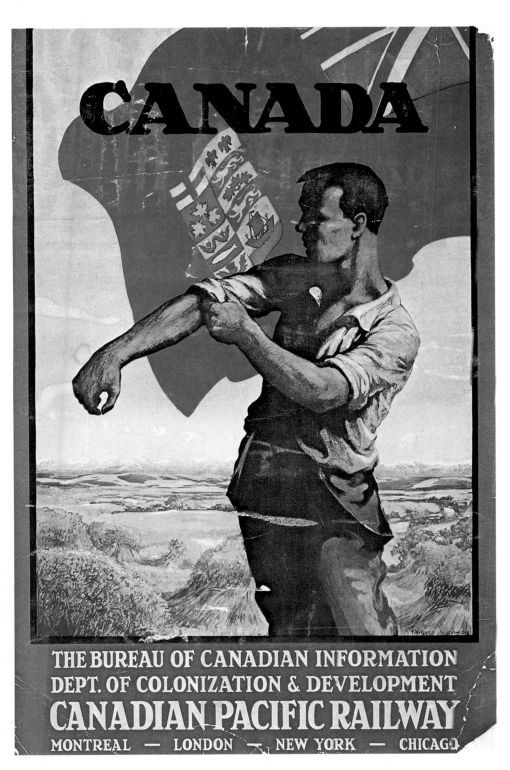

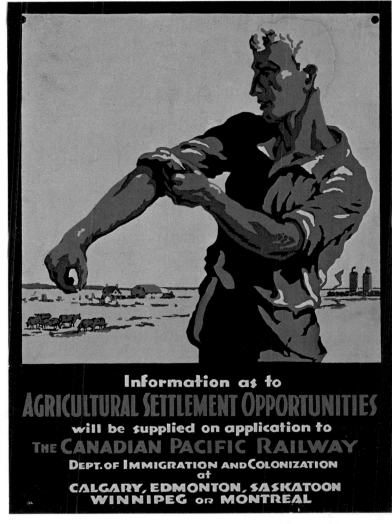

8. **Canada** c. 1910s or '20s; **C/A:** The Bureau of Canadian Information Dept. of Colonization & Development/Canadian Pacific Railway, Montreal; **M:** colour lithograph.

9. **Information as to Agricultural Settlement Opportunities...** c. 1920s; **C/A:** Canadian Pacific Railway Dept. of Immigration and Colonization; **M:** silkscreen.

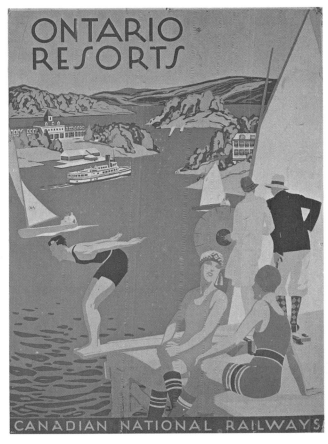

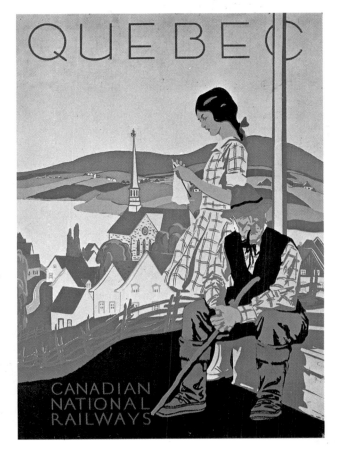

10. **Ontario Resorts** 1920s or '30s; **D/A:** J.E. Sampson; **S/A:** Sampson-Matthews Ltd.; **C/A:** Canadian National Railways; **M:** silkscreen.

11. **Quebec** 1920s or '30s; **D/A:** J.E. Sampson (1887–1946); **S/A:** Sampson-Matthews Ltd., Toronto; **C/A:** Canadian National Railways; **M:** silkscreen.

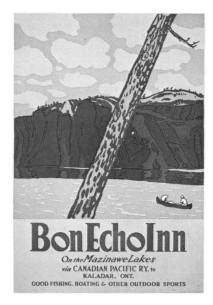

12. **Bon Echo Inn On the Mazinawe Lakes...** 1924; **D/A:** Alexander Young Jackson (1882-1974); **C/A:** Merrill Denison/Canadian Pacific Railways (?).

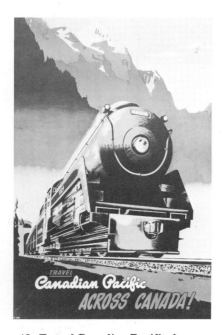

13. **Travel Canadian Pacific Across Canada!** c. 1940s(?); **A:** Peter Ewart (b. 1918); **C/A:** Canadian Pacific Railways.

and critic Robert Ayre. In February 1951 Ayre wrote that some 78 designs had been submitted, the first prize going to Gerard Caron of Ottawa. "Mediocrity and misplaced ingenuity," Ayre noted, "appeared as was expected. 'Mounties' and moose, skiers and salmon and sunsets and snowflakes, beavers, the maple leaf and the fleur de lis were all exploited, sometimes with droll results. Some of the competitors—and they were not all 'primitives'—hadn't the faintest idea what a poster should be and sent in landscape paintings, a few of them highly charged with patriotic symbols."[1]

Good posters for airlines and travel agencies are scarce in Canada, possibly because of the fact that when passenger services began to operate on a large scale, television had diverted advertising budgets to a medium which could reach more people and earn greater revenues than the poster was capable of doing. Consequently the art of the travel poster is dying or is already dead in Canada. Highly atypical is the publicity commissioned by Toronto's Unitours, whose Club-Med-style Nigril Village and resorts in the Caribbean have been advertised in controversial posters. Heather Cooper's "Couples" of 1977 sought to capture the abandoned mood of the luxury retreat by depicting a pair of copulating lions, the female partner being endowed with anthropomorphic breasts which passed uncensored by Unitours' U.S. office but had to be expurgated from the Canadian version. Nigel Dickson's "Hedonism" appeared in several formats, including a billboard, when it was issued in 1976. Defiantly sexist, it may have offended many but delighted still more, who may or may not have realized how manipulative are such images. The unusual use of black-and-white photography in the cropped, airbrushed torso proved surprisingly effective, by drawing attention to itself in the midst of all the dazzling super-boards and illuminated signs. The distance between this poster and the CPR's "Summer Tours for 1893" cannot be measured in miles or years. Rather, a drastic alteration in social attitudes occurred at the same time that a stylistic evolution was proceeding in a circuitous course: from complexity to simplicity, from representation to suggestion, from telling everything to hinting at much yet conveying the minimum of hard information.

Canadian travel posters could achieve a level of excellence by becoming more consistent. To compare with the best work produced in Europe, a standard format should be introduced similar to that of London Transport, whose signal success in poster publicity must partially be attributed to its adoption of the 40″ × 25″ sheet, together with the employment of a single printer. Frank Pick's enlightened policy of hiring major painters, designers, typographers and copywriters made it possible for London Transport to exploit the poster as a lucrative resource by over-printing runs for public sale, and reprinting classics of the past. The memorability of the finest in British and French travel posters is largely due to their artists' observing certain universal design principles. Tom Purvis summarized them in *Poster Progress* as follows: fitness to its purpose; the quality of pleasant shock; completeness as a unit; simplicity in thought and clarity of statement.[2]

[1]Ayre, Robert, "Ottawa artist takes first poster prize," in *The Montreal Daily Star*, 24 February 1951.
[2]Purvis, Tom. *Poster Progress*. Edited by F. A. Mercer and William Gaunt. London: The Studio, 1939.

14. **Turbo** c. 1968; **Logotype:** Allan Fleming (1929-1977); **C/A:** Canadian nNational Railways.

15. **Destination: Excellence** 1966; **D/A:** Vittorio Fiorucci (b. 1939); **AD:** Vittorio Fiorucci; **C/A:** Quebecair; **M:** silkscreen.

16. **Hedonism** 1976; **D:** Bob McGrath; **Ph:** Nigel Dickson; **AD:** George Whitfield; **S/A:** Tyler's; **C/A:** Unitours, Toronto.

4/ Military Posters

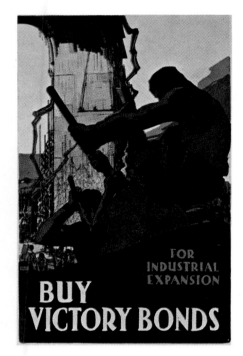

1. **Buy Victory Bonds; D/A:** Arthur Keelor (1890-19?); **AD:** A.H. Robson; **S/A:** Rous and Mann Press Ltd., Toronto; **C/A:** Rous and Mann Press Ltd./Victory Loan; **P:** Rous and Mann Press Ltd.; **M:** colour lithograph.

Overleaf

2. **Keep All Canadians Busy** 1918; **C/A:** Victory Loan; **M:** colour lithograph.

3. **Be Yours to Hold It High! A:** T. Nicolet (?); **C/A:** Victory Loan (War Poster no. 1); **M:** colour lithograph.

4. **Help Finish the Job...** 1941; **D/A:** A.J. Casson (b. 1898); **C/A:** National War Finance Board (Victory Bonds); **M:** silkscreen.

5. **Canada's New Army** c. 1940; **D/A:** Eric Aldwinkle (b. 1909) and Albert Cloutier (1902-1965); **AD:** Wartime Information Board, Ottawa; **M:** colour lithograph.

Traditionally, Canadians are a peace-loving people; yet the posters they produced to spur on the war efforts of 1914-18 and 1939-45 indicate that, if sufficiently aroused, they can express patriotic, nationalistic and even belligerent sentiments as vehemently as any other nation. In fact, our war posters possibly provide a more accurate indication of public feeling than do those writings which may have been distorted by government or big business propaganda.

The poster proved itself again and again as a vital piece of ordnance in the artillery of psychological warfare. But because this type of visual propaganda was so ubiquitously circulated and was not considered seriously as an art form, few historians or social commentators have ever taken the trouble to calculate its effect during wartime. The fact that so many military posters have survived seems remarkable until one considers they were printed in large quantities and displayed in numerous places. The archive is by no means complete, but the sheer volume of material that has survived the Second World War is truly staggering.

The first Canadian military posters were recruitment and call-up announcements and broadsides to warn the population against possible invasion. Posters also served as a means of communication between the military and the local inhabitants of garrison towns. To convey a sense of urgency, their standard format was that of the official proclamation, employing a variety of eye-catching display typefaces. The transition from old-fashioned broadsides to sophisticated photo-lithographic posters used in World War I was surprisingly swift.

The North West Rebellion led by Louis Riel in 1885 was the first armed conflict to attract concentrated press coverage in Canada. The fact that federal troops were dispatched stirred up so much public emotion and curiosity that the Toronto Lithographing Co. (then associated with *The Globe*) decided to launch *The Canadian War News*, a weekly publication which featured take-out lithographic versions of sketches done on the spot by staff artists W. D. Blatchly, J. D. Kelly and William Bengough. At the time the hand-carved wood-engraving was the standard form of pictorial reproduction; shortly thereafter the photographic halftone block was introduced, but it was the colour lithograph which demonstrated how effective the popular print medium could be.

World War I: "If ye break faith"

The declaration of war in 1914 caught Canada unprepared in more ways than one. An army had to be mobilized almost from scratch, using borrowed and outmoded equipment, and a propaganda machine had to be put in motion. Herbert A. Williams, spokesman for the Poster Advertising Association of

KEEP
ALL CANADIANS
BUSY

BUY 1918
VICTORY BONDS

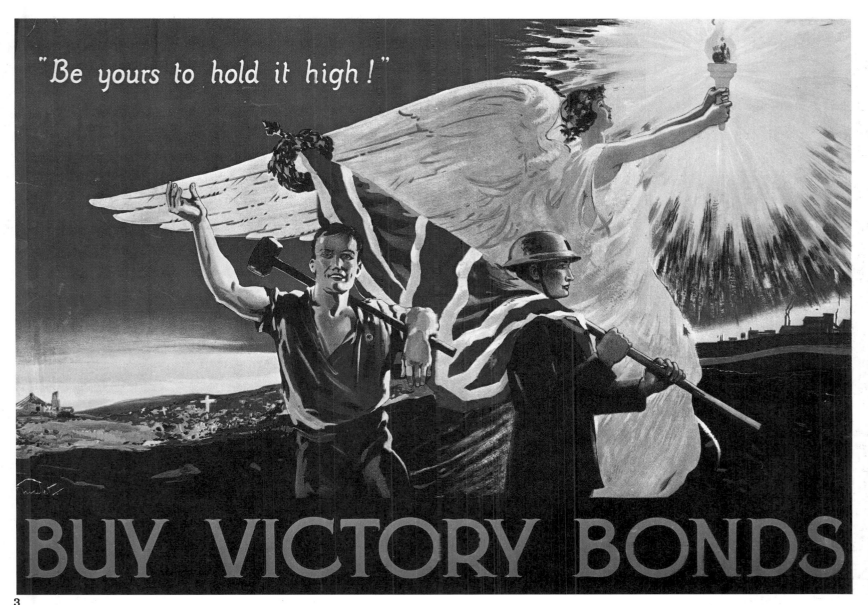

"Be yours to hold it high!"

BUY VICTORY BONDS

3

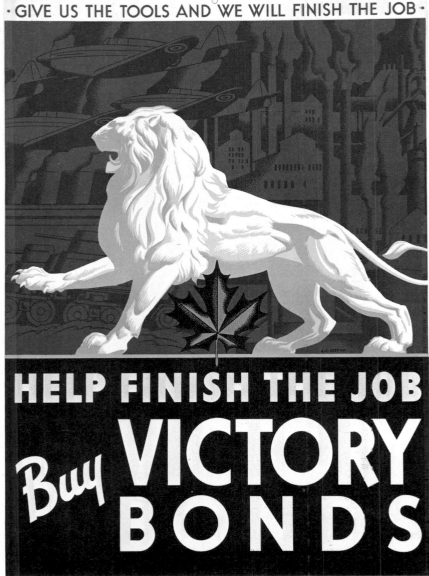

· GIVE US THE TOOLS AND WE WILL FINISH THE JOB ·

HELP FINISH THE JOB
Buy VICTORY BONDS

4

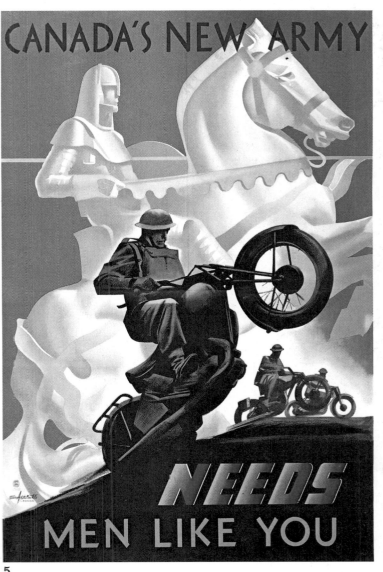

CANADA'S NEW ARMY

NEEDS
MEN LIKE YOU

5

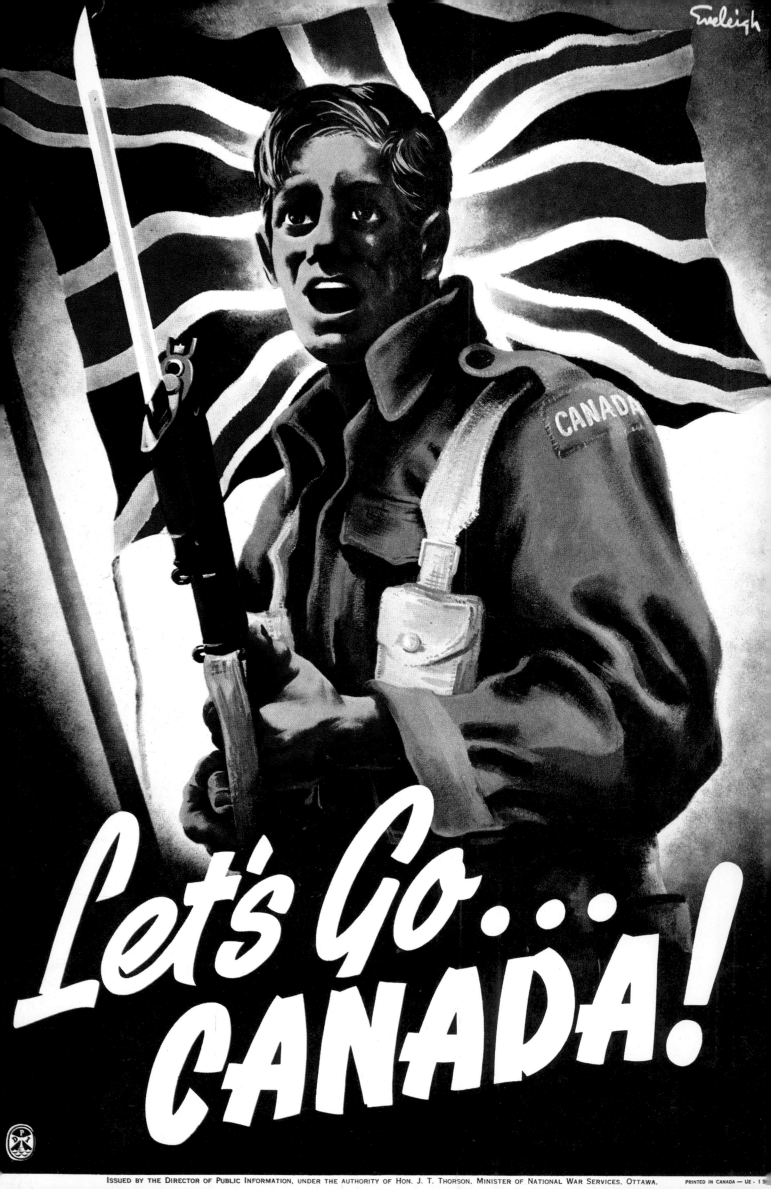

Let's Go... CANADA!

ISSUED BY THE DIRECTOR OF PUBLIC INFORMATION, UNDER THE AUTHORITY OF HON. J. T. THORSON, MINISTER OF NATIONAL WAR SERVICES, OTTAWA. PRINTED IN CANADA — UE - 19

Opposite

6. **Let's Go Canada!** **D/A:** Henry Eveleigh (b. 1909); **C/A:** Issued by the Director of Public Information under the authority of Hon. J.T. Thorson, Minister of National War Services, Ottawa; **M:** colour lithograph.

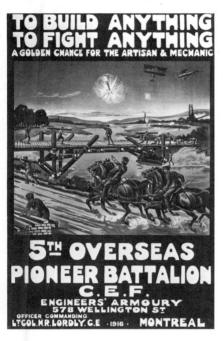

7. **To Build Anything...** 1916; **P:** The Mortimer Co. Ltd., Ottawa, Montreal, Toronto; **C/A:** 5th Overseas Pioneer Battalion, Canadian Expeditionary Force, Montreal.

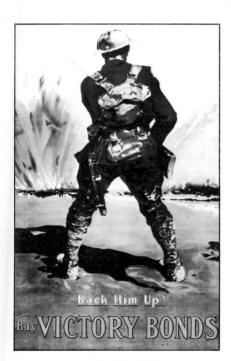

8. **Back Him Up!** **C/A:** Victory Loan (War Poster no. 6); **M:** colour lithograph.

Canada, described the situation at the outbreak of hostilities in the 1919 War Souvenir Edition of *The Poster*:

> Posters worked incessantly for recruits, the Patriotic Fund, the Red Cross, YMCA, Salvation Army, the Knights of Columbus, and in connection with all war activities. . . .
>
> Even with commercial ranks depleted, with many artists, writers, lithographers, poster men, and others who ordinarily mould public thought laying aside the pen and brush for manual training and for the science of war, some of the posters appearing in Canada were outstanding examples of publicity force that will never be forgotten. . . .[1]

Private business and the advertising industry stepped in to donate funds for war-poster campaigns, and to allocate billboard space for recruitment notices and Victory Bond drives. Posters were produced by commercial art studios and printing plants either on their own initiative or as a result of official commissions. Designs were procured in some instances through contests held for freelance and studio artists. The three posters by Arthur Keelor printed by Toronto's Rous and Mann Ltd. as part of a series of six contributions to the Victory Bond campaign originated in this way. Keelor's ability to adapt a variety of styles to the cause of the Canadian war effort indicates that he was familiar with the work of major British, European and American artists. The posters captioned "For Industrial Expansion" and "Our Export Trade Is Vital" were characterized by dynamic composition with strong vertical and diagonal thrusts, bright primary colours and bold lettering, and pictures of powerfully grouped labourers against an industrial or agrarian backdrop.

The lack of a coordinated plan may have been responsible for the uneven quality of the propaganda material issued by private firms. Ottawa therefore decided to set up the War Poster Service, which published material for coast-to-coast distribution to banks, schools, factories, offices and other outlets. The National Service, the Food Board, Victory Bonds, the Volunteer Home Guard, and several other government departments and agencies exploited the poster for educational, fund-raising and morale-building purposes. After the controversial Compulsive Service Act was passed in 1917, emphasis shifted to "home front" appeals for patriotism and calls for thrift, charity, conservation of resources, reduction of waste, and higher productivity at home.

At the beginning of the war, however, the most pressing need was for recruitment posters, in both English and French. Most of these were commissioned and printed locally and are full of hometown references, expressions of partisan pride, with the laws of cause and effect regularly distorted. To refuse to enlist was to guarantee defeat—or, at the very least, to risk future humiliation and disgrace. Coercive as such tactics may appear to modern sensibilities, their devisors evidently saw no alternative. The ends and the means so intertwined themselves that good and bad propaganda became indistinguishable.

Government alone had not the expertise to carry out so ambitious a program of thought-control and action-stimulus. The Canadian advertising industry had barely entered its adolescence, and the few commercial art and design studios in existence were usually departments of large printing or typesetting firms. Many of our poster designers received their first practical training during World War I; as we have seen, the methods they learned in the course of producing military and domestic propaganda proved alarmingly adaptable to post-war circumstances. Meanwhile, links between government and advertising, between politics and publicity, were being forged.

Charles Matlack Price reproduced two Canadian war posters by two anonymous artists in the 1922 edition of *Poster Design*, stating that they "give evidence that those far-flung members of the British Empire (i.e., Canada and Australia) were not relying for all their patriotic publicity upon the Mother country—'Your chums are fighting' with a very pointed question, 'Why aren't

[1] Williams, Herbert A. "Canada's flaming war posters stirred Dominion to action," in *The Poster: war souvenir edition*. Chicago: The Poster Advertising Association (1919) pp. 57–9.

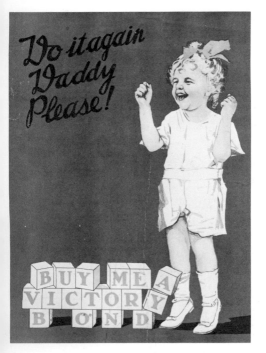

9. **Do It Again Daddy Please!**
A: J.E. Sampson; C/A: Victory Loan (War Poster no. 18).

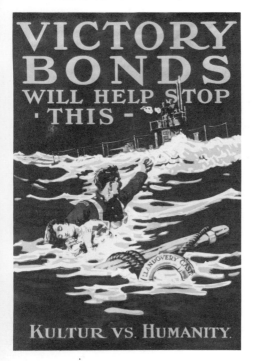

10. **Victory Bonds Will Help Stop This** 1918; C/A: Victory Loan; **Note:** The British merchant vessel *Llandovery Castle* was in service as a Canadian hospital ship when it was sunk returning to England from Halifax, on 27 June 1918. Out of 258 aboard only 24 survived.

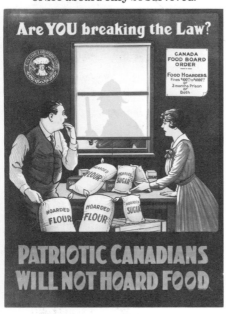

12. **Are You Breaking the Law?**
C/A: Canada Food Board.

YOU?' and 'Bring Him Home'—(have) a definite and compelling appeal."[2] Martin Hardie and Arthur K. Sabin thought that "Keep All Canadians Busy", being "simple in idea and design, with its fitting legend, shows what promise there is, and indeed attainment, among the Western children of our race."[3]

Although our own poster program's precedent was the Parliament Recruitment Committee of Great Britain, it developed independently and produced results which are comparable in quantity and sometimes in quality to the posters of other allied nations. Canada began issuing posters well before the United States' entry into the fray, and our War Poster Service provided the model for the Committee of Public Information's Division of Pictorial Publicity organized by U.S. painter and illustrator Charles Dana Gibson. Among Canadian-born volunteer artists who designed posters for the DPP were Arthur William Brown and Boardman Robinson; both of them went on to achieve considerable success after the war.

If the United States surpassed Canada in poster production, we can boast that our War Memorials program was the most enlightened ever to be devised. Unfortunately, few contributors to the Memorials were called upon to create posters and only occasionally were Royal Canadian Academicians drawn into the vulgar orbit of publicity; for example, J. E. H. MacDonald painted a stirring poster for the RCA's Patriotic Fund exhibition of 1914 (see Chapter 10); he also left rough sketches for other poster ideas, but was not hired to lend a hand in the production of official propaganda. It was A. Y. Jackson's harrowing letters from the front which first opened MacDonald's eyes to the true horrors of trench warfare. Shortly before going overseas himself, Jackson complained to MacDonald that even Toronto's most skilful illustrators and designers were being starved of commissions; "Tom (Thomson) is getting to the end of his tether," he wrote in October 1914, "and I guess there is not much commercial work to do in Toronto. (Arthur) Lismer tells me he could undertake to do it all himself. If the war keeps on, conditions can only get worse. The only job will soon be handling guns."[4]

German posters revealed an urgency and an energy which was missing from posters produced by countries not directly in the line of fire. The effect of bold directness is enforced by the use of radically plain hand-drawn and typeset letterforms; in fact, the vigorous *sans serif* capitals of many of these posters are the progenitors of the functional typefaces created in the 1920s and '30s by associates of the Bauhaus. In contrast, most of our own artists of the same period remained rooted stylistically in the nineteenth century.

Art critics of the day were divided in their evaluations of our war posters; some found them ugly, whereas others welcomed them because they contributed spots of colour and drama to our otherwise drab and sober cities. The advertising fraternity and billboard manufacturers, on the other hand, took unqualified pride in their contributions. In 1919, the editor of *The Poster* commended the Poster Advertising Association of Canada for its "remarkably successful war poster advertising campaign." The war had given the printing and copywriting industries a new lease on life, and both wished to maintain the positions they had gained through a judicious program of donations and volunteer services. By the end of World War I the billboard reigned unchallenged, and was to retain its preeminence for half a century.

World War Two: "Let's Go . . . Canada!"

Although the Second World War ended a scant forty years ago, the story of its posters is almost as clouded and as confused as that of the visual propaganda of World War I. In many instances, the posters themselves are the only

[2]Price, Charles Matlack. *Poster design*. New York: George W. Bricka, 1922; p. 25
[3]Hardie, Martin, and Arthur K. Sabin. *War posters issued by belligerent and neutral nations 1914–1919*. London: A. and C. Black, Ltd., 1920; p. 6.
[4]Letter from A. Y. Jackson to J. E. H. MacDonald in MacDonald Papers, Public Archives of Canada.

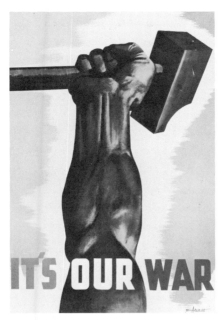

12. **It's Our War** 1940; **D/A:** Eric Aldwinkle; **C/A:** Issued by the Director of Public Information, Ottawa, under authority of the Minister of National War Service.

13. A.J. Casson (r) and Lord Athlone (l) with 1941 prizewinning Victory Loan poster design.

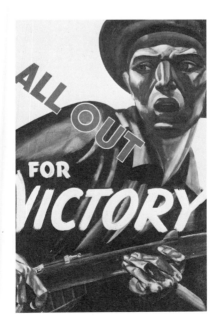

14. **All Out for Victory** 1942; **D/A:** Joe Rosenthal (b. 1921); **Note:** Original artwork. Poster never printed.

evidence left to us. They are often by obscure artists, unsigned, or undated, with few clues as to what occasioned them, who commissioned them, and how they were produced and distributed. Once they had served their function they were discarded as casually as shell-cases.

It appears that at the beginning of the war there was little coordination of propaganda programs. The apportioning of poster commissions was a haphazard process, with no one government department taking control of the operation until the Office of the Director of Public Information (DPI), which was succeeded by the Wartime Information Board (WIB), was established. Its numerous publications appeared under the authority of the Minister of National War Services, the Department of Army Recruitment (DAR), the Department of Munitions and Supply, the Department of National Defence, the National Salvage Office and the Canada Food Board. In 1940 the National War Finance Board launched the Victory Bonds, Victory Stamps, and Victory Certificates campaigns, all causes for which dozens of different posters were issued. The National Film Board was responsible for designing and distributing the WIB's numerous poster series, and also worked in close cooperation with other government departments whenever they required any publicity material.

One of the earliest posters of the Second World War was "Canada's New Army," a recruitment appeal of uncommon forcefulness, by English-born designer-painter, Eric Aldwinkle. He did two more posters before accepting a commission as official war artist with the RCAF, and was commended by *The Globe and Mail*'s art critic Pearl McCarthy. She singled out "Canada's New Army" for special praise, stating that "this poster cuts clean away from the old picture-group style, but without succumbing to the more modern closeup realism, it remains a remarkable picture." Aldwinkle's two other efforts are equally impressive if more conventional in composition and treatment of the subject matter. The theme of soldier and worker fighting shoulder-to-shoulder recurred frequently in posters which urged solidarity, greater productivity, and a closer identification with the war effort.

Recruitment seems to have been the primary concern of the DPI, and the methods used to convince people to volunteer and sign up with various services were typical and not dissimilar to those employed by other combatant nations. To make an active impression posters had to reach a large portion of the population over a carefully calculated period. In some cases billboards and streetcar-cards acted as the basic sustaining media. Many of the components in the original Department of National Defence recruitment campaign were later re-introduced in full-scale posters. This possibly explains the weakness of most Canadian World War II posters: they were essentially blown-up illustrations with poorly integrated captions, headings and images.

At the outset national and local contests were held, the winners being rewarded with prize money or Victory Bonds, as well as with the privilege of seeing their poster designs go to print. Former Group of Seven member A. J. Casson beat out some 110 rivals in the 1941 Victory Bond contest. The second prize went to Harold V. Shaw for a poster featuring a sailor's head and a slogan somewhat familiar to that used by Casson; Franklin Arbuckle won the third prize with his "Invest and Protect."

Casson's original design was for a billboard, but was first issued as a poster by the National War Finance Board in a format which was much reduced and cropped and not to the artist's taste. The Department of National Defence adapted his heraldic lion for use in a roll of honour issued to churches, businesses, industrial and educational institutions. To save money, it was common practice to recycle artwork, yet contests of this kind did excite public interest while supplying the voracious printing presses with an uninterrupted flow of fresh material.

The success of the NWFB's first competition spawned several imitations. The Art Gallery of Toronto held a nation-wide competition to which five hundred posters by 435 Canadian artists were submitted; 61 of them were later selected for display as part of the Gallery's "Britain at War" exhibition in 1942. The three top awards went to Joe Rosenthal, Charles R. Wilcox and William Winter. Ironically, it was Wilcox's second-prize winner that ended up being reproduced, although it is distinctly inferior to the efforts by Rosenthal and Winter. Rosenthal's "All Out for Victory" may have been too Russian-looking to appeal to the DPI.

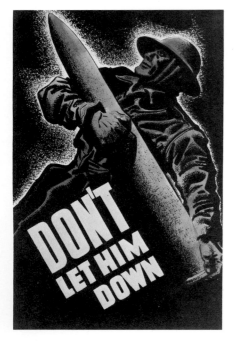

15. **Don't Let Him Down** 1942; **D/A:** William Winter (b. 1909); **Note:** Original artwork. Poster never printed.

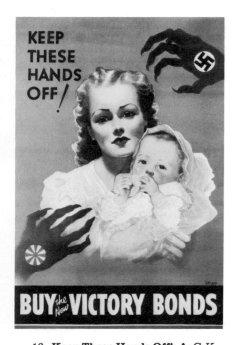

16. **Keep These Hands Off!; A:** G.K. Odell; **C/A:** National War Finance Board (Victory Bonds).

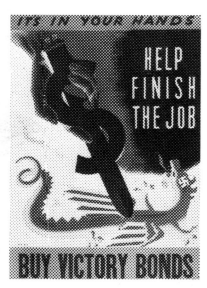

On December 19, 1942, an article in the *Montreal Gazette* by Gerald Clark, headed "Poster Campaign Botched by Government, Artists Disclose," brought to public attention the behind-the-scenes machinations which invariably mar and confuse the efforts by artists and bureaucrats to work together:

> ... Previously, a group headed by H. O. McCurry, Director of the National Gallery, had approached the government offering its services in the art of camouflage and war records, but these services were not considered necessary.
>
> ... McCurry had lined up the country's top artists, art directors and experts. Their plan was to act as a voluntary advisory board to the Department of Public Information, to work in conjunction with representatives of government departments in mapping a scientific poster campaign. With the approval of the Hon. J. G. Gardiner, the Minister of National War Services, their appointment was announced in the press on October 17, 1940. Starting its work, the committee suggested that Canada use the then famous British poster of Churchill proclaiming "Come, then let us to the task." According to the committee, there was little in that poster that could have been improved, both as to simplicity and forceful-ness. It refused to approve a variation prepared for the Information Department, claiming it was jumbled and valueless as a morale booster. From that moment the Artists' Committee was overlooked and was not summoned again. Some of its members said that the whole poster business had fallen into the hands of commercial advertising men who don't know anything about the psychology involved in wartime graphic arts.[5]

A follow-up article in the *Standard* noted that "if Canada's war effort is to be interpreted by posters as effectively as the British, Russian and American campaigns, there must be a plan."

Although the American war poster campaign is frequently cited as an example of how to mount and mobilize an efficient propaganda program, Canada's own early endeavours in this field provided the United States with the working model on which to base their operations. In early 1942, employees of Young and Rubicam Inc. conducted a survey of Canadian war posters in Toronto. This was done at the request of the Graphics Division of the United States Office of Facts and Figures, a body established by the National Advisory Council on Government Posters. Thirty-three posters which had been used in five different campaigns were studied, and interviews employing the "recognition method" were conducted with men and women of various income groups. A set of four basic findings was promulgated:

1. War posters that make a purely emotional appeal are by far the best.

2. War posters that are symbolic do not attract a great deal of attention, and fail to arouse enthusiasm.

3. War posters that make straightforward, factual appeals are much less likely to be effective than those that make emotional appeals.

4. Humourous war posters do not attract as much attention, nor do they make as popular an appeal as those carrying an emotional or even factual message.

The interviews quoted in Young and Rubicam's survey give a frightening impression of the average adult Canadian's apparent lack of visual and verbal sophistication. The poster judged the most successful was G. K. Odell's ludicrously sentimental "Keep These Hands Off!" Its virtue was that it "Makes an outright emotional appeal." Considered to be equally effective was an unsigned "blood and thunder" Victory Bonds poster featuring a wounded soldier on the attack. Two examples of abstract design, Les Trevor's "It's in

[5]*Montreal Gazette*, 19 December, 1942.

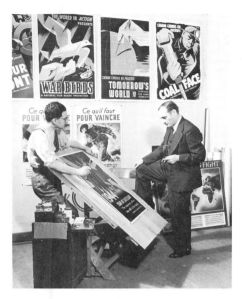

18. Harry Mayerovitch (l) and John Grierson at National Film Board studying Mayo's "1944 Year of Decision" poster.

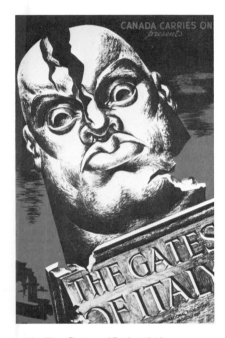

19. **The Gates of Italy** 1943; **D/A:** Harry Mayerovitch (b. 1910); **S/A:** The National Film Board, Ottawa **C/A:** The National Film Board.

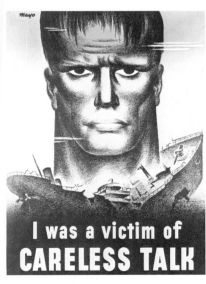

20. **I Was a Victim of Careless Talk; AD:** Harry Mayerovitch; **S/A:** The National Film Board, Ottawa.

Your Hands" and A. J. Casson's "Do Your Share in the War Weapons Drive" were dismissed as dismal failures. Young and Rubicam researchers saw the posters which today may strike us as pleasing and strong as being feeble or incomprehensible to the common viewer.

It seems that Canada's war posters were at their most vociferous when they confronted the spectator with an image of a wounded warrior urging on his comrades and lunging with fixed bayonet at an unseen enemy. There are few stylistic or compositional variations to distinguish posters of this nature, but the best of the lot is undoubtedly Montreal painter-designer Henry Eveleigh's "Let's Go . . . Canada!". It appeared in large and small formats and was widely circulated. In fact, in Eric Aldwinkle's view, it is Canada's most impressive war poster.

Similar posters were produced in runs of thousands by the National War Finance Board, one of the most prolific sponsors. This board, set up to meet the growing demands of Canada's war effort, was requested by the government to raise $600 million during the first three weeks of June, 1940. With the assistance of banks, insurance companies, and other private financial organizations, a campaign to sell Victory Bonds was immediately mounted; more than $800 million was subscribed, compared to $47 million raised during World War I. There is no question that the poster contributed enormously to the success of these World War II bond drives.

As the war progressed, posters for factories became almost as plentiful as those advertising Victory Bonds. By 1943 paper rationing was in effect, although when "plant posters" began to appear in 1940 there had been few material restrictions.

Pictorial propaganda was also directed against those with "loose lips" whose "careless talk" might bring about "tragedy in wartime." The suspicion these warnings created must have been as oppressive as the unflagging optimism of the plant posters. Many interpretatons of the "loose lips sink ships" theme were published by courtesy of the Wall Have Ears Organization, an independent American and Canadian artists' and writers' association, which by 1943 had contributed over one hundred designs. Easily the most powerful of these posters produced in Canada was Harry Mayerovitch's (Mayo's) "I was a victim of Careless Talk," issued by the National Film Board for the WIB. John Grierson, the revolutionary British documentary film maker who founded the NFB in 1939, had thought so highly of Mayo's paintings and cartoons that he invited the artist to do posters for the NFB.

Mayo's humanist concerns turned him toward silkscreen as a medium; he favoured it for its freshness and immediacy, its relative cheapness and its ability to communicate simple but important messages directly and memorably. He also did some airbrush and charcoal posters for offset reproduction in large editions. He summed up his beliefs about the medium he had so swiftly mastered in a statement prepared especially for this book:

The poster is at its most powerful when it rouses to action in a significant cause, when it exacts sacrifice, dedication, responsibility. Its aim: to ignite a flame of urgency, to steel the will to survive.

The message must be flashed in the blink of an eye, its import explode in the mind. It must reproduce in miniature the crisis that gave it birth. It means: the compression of the idea to its essentials, the ruthless exclusion of diverting detail.

This presupposes the artist's genuine belief and commitment, for only his conviction can produce vigorous composition, eloquent colour, unambiguous theme, impassioned execution.

Wars and social upheavals, not surprisingly, give rise to the most stirring posters. Even those produced overnight in hidden cellars, painfully scratched on scraps of paper scrounged behind enemy lines, often attained a grandeur far transcending their pathetic origins.

In Canada, as elsewhere, the anti-Hitler war aroused strong moral reaction from poster artists, and a growing awareness that, in John Grierson's pungent words, "You cannot sell the war effort as though it were cornflakes."

The epochal theme ennobled the craft of the poster artist, and achieved, what the artist seldom attains, a common destiny with his audience and an uncommon peace with himself.

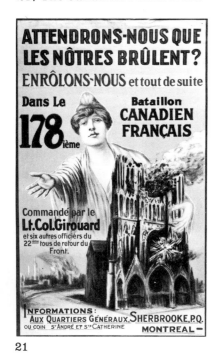

21

The relative gentleness of Canada's wartime posters can be attributed in part to the fact that they were not directed at the enemy, but were intended either for home consumption or to encourage the troops overseas. Posters of occupied countries and countries in direct lines of fire were naturally more melodramatic and more persuasive. Ours were usually tame and humane attempts to cheer ourselves up and to spur ourselves on. Our poster artists resisted depicting actual conditions and attitudes in Canada, and rarely managed, or where permitted, to depict the gruesome atrocities and scenes of violence which confronted the men in uniform. Did they work? Did people believe what they said, do as they ordered, react as they indicated? Foreign as some of the sentiments and politics may now appear, the posters seem to have been in tune with the times, and to have achieved their ends to a remarkable degree. What is distressing is the discovery that during the war years experts in propaganda and the general public itself would probably have disagreed with our own preferences, which are based on aesthetics rather than on the findings by Young and Rubicam: "War posters that make a purely emotional appeal are by far the best."

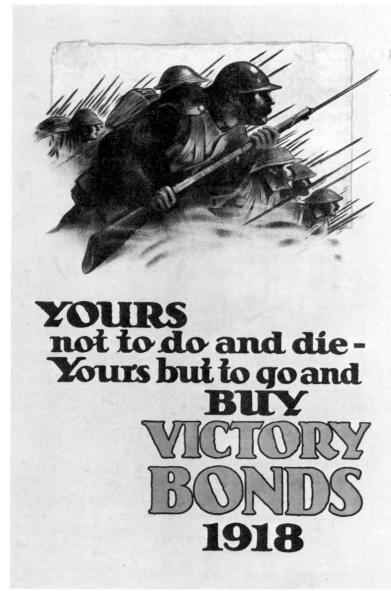

22

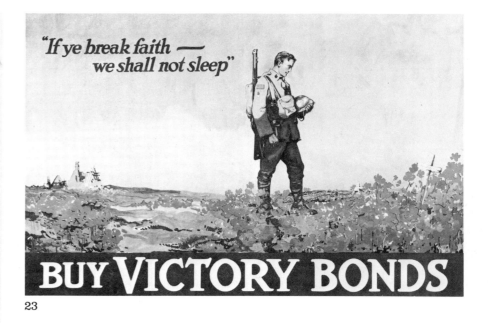

23

21. **Attendrons-nous que les nôtres brûlent? A:** W.H.T. (?); **C/A:** 178ième Bataillon Canadien Français, Montreal; **P:** Howell Lith., Hamilton.

22. **Yours Not To Do and Die...** 1918; **C/A:** Victory Loan (War Poster no. 8).

23. **If Ye Break Faith... C/A:** Victory Loan (War Poster no. 1).

24. **Pave the Way to Victory; C/A:** Victory Loan (War Poster no. 5).

25. **Buy Victory Bonds; A:** A. Bruce Stapleton; **C/A:** N.W.F.B. (Victory Bonds).

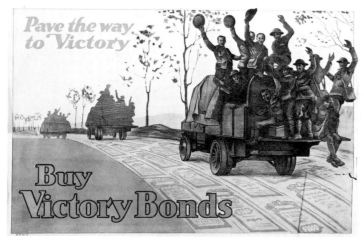

24

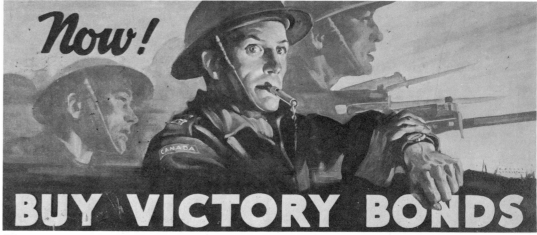

25

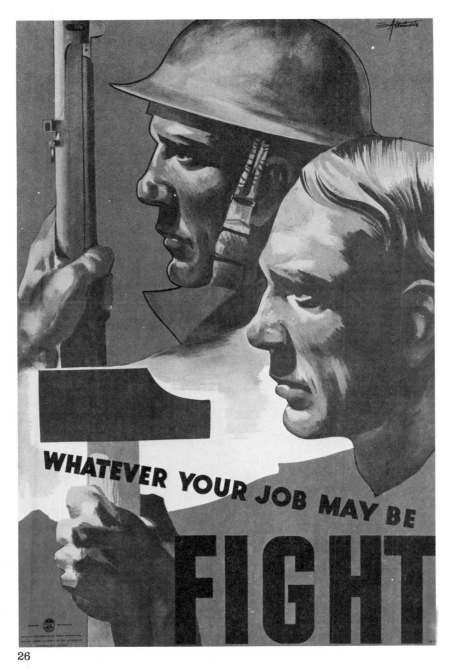

26

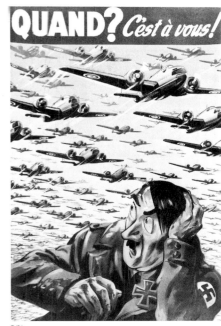

27

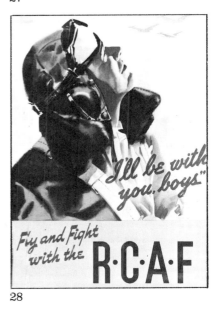

28

26. **Whatever Your Job May Be
Fight** 1940; **D/A:** Eric Aldwinkle;
C/A: Issued by the Director of
Public Information, Ottawa, under
authority of the Minister of National
War Services.

27. **Quand? C'est à vous!**
C/A: Canadian Wright Limited
(published and distributed with the
authorization and under the sur-
veillance of the Director General of
Aircraft Production).

28. **I'll Be With You, Boys; A:** Joseph
Sydney Hallam (1899-1953);
C/A: Royal Canadian Air Force.

29. **Buy War Savings Stamps;**
D/A: Rex Woods (b. 1903);
C/A: National War Finance Board
(War Savings Stamps).

30. **Every Canadian Must Fight;**
A: Philip Surrey (b. 1910);
C/A: Director of Public Information,
Ottawa.

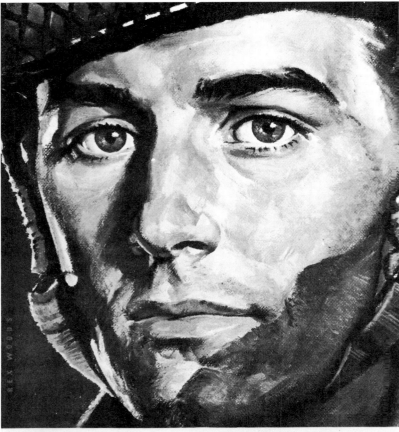

29

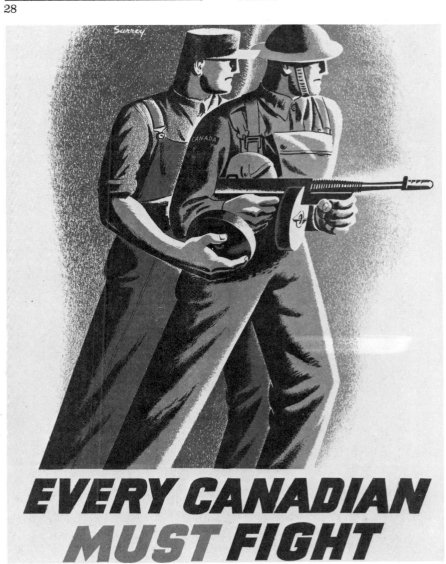

30

The Unknown Pointing Soldier

One of the most striking of all Canadian World War I posters is an unattributed case of quite blatant plagiarism. "*Emprunt de Victoire*": (in its English incarnation entitled "Buy Your Victory Bonds"), a large colour lithograph of 1917 or '18, belongs in the ranks of what Maurice Rickards called "the world's army of exhortation—the pointing, beckoning, declaiming figures that called from everywhere for more of everything."[6] At the head of the column was Alfred Leete's much-reproduced "Britons," depicting Lord Kitchener aiming his index-finger at the not-yet-enlisted man of the street. The portrait first appeared on the cover of the 5 September 1914 issue of *London Opinion*; the Parliamentary Recruiting Committee then decided to use it as the basis of a poster campaign. Another version by Leete bore the slogan, "Your Country Needs *YOU*." Subsequently, many adaptations of this theme were printed in both world wars and in between. As late as 1968 English artists were merrily mocking the image. A variation was a poster many consider to be among the most compelling and memorable images of World War I: Achille Lucian Mauzan's National Loan Poster of 1917 entitled "*Fate tutti il vostre dovere!*" ("Everyone to his duty!"). According to Rickards, "the Italian certainly appeared in greater numbers, and in a wider variety of shapes and sizes, than the pointers and beckoners of any other country." Whatever the poster's original artist might have felt about the war or the rhetoric it occasioned, he handled his subject with more technical skill than another anonymous draughtsman who employed the pointing-soldier motif to enlist recruits for "Kitchener's Own," the 244th Battalion, Montreal. Postwar illustrations delighted in transforming the stereotype to communicate commercial messages. A billboard of the 1920s—possibly by J. E. Sampson—gave the soldier a wig and robes and admonished the bread-buyer to "be the Judge" of Christie's product. During World War II the pointer was back in uniform, again pushing Victory Bonds (and, by inference, E. L. Ruddy Ltd., donor of the billboard).

The return to peace did not retire the universal trooper from service. "Buy Your Victory Bonds" was included in the 1969–70 exhibition *Posters of Three Wars* mounted by the National Gallery of Canada's Extension Services. It may have been the direct inspiration for posters and flats designed by the Ottawa graphics firm of Frost, Milton, Young for a National Arts Centre Theatre Company production of Joan Littlewood's *Oh What a Lovely War*. In 1978 Burlington advertising artist Jim Haines produced a Canadian equivalent of "I Want You"—General Sir Isaac Brock supplanting the goateed American—a prize-winning poster designed to "recruit" students for Brock University in St. Catharines, Ontario. At this very moment some artist somewhere is probably concocting yet another lampoon of a once-commanding image.

[6]Rickards, Maurice. *Posters of the First World War*. New York: Walker & Co., 1968.

31. **Buy Your Victory Bonds** c. 1917-18; **C/A:** Victory Loan.

32. **Prestito Credito Italiano** 1917; **A:** Achille Lucian Mauzan; **P:** Civica Raccolta Stampe Bertarelli, Milano.

33. **Get Ready!** 1918; **A:** Herbert A. Williams; **C/A:** Williams-Thomas Ltd., Montreal/Victory Loan; **P:** Williams-Thomas Ltd. **Note:** This billboard was erected in October 1918 and hailed by its sponsor as "the largest poster ever made."

34. **Last Chance! C/A:** Victory Loan; **Note:** Toronto Transit Commission poster-car.

35. **Stick It Canada! C/A:** Victory Loan. **Note:** A small Victory Bonds adhesive-backed sticker.

36. **You Can Help To Build Me a Plane** c. 1939-45; **C/A:** War Savings Certificates/E.L. Ruddy Co. Ltd.

37. **Oh What a Lovely War** 1973; **D/A:** Design Workshop, Ottawa; **C/A:** National Arts Centre, Ottawa.

38. **Now Hear This** 1917; **A:** Peter Swan; **C/A:** The Toronto Symphony Orchestra. **Note:** Cover of brochure advertising the 1977-78 TSO season.

39. **Isaac Brock Wants You** 1978; **D/A:** Jim Haines; **AD:** Doug Geddie; **S/A:** Etcetera Advertising Ltd., Burlington, Ontario; **C/A:** Liaison and Information Office, Brock University.

40. **You Can Help Hasten Victory** c. 1939-45; **C/A:** Victory Loan/Remington Rand Ltd.

41. **You Are Needed To Take My Place; C/A:** The 244th Battalion, Canadian Army, Montreal.

42. **You Be the Judge** c. 1929-30(?); **C/A:** Christie, Brown and Co. Ltd., Toronto.

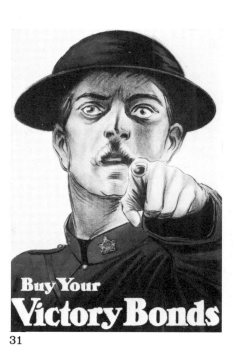

31

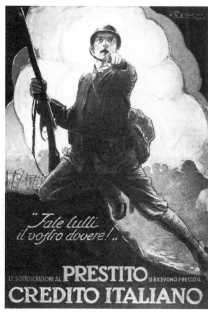

32

33

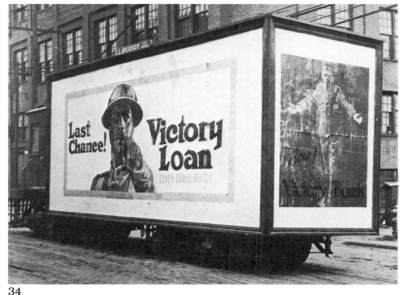

34

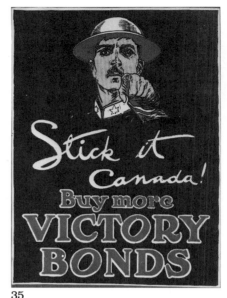

35

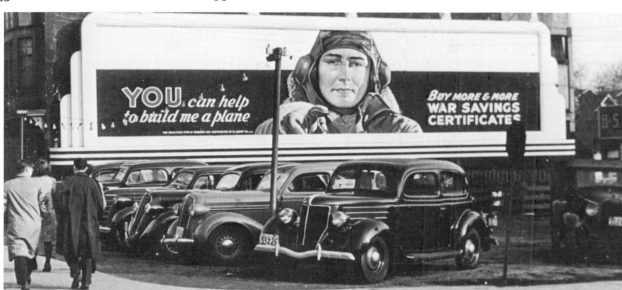

36

37

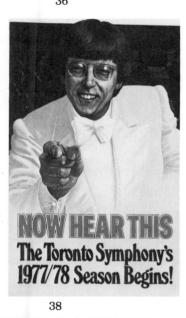

38

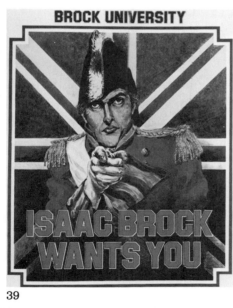

39

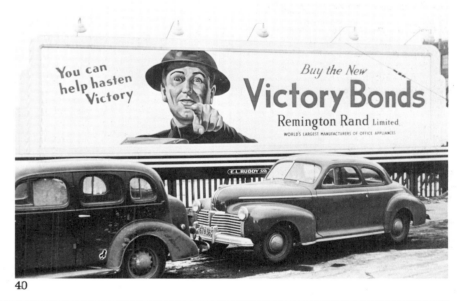

40

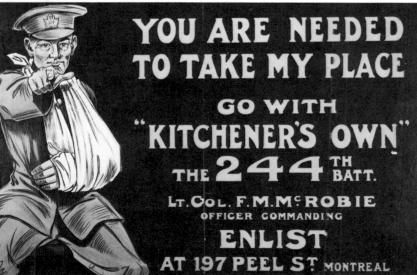

41

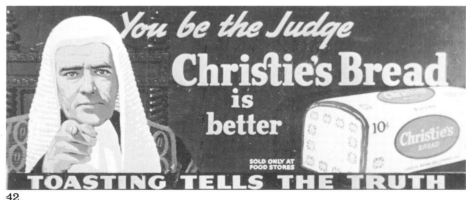

42

5/ Circus and Carnival Posters

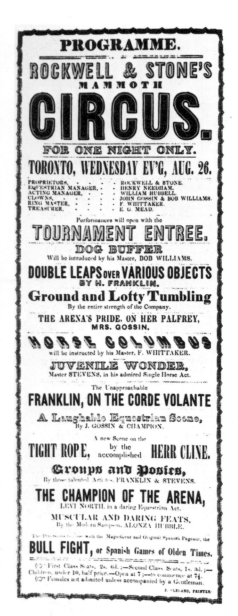

1. **Rockwell & Stone's Mammoth Circus** 1846; C/A: Rockwell and Stone; P: James Cleland, Toronto.

The period from 1880 to 1910 was the golden age of the circus and the carnival. During that time there were few means of advertising such events outside of billboards, placards, handbills and wall posters. The circus poster played an important role. Jules Chéret, often called the father of the modern poster, is said to have been strongly influenced by American examples of the genre dating from the 1850s and '60s. He would have been familiar with the large lithographic announcements—executed by emigrant German masters of stone-printing—which were pedantically literal and too realistic. By comparison, Chéret's work and that of his followers is elusive and suggestive. Yet some of the sawdusty tawdriness of travelling menageries, freak-shows, and acrobatic troupes is conveyed in these primitive images.

Many jobbers depended on the travelling shows and carnivals for their livelihoods, as a contract with a circus company assured a poster-printer of fairly regular business at high volume. Probably the most successful producer of circus and theatrical posters is North America was the Strobridge litho-graphic establishment of Cincinnati. The artists involved in most of the work of this period were anonymous. What Jack Rennert says of the American circus industry also applies, with some qualifications, to the Canadian side.

> No other industry so thoroughly used posters and billboards. In fact, the circus industry invented the billboard industry and the amount of "paper"—as sheets were called then—was prodigious. There might be three or four railway cars, two weeks ahead of the circus, and within a twenty-mile radius of that circus location would, within one day, put up from 5,000 to 8,000 pieces of "paper"—and the average size sheet would be 16-sheet billboards to be put up on sides of barns and buildings or specially built or rented boards.[1]

Canada possessed only a small share of the industry's business, since the survival of circuses depended upon year-around circuits and unbroken bookings. Most of the travelling shows which visited our towns and cities were from the United States, although at various times we did have our own itinerant one-, two-, and even three-ring bigtops with their pendant midways.

One of the earliest travelling circuses known to have employed a Canadian poster-printer was Rockwell and Stone's Mammoth Circus, which visited Toronto in 1846. James Cleland, printer of the *British Colonist*, used ten different typefaces to suggest the variety promised by this small tent circus. The broadside format was standard at that time, just as the chromo-lithographic was when Barclay, Clark and Co. printed the poster advertising "Toronto's Grand Summer Carnival" of 1890. When King Show Print of Estevan, Saskatchewan produced its poster for the "King Bros. and Christiani Combined

[1]Rennert, Jack. Introduction, *100 years of circus posters.*
New York: Avon Books, 1974. A Darien House Book.

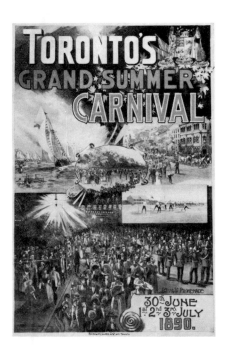

2. **Toronto's Grand Summer Carnival** 1890; **C/A:** Toronto Carnival Commission; **P:** Barclay, Clark and Co. Ltd., Toronto.

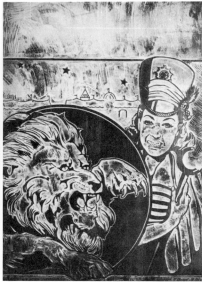

3. Engraved basswood block used in printing a coloured circus poster by King Show Print, now in Massey College Library, Toronto c. 1920s(?). Chalk has been added to show cut-away areas, and dark dye to show raised areas. Wooden letters were locked into space at the top.

Circus'' some time in the 1940s or '50s, photography and wood-block printing had allied themselves in a short-lived marriage. Theo Dimson's recent poster for Puck's Canadian Travelling Circus makes use of silkscreen's immediacy to convey its clownish punch.

The constant in all this is King Show Print, whose history is one of the intriguing but little-known chapters in the annals of Canadian pictorial printing. Andrew King, the proprietor of this pioneering firm, learned his trade at the composition stand of a small newspaper printing-office in the prairies, where he operated equipment little improved from Gutenberg's time. King's autobiography is a valuable source of information about early printing methods in the Canadian West around the turn of the century. In 1912 quite by accident, while in Rouleau, Saskatchewan, he was given the opportunity to become engaged in what he described as "a specialized line of printing which otherwise I would never have dreamed of producing."[2]

He goes on to relate how the American printer assigned to provide posters for a circus tour had failed to send the commissioned papers in time, and how his agent had suggested impatiently that King set up a poster printing shop "somewhere in the part of Canada from which a prompt and convenient service could be obtained." King knew nothing about circus-posters and had to study hard. "It was interesting," he wrote, "to learn that all these sizes (i.e., of "show" one-sheet posters measuring 28″ by 42″ and of 28-sheet billboards) had been standardized for years." Because there were just six show days a week, with date-lines for a week at a time, orders could be printed entirely on full-sized sheets; after they were printed the variously sized posters were then cut apart. This procedure enabled presses to run at full-cylinder size capacity all the time.

At first, King's only customers were companies whose shows visited Rouleau (at an average of about one a week). At that time there were only five other Canadian poster plants, situated in Montreal, Toronto, Chatham, Winnipeg and Vancouver. Gradually, the Enterprise Show Print name spread across the prairies. Unable at first to compete with the large American poster plants, King decided to specialize in posters for sports days, dance bands, department stores, fairs and exhibitions. By 1916, 75 per cent of the large exhibitions were customers of Enterprise Show Print, which had adopted circus billing methods by sending out poster crews to blanket each show's drawing area. To meet this demand, and to cater to the carnivals which followed the fairs, rodeos, and exhibitions, King had to obtain still larger sizes of wood type, along with the "bull" date figures measuring seven feet square. With his new equipment he could supply circuses with any size of paper or card and in any quantity they required, in addition to his wood-block engraving service. The fact that such a city-type operation could be established in a small town earned King considerable and valuable publicity. His list of customers grew rapidly and by 1919 he was supplying posters to dramatic and musical comedy companies, circuses, carnivals, and other users from St. John's, Newfoundland to Victoria, B.C., and as far south as Kentucky and the Pacific Coast states. As the competition was geared solely to the production of smaller-sized posters, Enterprise Show Print eventually became the only wood-type poster printing plant of its kind in Canada.

The 1919 Winnipeg general strike was King's second "bit of good luck." As the Winnipeg plants were crippled by the walkout and could not ship orders, travelling shows turned to King during the crisis and subsequently became permanent customers. In 1923 Patty Conklin and Speed Garrett met in Winnipeg; soon after they began touring their collection of rides, games and shows around the prairies and to northern logging camps, hauling "gilly" outfits from railway yards to fairgrounds by horses or trucks. King served the partnership until 1937, when Patty Conklin, having been awarded the contract to operate the midway of the Canadian National Exhibition, sold his travelling Conklin Shows to Jimmy Sullivan of Wallace Brothers. On his purchase of *The Estevan Mercury* in 1944, King moved his poster plant from Rouleau to Estevan, Saskatchewan and changed the company's name to King Show Print. After World War II the newspaper and the show print business were jointly

[2]King, Andrew. *Pen, Paper and Printing Ink.* Saskatoon: The Western Producer Prairie Books, 1970, p. 69.

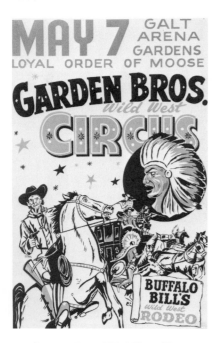

4. **Garden Bros. Wild West Circus;** C/A: Loyal Order of the Moose/ Garden Bros.; P: Price Signs, North Bay, Ontario.

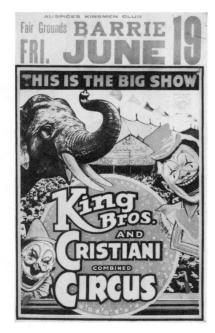

5. **King Bros. and Christiani Combined Circus** c. 1950s(?); C/A: King Bros. and Christiani, Vancouver/Barrie Kinsmen Club; P: King Show Print, Estevan, Saskatchewan.

owned by King and his two sons, Stirling and William; they employed a staff of between thirty and thirty-five people.

Finding an artist skilled at depicting "wild animals, clowns, ferris wheels, horses, acrobats and other features common to carnivals and circuses, at the peak of their exciting performances," at first posed a problem. Initially, King purchased drawings from various sources in Seattle, Washington, but finally "the proper artist was found, in the person of Herb Ashley, of Banff, Alberta, a part-time commercial artist with an understanding flair for show posters." The method of reproduction was essentially that of the Japanese wood-block print: one engraved panel for each colour of ink, with secondary hues being achieved by overprintings.

Professor Douglas Lochhead, former Librarian of Massey College, Toronto, noted in the preface to King's autobiography that "Although the full story of printing in Canada has yet to be written there is no lack of colourful and rich material. It is replete with energetic imaginative and talented men and women whose continued pioneer printing endeavours are around us everywhere. Three names dominate the scene because of their inventiveness, dedication and sheer talent—(James) Evans, (Carl) Dair and King."

It was Dair who had put Lochhead onto the story of the founder of King Show Print. In recognition of Andrew King's achievements a "King's Corner," featuring examples of his large wood engravings, was established in the Bibliography Room for Graduate Studies at Massey College. "It is, I believe, his engraving and the printing of three-colour circus posters in the 1920s, '30s and '40s," Lochhead observed, "which mark him as an artist and a major figure in Western Canadian and North American printing history."[3]

Today, when most large travelling circuses have traded the big top for the enclosed arena, the wood-block poster 'has also been replaced with more sophisticated means of advertising. The old-fashioned carnival has fallen victim, like so many other forms of amusement, to television, the movies and sporting events. Yet, as I write, small domestic circuses are enjoying a renaissance of sorts. In Canada at the moment there are five touring companies in operation and at least one itinerant circus is using posters little changed from those produced by King Show Print and similar poster plants. The nostalgia boom may yet reinvigorate the genre, just as it has revived other popular art-forms threatened with oblivion until not long ago.

[3]Lochhead, Douglas. *Ibid.*, Preface.

6. **Puck's Canadian Travelling Circus** 1976(?); D: Theo Dimson (b. 1930); P: Bob Middleton, Toronto.

7. **Conklin Shows** c. 1950s(?); P: King Show Print (?).

8. **Bob Morton's Circus** c. 1920s; C/A: Rameses Shriners/Bob Morton's Circus.

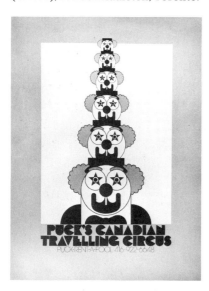

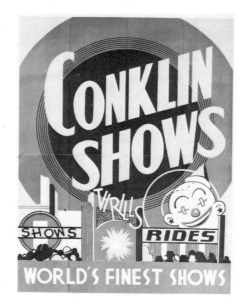

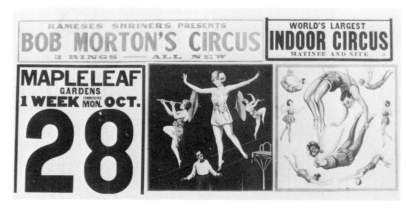

6/ *Sports Posters*

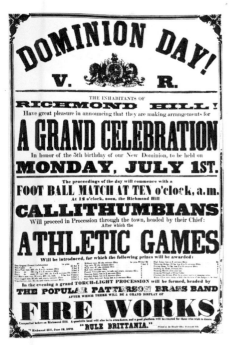

1. **Dominion Day!** 1872; **P:** *Herald* Office, Richmond Hill, Ontario.

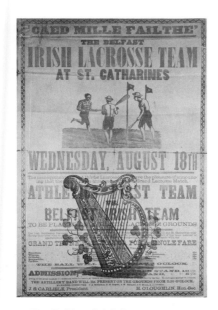

2. **The Belfast Irish Lacrosse Team.** . . 1886; **C/A:** The Athletic Lacrosse Club, St. Catharines, Ontario.

The rare sports posters of the middle and late nineteenth century which have survived provide us with a graphic demonstration of a minor but very revealing change in the makeup of Canadian society. Over the last three decades professional sport has become part of the entertainment industry and is advertised on and in the mass-media. Many of their proprietors also invest heavily in the leagues themselves. In the past participants may well have outnumbered spectators, and few competing teams were professional in stature. "Sports days" were common festivities when people had to provide their own entertainment, and at a time when scattered communities periodically came together for some friendly competition and general merry-making. We can see from broadsides promoting such events that the advertised sports features shared equal billing with concerts, dances, speeches and demonstrations of livestock and machinery.

However intense partisan rivalries might have been, posters of the period clearly indicate that control of sports had not fallen into the hands of moguls and manipulators. Until the 1930s the relative crudeness and simplicity of the wood-type, woodcut-decorated broadsides produced at the behest of sports committees and civic authorities suggest the innocent fervour of true amateurism.

For some reason, the entrepreneurs who began to consolidate sports empires in the first decades of this century seldom resorted to posters to call attention to the events they mounted. This is curious, since the travelling circuses and annual exhibitions which occupied the same arenas, stadia, racetracks and playing-fields as the sports competitions and demonstrations reached the public primarily through posters and billboards.

It could be suggested that occasions such as the Olympic Games may be closer in essence to festivals—or, for some, to religious or patriotic rituals—than to international athletic meets. In my eyes, at least, the twenty-first modern Summer Olympics were as much a graphic debacle as they were a financial one. The story of this melancholy outcome of inconsistent planning and derivative thinking is sad but salutary.

In May 1970 the International Olympic Committee voted to stage the 1976 Olympiad in Montreal; immediately thereafter the Montreal Organizing Committee (COJO) began to sketch out its program, but set aside the task of commissioning posters for the Games until it was almost too late—much to the dismay of Quebec's design community, who had been kept in business by Expo 67 and now badly needed a boost. Only a publicly financed major event of the proportions of an Olympiad or a world's fair can provide this kind of stimulus. When it was discovered that COJO had allocated no more than $100,000 for the coordination of what in 1970 was promised to be "a vast Canadian cultural festival," and that the federal government had no intention of initiating any cultural activities to coincide with the Games, the question began to be asked: was this splendid opportunity to be wasted through niggling and negligence?

In 1969 the International Olympic Committee amended its Rule 31 to determine that future Arts and Culture programs should be national rather

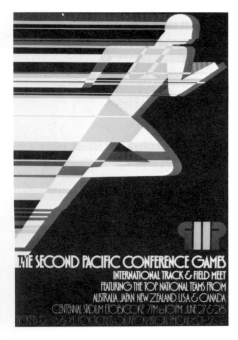

3. **The Second Pacific Conference Games** 1973; **A:** David Chestnutt; **D:** Theo Dimson; **AD:** Theo Dimson; **S/A:** Reeson, Dimson and Smith; **C/A:** Pacific Conference Games.

4. **Aviron** 1977; **D:** Guy Lalumière; **S/A:** Guy Lalumière et Associés; **C/A:** Gouvernement de Québec, Ministère de l'Education.

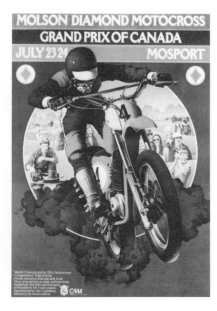

5. **Molson Diamond Motocross** 1977; **D/A:** Roger Hill; **AD:** Michael Fromowitz; **C/A:** Molson Breweries/ Canadian Motorcycle Association.

than international in character. In 1975, Jean Dupire, Co-Ordinator of COJO's Arts and Culture, boldly announced in *Art Magazine*'s "Forum: Canadian Olympics" that his department would "use the Olympics as a 'world platform' for Canadian culture."[1] Nowhere among the projects suggested by Dupire was specific mention made of the poster. In the same issue of *Art Magazine* Dr. Ray Levin issued "a plea for a poster program for the Canadian Olympics."[2]

Not until February 1975 did the Artists'-Athletes' Coalition for the Cultural Celebration of the 1976 Olympiad announce its poster project, a national design competition to select the twelve best posters featuring graphics by Canadian artists. These posters were to be distributed free of charge to schools, colleges, museums, art galleries and libraries across Canada, and to participants in the Games. A limited edition of signed and numbered copies costing $40.00 each was to be sold through art galleries, while a regular $5.00 edition would be made available through "normal retail outlets." The commissioning and competition phases were funded by the Canada Council and the Ontario Arts Council, and the project was conducted in association with the Olympic Club of Canada and the Olympic Trust of Canada. The judges were curators, administrators, a professor of physical education, an art dealer, and a painter; Toronto's Burton Kramer was appointed to design the basic format for each poster including the typesetting and disposition of a standard text. The precedent for this procedure had been set by the posters for the Lausanne Fair and the Tokyo and Munich Olympics. Only two of the artists selected from the lists supplied by each member of the jury had graphic designer credentials: Allan Fleming and Pierre Ayot. In all, some three hundred designs were submitted, ten eventually being chosen as winners. The winning compositions reveal only vague attempts to conform to the organizers' idealistic concept of "bridging the traditional Canadian gulf between sports and the arts." Several artists in fact, had been content to repeat motifs found in their abstract paintings, none of which had anything to do with sports.

Georges Huel, Director General of Graphics and Design for the XXI Olympiad, hoped to use the occasion to demonstrate the role graphic design could play in the shaping of the two "super weeks" of this world sports spectacle. "I wanted to show . . . that with good planning, the right people involved in design can really contribute to an event like our Games. Every piece had to be friendly, unpretentious and radiate a dash of youth!" Predictably, the "right" people turned out to be Montreal's design establishment. Huel looked after signage, furniture design, uniforms, etc., and Pierre-Yves Pelletier acted as deputy-director in charge of all printed material. Fritz Gottschalk headed the Design and Quality Control Office. After these appointments had been made, the work was divided among "the best qualified private design firms." In all, eight permanent designers and over one hundred freelancers were involved. Nowhere in the official literature was an effort made to define the Canadian mentality, nor do any of COJO's posters reveal the designers' intentions to interpret our way of life, which is neither singular nor constant from coast to coast. This proves once again that the highly charged, artificial atmosphere bred by occasions such as the Olympic Games is not conducive to a successful original graphics program.

Of the two poster series issued by COJO—one photographic, welcoming visitors to the Games and illustrating various sports in the program, the other illustrative, showing buildings and competition sites and stylized versions of the Games' insignia—the latter, general series was slightly more successful, since it avoided the cliché of the cropped blow-up. The former series contains a few memorable images, selected from some twenty thousand photographs taken during the 1972 Munich Games. What is lacking in both these series is a commitment to the occasion, and the kind of attention-grabbing graphic power that made the Munich posters photographically and illustratively so arresting. Even more damning is the almost total absence of wit.

The idea of friendly competition among hostile nations may be a contradiction in terms, or at least an evasion of political and economic reality. Could the fault lie in the nature of the Games themselves?

[1]Dupire, Jean. *Artmagazine*, Winter 1975; p. 6.
[2]*Ibid.*

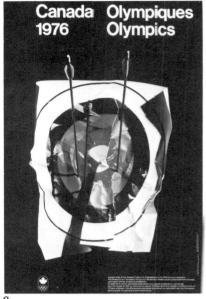

6

Kingston 1976

7

8

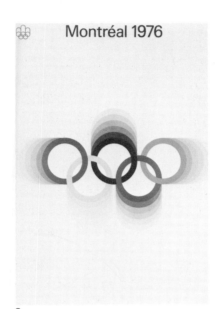

9

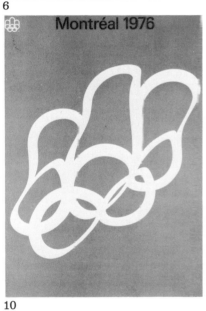

10

11

12

13(a)

13(b)

6. **Canada 1976 Olympiques Olympics** 1976; **A:** Pierre Ayot (b. 1943); **D:** Burton Kramer Associates, Toronto; **C/A:** Artists'-Athletes' Coalition for the Celebration of the 1976 Olympics; **P:** Herzig-Somerville Ltd., Toronto; **M:** Offset.

7. **Kingston 1976** 1976(?); **D:** Raymond Bellemare; **A:** Jacques Gagnon; **AD:** Pierre-Yves Pelletier; **C/A:** Comité d'Organisation des Jeux Olympiques (COJO), Montreal.

8. **Montréal 1976 AD:** Pierre-Yves Pelletier; **C/A:** COJO.

9. **Montréal 1976; D/A:** Ernst Roch (b. 1928) and Rolf Harder (b. 1929); **AD:** Pierre-Yves Pelletier.

10. **Montreal 1976; D:** Yvon Laroche; **AD:** Georges Huel and Pierre-Yves Pelletier; **C/A:** COJO, Montreal.

11. **Canada Olympiques 1976 Olympics** 1976; **A:** Lucy; **D:** Burton Kramer (b. 1932); **S/A:** Burton Kramer Associates; **C/A:** Artists-Athletes Coalition, Toronto.

12. **Montréal 1976** ("Amik") 1976(?); **D:** Yvon Laroche, Pierre-Yves Pelletier, Guy St-Arnaud; **AD:** Georges Huel and Pierre-Yves Pelletier; **C/A:** COJO.

13(a)(b) **Montreal 1976; D/A:** Vittorio Fiorucci; **AD:** Vittorio Fiorucci. **Note:** These two posters were submitted by Vittorio Fiorucci to COJO for publication in its poster series but not accepted, so screen-printed by the artist at his own expense.

7/ Political, Election and Protest Posters

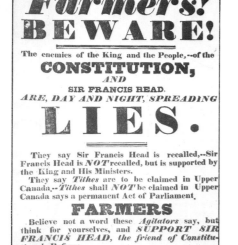

1. **Farmers! Beware!** 1836; **P:** Albion Office, Toronto, John F. Rogers, Printer.

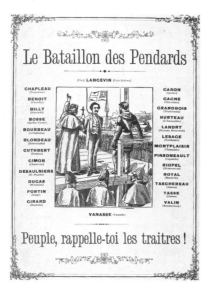

2. **Le Bataillon des pendards** 1887; **A:** J. Lecomte (woodcut or wood-engraved inset illustration).

Canada has frequently experienced decades of political unrest, social injustice and serious deprivation for many. Yet our political propaganda has been comparatively low-keyed, and our posters and broadsides, unlike those of other, more volatile peoples, appear temperate, calm and unexciting. In France, for instance, a continuity exists between the crude and raw but powerful broadsides paraded by the revolutionaries of 1789, the Communards of 1871, and the students in the 1968 Paris uprising. In Communist China the wall-poster is still the front line of communication, informing, exhorting and entertaining the people. In the United States, the posters which appeared during the anti-Vietnam War demonstrations unwittingly reflected the very methodology of slick mass media advertising which the protesters tried to vilify; nevertheless, they conveyed a kind of social consciousness, in contrast to Canadian posters of the same vintage which appeared smug and bore signs of being remote from the centre of action.

Yet there was a time in Canada when political broadsides and posters told a different story. In the nineteenth century, for every deferentially polite plea by a candidate to the electorate, there was a passionate call to arms, a libellous attack, an appeal for justice or a rude satire. While today's political copywriters try to make messages sound as catchy as the slogans for breakfast-cereal commercials, their nineteenth century counterparts indulged in verbose rhetoric. Until the advent of daily or weekly newspapers, posters were designed to be read like a speech or a proclamation, and supplied the population with necessary facts and figures. These early broadsides got their messages across by means of a wide assortment of display typefaces rather than with illustrations. Broadsides with pictorial content were usually printed from engraved copperplates until lithography took over from letterpress.

Political strategists and students of the media today are divided in their estimation of the value of pictorial publicity. Not only is the poster restricted in its scope because of our harsh climate and the ordinances which limit the posting of signs, but election budgets are now primarily devoted to television, radio and press advertising. Nonetheless, the election poster is far from dead. Most candidates well know that the lawn poster is still one of the most effective ways of winning the attention of voters—if only by annoying them into awareness.

Also, until recently, few studies have been conducted to determine to what extent voting-patterns are influenced by posters. This much, however, is known: the public mistrusts slick design and frivolously witty or ambiguous slogans. Instead, it prefers straight information and definable images. Simplicity is still taken as an indication of sincerity; yet promotional materials that smack of penny-pinching or a lack of funds are as suspect as those that reek of high-powered patronage. All of these factors add to the woes of the poster-artist, who has to promote political candidates who may be dull, uninspiring, or even untrustworthy subjects.

That the art of the political poster is yet in its infancy in Canada should come as no surprise to anyone who has studied the posters of countries which respect the power of the medium to move masses and affect change. But has the

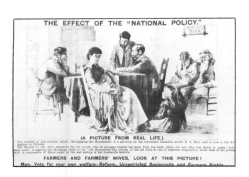

3. **The Effect of the 'National Policy'** 1891; **A:** George A. Reid (lithograph after his 'Mortgaging the Homestead'); **C/A:** Liberal Party of Canada.

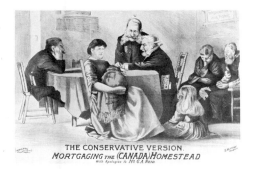

4. **The Conservative Version...** 1891; **D/A:** Sam Hunter; **C/A:** Conservative Party of Canada. **P:** Sabiston Litho. and Pub. Co. Montreal.

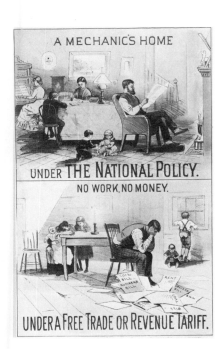

5. **A Mechanic's Home Under the National Policy** 1891; **C/A:** Published by the Industrial League, Frederic Nicholls, Hon. Sec.; **P:** Toronto Lithographing Co., Toronto.

poster always been a secondary weapon in Canada's political wars? It is difficult to make such an assessment because so little data has been gathered on the subject.

We do know that the first Canadian federal election to be fought with the aid of pictorial posters brought out so much visual and written propaganda that it led historian O. D. Skelton to describe it as "the most bitterly contested since Confederation."

The election campaign in 1891 was the ailing Sir John A. Macdonald's last battle. He left no doubt in anyone's mind that a Liberal conspiracy was afoot which favoured a reciprocal trade policy with the Americans. This policy was naturally anathema to the Conservatives and their backers, the industrialists and merchants—among them the brass of the Canadian Pacific Railway and of the Industrial League. The ensuing poster war established the Tories as unrivalled masters in the dubious art of denunciation, innuendo and slander. The Industrial League's unknown poster-draughtsman managed to outflank the ill-prepared Liberals by sowing the seeds of what proved to be an unfounded but very real suspicion: unrestricted trade reciprocity with the United States and direct taxation would ruin the Canadian businessman and end Canada's close ties with Britain.

The anonymous artist of the poster bearing the slogan "The Old Flag, The Old Policy, The Old Leader" was lucky in having Sir John A. Macdonald as a subject, as he was a man whose face was well-known and whose features were full of character. The poster showing Sir John A. riding forward to victory on the shoulders of a typical farmer and a typical industrialist, the Union Jack in full flourish behind him, brashly implies that two radically opposed factions can come together to support a leader who by then was actually running on charisma and reputation, rather than on a solid political platform.

"Laying Out the Grit Campaign," again by an unknown artist working for Toronto Lithographing Co., was part of another set of cartoon-posters sponsored by the Industrial League in 1891. They sought to convince voters that the Liberals' free-trade policy was a "will o'the wisp" threatening to lead the nation into the "swamp" of United States' domination. The villains of these pieces were Sir Wilfrid Laurier (looking remarkably like a young Pierre Trudeau) and the corpulent Sir Richard Cartwright, "Senator of the State of Ontario." Both these men were shown plotting with the Americans to break down the tariff barriers to open the way for a Yankee raid on the coffers of Canada so closely guarded by Sir John A.

Playing on the fears of U.S. domination has frequently proved effective as a Canadian election ploy, but rarely was manipulation so blatant or so funny. The Grits entered the fray with a lithographic reproduction of George A. Reid's "Mortgaging the Old Homestead," an oil painting now hanging in the National Gallery of Canada. It was superscribed with the slogan, "The Effect of the 'National Policy.'" This poster proclaimed that the chief sufferers of Sir John A. Macdonald's protectionist stand were the farmers, who had to pay high prices for goods manufactured in Canada. Not missing a trick, the Industrial League's caricaturist replied with a parody on the Liberals' appeal entitled "The Conservative Version. With apologies to Mr. G. A. Reid." The poster is signed S. Hunter, probably Sam Hunter (1858-1939), a Toronto newspaper cartoonist. Might Hunter have been the artist of other unsigned Industrial League cartoon-posters? Or the illustrator of the two-part Conservative poster, "Under the National Policy (and) Under a Free Trade or Revenue Tariff," which showed an out-of-work bankrupt holding his head in his hands—a copy of the Mercier figure in the Reid-Hunter takeoff? As the main colourlithographic posters published by the Industrial League depended for their impact on the sometimes cruel caricaturing of Sir Wilfrid Laurier and his cohorts, it is unlikely that Hunter was responsible for them. Comparing the amateurish pen-draughtsmanship of Hunter's editorial cartoons with the clever and adept crayon-work of this series of posters makes the ascription even more unlikely.

The success of the 1891 election posters taught the Liberals a lesson. In a later campaign one of their posters implied that to vote Tory was to side with the wolf of "Hard Times" which howled at the door of the "Workman's Home." Another Liberal poster revealed that behind Sir Robert Borden's "Legislation for Interests" was that pushy backroom boy, "Special Privilege."

6. **Vive le Canada libre** 1968;
C/A: Laurier LaPierre/New
Democratic Party.

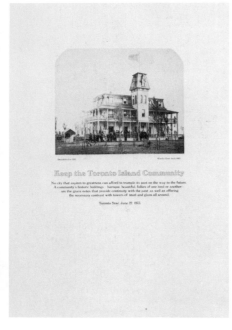

7. **Keep the Toronto Island
Community** 1973; **D**: Rick/Simon
(b. 1945); **C/A**: Save the Island
Homes Committee; **P**: Coach House
Press, Toronto.

8. **Keep Out the Wolves** 1891;
C/A: Published by the Industrial
League, Frederic Nicholls, Hon.
Sec. **P**: Toronto Lithographing Co.,
Toronto.

9. **How Direct Taxation Works** 1891;
C/A: Published by the Industrial
League, Frederic Nicholls, Hon.
Sec.; **P**: Toronto Lithographing Co.,
Toronto.

From then on illustrated posters became integral parts of any election campaign. The same imagery continued to be employed until the 1930s, when symbolic figures began to be supplanted by photographs or portraits of candidates.

Henceforth the appeal of the political poster declined steadily—perhaps irreversibly. The image-makers who were hired by political parties to depict a candidate as possessing "presence," or a somewhat mythical charisma which the Pierre Trudeau posters periodically strove to convey, usually failed. By and large the electorate remains suspicious of any attempts to apply contemporary advertising techniques to the primitive science of political puffery. The 1968 federal election campaign produced several posters couched in the idiom of the psychedelic rock-concert or "head" poster. The irony of framing Robert Stanfield or Allan Lawrence in a cartouche of Da-glo flourishes may not have struck the P.R. man as ludicrous, but it hardly escaped the voter. Although Laurier LaPierre's lighthearted poster of the same year stands out in its irreverence in a sea of dullness and timidity, it did not save him from going down to defeat.

Candidates who cannot afford television coverage resort to lawn-posters. But as printing costs rise, as vandalism increases and as public opposition to forests of signs in residential areas grows, the days of the political poster may well be numbered. Other, less offensive types of promotion may eventually become popular.

As far as I can determine, Canadian posters of protest are rare and have never been studied as evidence of political attitudes and social conditions. Yet many have been produced by individuals and groups to promote various causes. These may be as old or older than the placards financed by political parties.

Radical Canadian causes have been sporadically espoused in posters and handbills debating the pros and cons of Prohibition, announcing rallies and demonstrations, and protesting socio-economic ills. French Canadians opposed to conscription in both world wars resorted to hastily produced broadsides and placards just as the *Front de Libération du Québec* did in the 1960s. Such posters, often poorly designed and unoriginal in concept, rely on dense, cliché-ridden copy and pictures of fist-clenching revolutionaries.

The "agit-prop" and fund-raising posters published by ecological and architectural conservation groups, anti-expressway fighters, or individuals who wish to vent their feelings, may be less predictable but graphically more interesting. Toronto's Coach House Press specialize in elegantly designed and attractively printed posters of this kind. Early in the 1970s the Press's Rick/Simon was commissioned by the Save the Toronto Island Homes Committee to design and print posters to support their cause. In 1971, Allan Fleming designed the posters for the people opposed to Toronto's Spadina Expressway. The lithographed prints were so artistic that they were issued in a limited edition and as a larger unsigned run.

Yet the idealistic reformer and political satirist has always had to contend with a complacent, somewhat indifferent and inherently conservative audience. Could the frustration induced by this state of affairs explain the nature and scarcity of Canadian political posters?

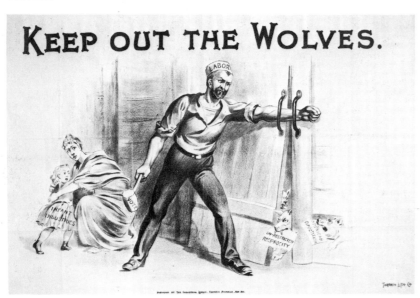

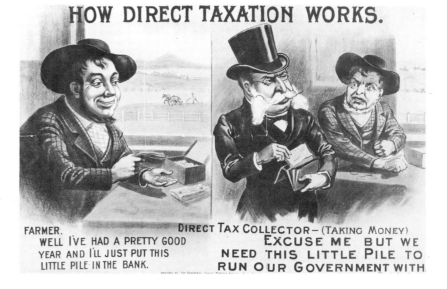

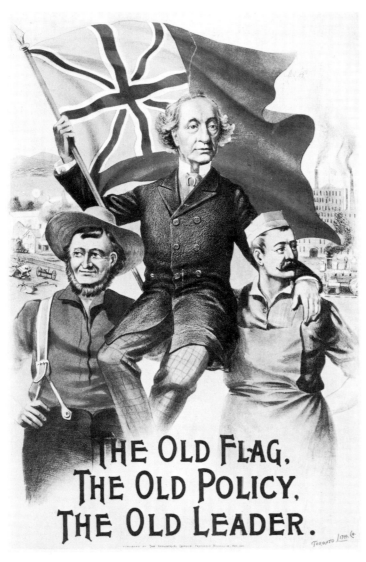

THE OLD FLAG.
THE OLD POLICY,
THE OLD LEADER.

10. **The Old Flag, the Old Leader, the Old Policy** 1891;
C/A: Published by the Industrial League, Frederic
Nicholls, Hon. Sec., **P:** The Toronto Lithographing
Co., Toronto.

11. **What Borden Brought You. . .** 1917(?);
C/A: Liberal Party.

12. **Laying Out the Grit Campaign** 1891;
C/A: Published by the Industrial League, Frederic
Nicholls, Hon. Sec.; **P:** The Toronto Lithographing
Co., Toronto; **M:** colour lithograph.

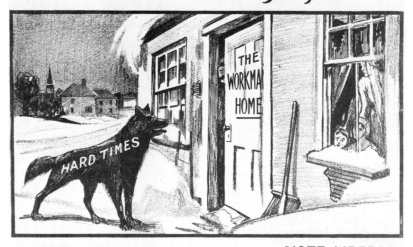

What Borden brought you

REMEMBER 15 YEARS PROSPERITY. VOTE LIBERAL

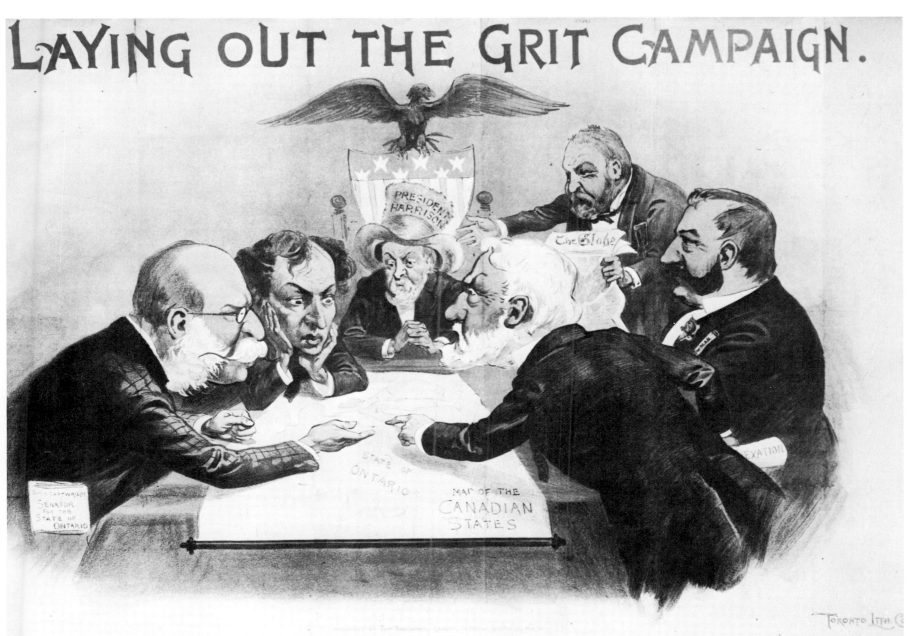

LAYING OUT THE GRIT CAMPAIGN.

13. **The Will O' the Wisp** 1891; **C/A:** Industrial League or Conservative Party.

14. **The Way He Would Like It. Canada for Sale** 1891; **C/A:** Published by the Industrial League, Frederic Nicholls, Hon. Sec.; **P:** Toronto Lithographing Co., Toronto.

15. **Under the National Policy** 1891; **C/A:** Published by the Industrial League (?); **P:** Toronto Lithographing Co., Toronto (?).

16. **The Great Egg Problem Solved** 1891; **A:** C.J. Patterson; **C/A:** Industrial League or Conservative Party; **P:** Sabiston Lith. & Pub. Co., Montreal.

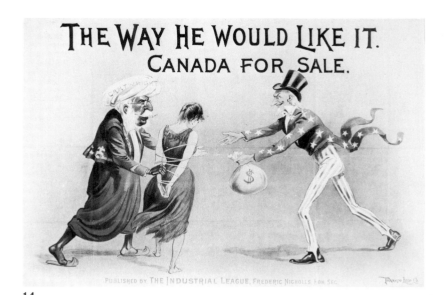

14

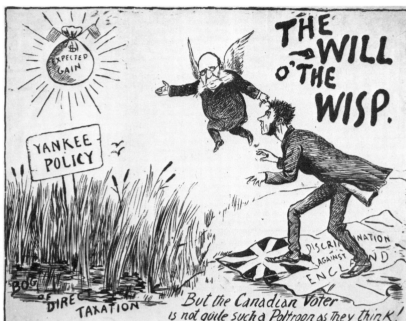

13

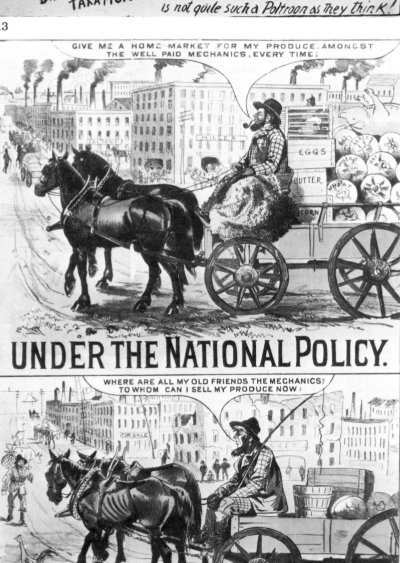

15

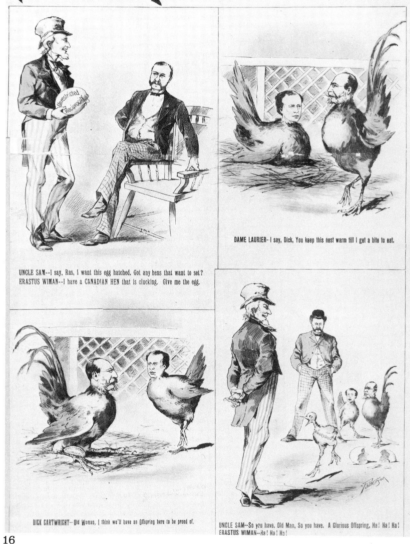

16

17. **The Fiddler** 1917(?); **A:** R.K.; **C/A:** The Union Government Publicity Bureau, Ottawa; **P:** The Heliotype Co., Limited, Ottawa.

18. **Re-elect Joseph H. Harris...** c. 1920s(?); **C/A:** Joseph H. Harris/Conservative Party.

19. **We Can't Undo the Lock. Sir John Is On Guard** 1891; **C/A:** Published by the Industrial League, Frederic Nicholls, Hon. Sec.; **P:** Toronto Lithographing Co., Toronto.

20. **Birds of a Feather** 1899; **C/A:** Toronto Theatrical Mechanical Association; **P:** Alexander and Cable Ltd., Toronto. **Note:** Chromolithographed on cloth. Published by an association advocating closer ties with the United States.

21. **A United Canada Will Solve Your Problems** 1935; **C/A:** Liberal Party.

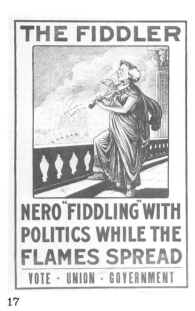

THE FIDDLER

NERO "FIDDLING" WITH POLITICS WHILE THE FLAMES SPREAD

VOTE · UNION · GOVERNMENT

17

18

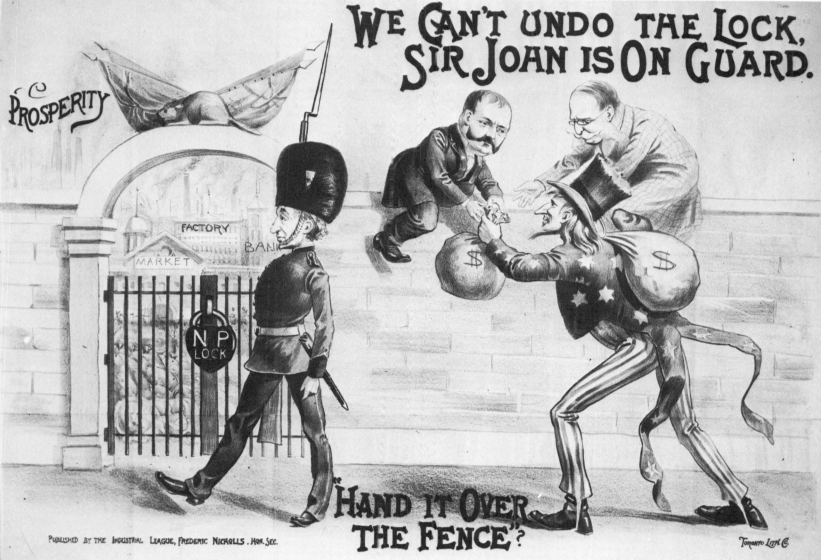

19

20

21

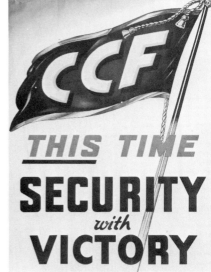

22

23

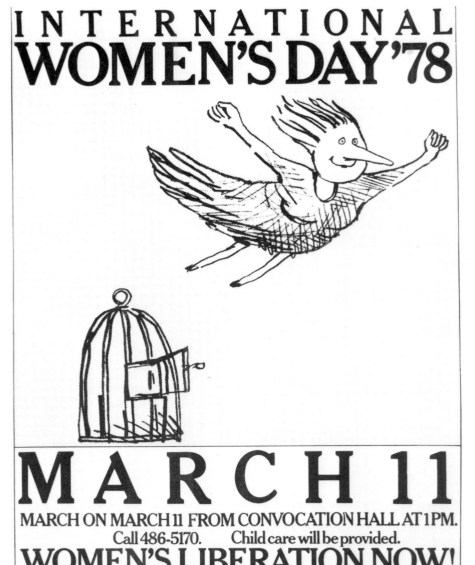

24

25

22. **Re-elect Fred Rose** 1945; **C/A:** Fred Rose/Canadian Labor-Progressive Party.

23. **CCF** 1945(?); **C/A:** Co-operative Commonwealth Federation.

24. **Take a Closer Look!** 1978; **Ph:** Toronto Historical Board; **C/A:** Prepared for the City of Toronto and the Ontario Heritage Foundation by the Toronto Historical Board.

25. **International Women's Day '78** 1978; **D/A:** Barbara Klunder (b. 1948); **C/A:** various.

26. **Visitez le Nouveau Québec** c. 1967–68; **D/A:** Vittorio Fiorucci; **AD:** Vittorio Fiorucci; **C/A:** Vittorio Fiorucci.

27. **A Colossal Monument!** 1971; **D/A:** Dennis Burton (b. 1933); **Production:** Allan Fleming; **C/A:** The Spadina Review Commission; **P:** Herzig-Somerville Ltd., Toronto.

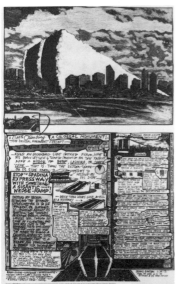

26

27

8/ Book and Periodical Posters

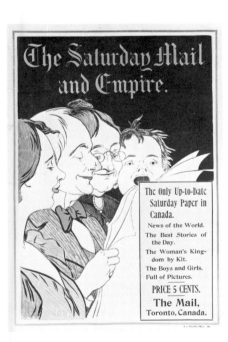

1. **Saturday Night** 1896;
C/A: *Toronto Saturday Night.*

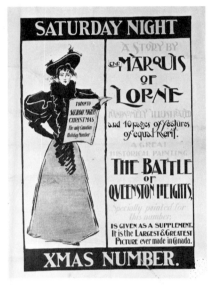

2. **The Saturday Mail and Empire**
1890s(?); **P:** H.I. Ireland, Phila-
delphia.

Posters advertising publications appear to be a minor aspect of the art form. Yet it was precisely this type of illustrated notice which revolutionized graphic arts in the United States in the 1890s, and introduced to this continent the simplified, stylized *art nouveau* draughtsmanship, lettering and colouring which had swept France, Belgium, Italy and England by the end of the 1880s.

In 1894 Will Carqueville became chief designer of *Lippincott's*, and Will Bradley was commissioned by *The Inland Printer* to design a permanent magazine cover; the editor was so pleased that Bradley was asked to create a new one each month. In all, he produced eighteen between 1894 and 1896. These covers were also used as posters to advertise the magazine. Their style was that peculiarly American combination of William Morris's neo-medieval arts and crafts ornamentation and the sensuous sinuosities of *art nouveau* as filtered through the pen of Aubrey Beardsley. Bradley's "The Twins," designed for *The Chap-Book* in 1894, is supposedly the first *art nouveau* poster to be printed in North America. Already Bradley's influence was potent and widespread and it seemed that every aspiring young designer of that era sought to emulate or imitate him. He, along with Penfield, Maxfield Parrish, and lesser luminaries such as Louis Rhead, Ethel Reed, Frank Hazenplug, J. J. Gould, Will Carqueville, Ernest Haskell, J. C. Leyendecker, John Sloan, Charles Woodbury, FLorence Lundborg and Robert Wildhack, may be said to have adapted for commercial purposes the earlier innovations of Jules Chéret, Henri de Toulouse-Lautrec, and Alphonse Mucha. Their work is characterized by a preference for pattern and decorative line, for flat colours and silhouettes, and for floral motifs and repeated curvilinear rhythms. The reprographic method was overwhelmingly that of lithography, although only in a few cases did artists actually draw on the stone themselves. More usually the finished artwork was transferred photo-mechanically to a prepared zinc or aluminium plate. By choosing this modern technique they succeeded in breaking the stranglehold on commercial illustration so long maintained by the German-trained chromo-lithographers. The new mode was a kind of graphic shorthand—fleet, free and easy, effortlessly elegant. Its popularity became evident to magazine and book publishers who found that newsagents' and booksellers' window-bills were being snatched up eagerly by customers.

The avidity of these collectors encouraged entrepreneurs in 1896 to launch two magazines devoted exclusively to the new art-form—*The Poster* and *Poster Lore*. Both were short-lived. Several periodicals offered their subscribers facsimile reproductions of over-runs of their latest placard or poster, somewhat in the manner of the Imprimerie Chaix's *Les Maitres de l'Affiche* issued in Paris between 1896 and 1900. It is difficult today to imagine the fanaticism with which poster-collectors went after new compositions by favoured artists. Simultaneously with the American periodicals and newspapers which began to issue special-edition covers and posters, Canadian newspapers such as the Toronto *Globe*, *The Mail and Empire*, and *Toronto*

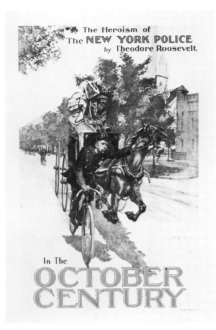

3. **October Century** 1897; **A:** Jay Hambidge (1867-1924); **C/A:** *The Century*; **P:** H.A. Thomas & Wylie Lith. Co., New York.

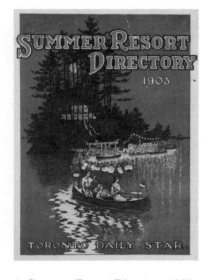

4. **Summer Resort Directory 1903** 1903; **D/A:** C.W. Jefferys (1869-1951); **C/A:** *Toronto Daily Star.*

5. **Crowfoot, Chief of the Blackfeet** 1972; **Ph:** Glenbow Alberta Institute, Calgary; **AD:** Mel Hurtig; **C/A:** Hurtig Publishers, Edmonton.

Saturday Night issued colour-lithographic covers and inserted prints for their weekend, Christmas and summer holiday numbers. Many of our best illustrators, such as William Cruikshank, G. A. Reid, C. M. Manly, J. D. Kelly, W. V. Alexander, F. H. Brigden and Robert Holmes, frequently contributed to these special editions. They were members of the Toronto Art Students' League, as were C. W. Jefferys and Norman Price, who, like so many of their contemporaries, were forced to seek employment in the United States because Toronto could not provide them with steady jobs or regular commercial art commissions.

C. W. Jefferys, following the lead of his artist-friends Duncan McKellar and William Bengough, arrived in New York in October 1892. The skill in pen draughtsmanship which he had acquired as an illustrator for the Toronto *Globe* and other Canadian newspapers immediately earned him a position on the prestigious *New York Herald*. Jefferys thus stepped from relative obscurity into the company of such masters of their medium as William Glackens, Wallace Morgan, and Jay Hambidge. For examples, see Chapter 12 p. 67.

The *Herald* published a heavily illustrated Sunday edition which was advertised by small placards displayed on newsstands and in tobacconists' windows. Jefferys' contributions are among the best and compare favourably with work done in the same period by Gleckens, Ernest Haskell, Claude Fayette Bragdon, Louis Rhead, and Frank Nankivell. One can detect the influence of Edward Penfield in Jefferys' use of relatively flat and unshaded patches of colour, and of Charles Dana Gibson in the postures and costumes of female figures. His technique, nevertheless, belongs to an earlier era of the poster. His compatriot and fellow staff-member on the *Herald*, Simcoe, Ontario-born Jay Hambidge, also produced periodical posters. He employed a highly finished realistic style which was reproduced by lithographic process on the covers and placards of *The Century* published in the late 1890s.

Jefferys returned to Canada in 1901, having failed to adjust to New York's viciously competitive commercial art climate. He set up his own design studio in Toronto and became art director of the *Toronto Star*, producing, among other things, posters for the 1903 and 1904 *Summer Resort Directories*.

Poster artist A. A. Martin was deeply interested in adapting to North American applications the elaborately decorative style of William Morris and his disciples in the arts and crafts movement. He had a chance to demonstrate his theories in a poster for the 1900 spring issue of *Canadian Architect and Builder*—a pleasing if not altogether successful attempt at relating lettering to images and ornamental borders.

As elsewhere in this study, there is a gaping hiatus between the known work of the 1890s and 1900s and that of our own period. If publishers of books and periodicals issued posters to advertise their wares in the interregnum, I have yet to locate examples worthy of reproduction. It seems that only recently the efficacy of this relatively cheap medium in spreading the word about publications is being realized. The poster by Edmonton publisher Mel Hurtig to advertise *Crowfoot, Chief of the Blackfeet* illustrates that a poster need not be expensively designed or especially colourful to make its point. Far more elaborate are the witty, if sometimes in-jokey, posters designed and printed by Toronto's Coach House Press; the sophistication indicates one of those bizarre ironies of the world of Canadian publishing: an underground press, heavily government-subsidized, can afford to produce publicity on a level denied all but the most successful commercial publishers.

6

7

6. **1903 Toronto Art League Calendar** 1902;
D/A: Norman Mills Price (1877-1951)
C/A: Toronto Art League; **P:** The Musson Book
Co. Ltd., Toronto.

7. **Summer Resort Directory...** 1904; **D/A:** C.W.
Jefferys (1869-1951); **C/A:** *Toronto Daily Star.*

8. **S. Thompson's Books!** 1827; **C/A:** William
Lyon Mackenzie; **P:** William Lyon Mackenzie,
York, Upper Canada.

9. **The Century for November** 1896; **A:** Jay
Hambidge; **C/A:** *The Century.*

9

10

10. **Mayfair Thirtieth Anniversary...**
1957; **D/A:** Allan Fleming; **AD:** Keith
Scott; **C/A:** *Mayfair*, Toronto;
P: Crombie Publishing Co.
Note: Poster-like cover designed of
typographic elements.

11. **Canadian Architect and
Builder...** 1900; **D/A:** A.A. Martin
(c. 1896-1954); **C/A:** *Canadian
Architect and Builder*, Toronto and
Montreal.

11

44

12

13

12. **Holy Smoke. . .** 1967(?); **A:** Wes Chapman; **D:** Jackie Young; **W:** Garry Topp; **AD:** Jackie Young; **S/A:** *The Twenty-Five Cent Review*; **C/A:** Benson and Hedges (Belvedere).

13. **Johnny Canuck Chained to Freedom** 1971; **C/A:** Peter Martin Associates, Toronto.

14. **To Celebrate Drawing** 1976; **A:** Ernest Lindner; **D:** Gene Aliman; **Ph:** Eberhart Otto; **C/A:** *artscanada*; **P:** Herzig-Somerville Ltd., Toronto.

15. **Rat Jelly** 1973; **AD:** Stan Bevington; **C/A:** Coach House Press, Toronto; **P:** Coach House Press.

16. **Vive le français!** 1976; **D/A:** Ann Vosburgh and Robert Vosburgh; **Ph:** Villy Svarre; **C/A:** Addison-Wesley Publishers; **P:** Herzig-Somerville Ltd., Toronto.

17. **1973 Cape Dorset Prints/Estampes** 1973; **P:** Art Inuit.

18. **The Cage** 1975; **A:** Martin Vaughn-James; **C/A:** Coach House Press, Toronto; **P:** Coach House Press.

19. **Sculpture in Canada** 1978; **A:** Michael Hayden; **Ph:** Shin Sugino; **C/A:** Toronto Transit Commission and *Artmagazine*; **P:** Herzig-Somerville Ltd., Toronto.

14

15

16

17

18

19

9/ Government Agencies, Institutions, Societies and Organizations

Posters designed to attract settlers from abroad were among the first to be published by the federal government. Ottawa did not get into the business of producing and using such material on a large scale again until the First World War. Few peacetime ministries appear to have regarded the poster to possess qualities suitable for their own needs, however effective the medium may have proved in periods of crisis. Postwar posters for government agencies were rarely on a par with the work done under the duress of wartime deadlines and paper shortages.

This situation continued well into the 1960s until Expo 67 gave strong impetus to government agencies and design firms alike to bring themselves up to world standards. International events such as Expo 67 naturally brought Canada to the attention of countries which previously had hardly been aware of her existence. After Expo, however, the bulk of publicity commissioned by provincial and federal government agencies smacked of compromise and timidity; mundane, safe, and unexceptional, it revealed the logic of bureaucrats who consistently awarded contracts to the same design agencies and advertising houses, which could be expected to come up with a reliable if uninspiring product.

Certain elements of the public service entertained more charitably than others the notion that good graphics may win points for departments and their ministers. Gradually, individual design units began to be added to the publicity bureaux of various ministeries and agencies, while a number of private companies learned the complicated dance-steps involved in wooing the behemoth of bureaucracy to the cause of modern-day advertising techniques. Posters have played a part in this revolution in taste and tactics, especially in departments with high public profiles, and in fields where large amounts of vital information must be conveyed clearly and decisively. One reason why the Swiss school of design dominates here is that its characteristic neatness and clarity are ideally suited to the task of telling much in a relatively small space. Designers for institutions such as parks or recreation areas, for example, are faced with the problem of how to position the set copy within the confines of a poster whose impact depends on visual rather than on verbal matter. A poor designer will merely reduce the type to the minutest legible face and strip it in at the extreme top or bottom of the poster. A good designer will try to integrate text and image in a way that causes each element to support and emphasize the other.

The National Museums of Canada, the Department of Indian and Northern Affairs, the National Capital Commission, the Department of Industry, Trade, and Commerce (which oversees the Canadian Office of Design and Design Canada) and the Department of External Affairs have been most prominent among federal users of pictorial publicity. A fair indication of what is possible under enlightened guidance is the graphics department of the Department of External Affairs' Exhibitions Branch, supervised by Frank Mayrs, himself a designer and painter of note. The work produced on a

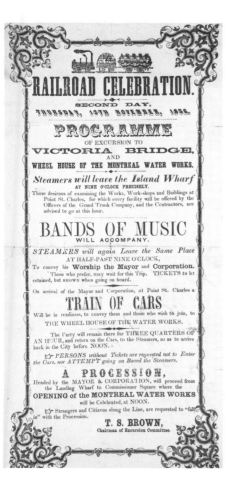

1. **Railroad Celebration** 1856; **C/A:** Mayor and Corporation of Montreal.

contractural basis by such designer-illustrators as Morris Danylewich and Neville Smith demonstrates this department's open-ended, open-minded approach.

As posters reproduced in this section indicate, many styles are at the designer's disposal for the promotion of nonprofit charitable organizations, societies, institutions and government departments. The choice ranges from the illustrative to the photographic, the severely Swiss-classical to the pop-influenced comical or romantic. It all depends on the sponsor, and the amount of freedom the artist and designer are permitted in their interpretation of the subject-matter. Some designers manage to thrive in both the commercial and the institutional realms. It requires special skills to be able to handle content supplied by a public office, skills that the average commercial designer with his traditional wariness of words and reliance on gimmicks and gloss rarely manages to develop.

Some institutions, especially colleges and schools with fine and applied arts departments, allow staff and students the opportunity to create posters to attract the attention of the public. These tend to be more esoteric and experimental than unsubsidized forms of advertising; nevertheless they provide good training which otherwise might not be available. Usually it is this type of poster commission that a "fine" artist will accept while he might refuse an invitation to do an ad for a business firm.

The federal government of Canada is today our third largest advertiser. Annually it spends about $9.5 million—or, roughly 40¢ per capita—to sell its image and services to the taxpayer, to big business and to the world. By disbanding Information Canada and closing bookstores which stocked quantities of the posters produced by federal agencies, the government has unfortunately deprived itself of one of its few truly national distribution points.

2. **Painting of the Northern Renaissance** 1975; **C/A:** School of Art, University of Manitoba, Winnipeg.

3. **Ecole d'Art du Musée des Beaux-arts de Montréal** 1968; **D:** Rolf Harder; **S/A:** Design Collaborative, Montreal; **C/A:** Musée des beaux-arts de Montréal.

4. **Toronto Centennial Celebration** 1934; **A:** Jules Laget; **C/A:** Corporation of the City of Toronto.

5. **Ontario Student Assistance Program** 1974; **D/A:** Tiit Telmet; **S/A:** Gottschalk and Ash Ltd., Toronto; **C/A:** OSAP, Ontario Ministry of Education.

6. **Bekanntmachung** 1885; **C/A:** Department of the Interior, Ottawa; **P:** Free Press, Winnipeg.

2

3

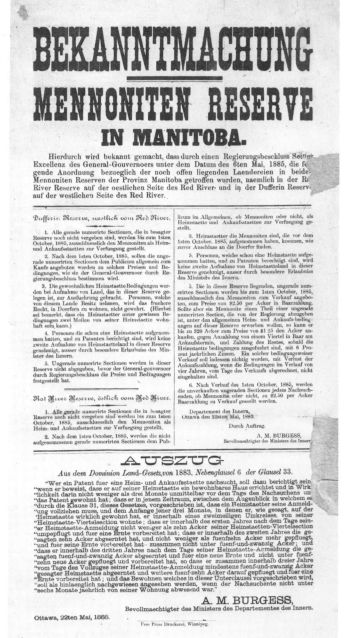

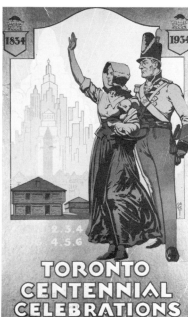

4

5

6

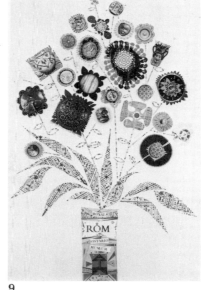

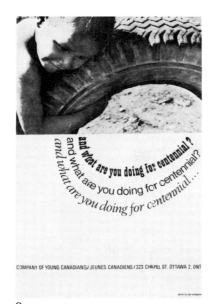

7 8 9 10

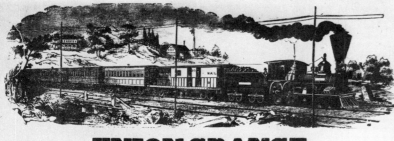

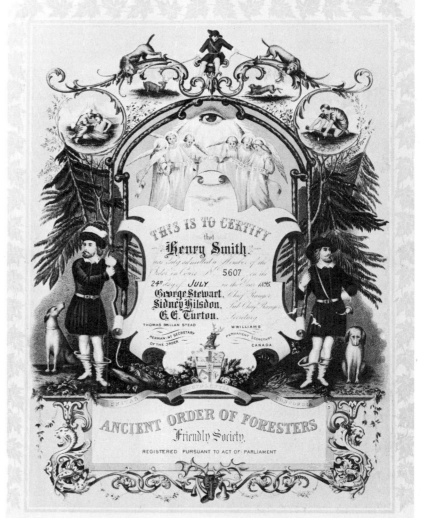

11

12

7. **Tastes So Good** 1978; **D:** Michael McLaughlin; **Ph:** Gillian Proctor; **S/A:** Ogilvy and Mather, Toronto; **C/A:** Ontario Milk Marketing Board.

8. **What Are You Doing For Centennial?** c. 1967; **Ph:** Tom Wakayama; **C/A:** Company of Young Canadians, Ottawa.

9. **ROM** early 1970s; **D/A:** Harold Town (b. 1924); **C/A:** Royal Ontario Museum, Toronto.

10. **Rochdale College** c. 1973(?); **D:** Rick/Simon; **C/A:** Rochdale College, Toronto; **P:** Coach House Press, Toronto.

11. **Union Grange Pic-Nic** 1878; **C/A:** North and South Simcoe and North York Division Granges, IOGT; **P:** Advance Print, Barrie.

12. **Ancient Order of Foresters** c. 1890s; **C/A:** Ancient Order of Foresters of Canada.

13. **Heritage Day** 1978; **D/A:** Frank Mayrs (b 1934); **C/A:** Heritage Canada, Ottawa.

14. **Workshops** 1974; **C/A:** Ontario College of Art, Toronto.

13 14

10/Art Exhibition Posters

If asked to define a poster, most people would probably describe an art-exhibition announcement rather than an advertising placard or a car-card which they might see every day of their lives. While managing a Toronto poster gallery, I found that the majority of our customers asked for exhibition posters, and preferred even a poor reproduction of a painting or a sculpture to a well-designed example of commercial advertising. A poster, it is commonly assumed, is only a work of art if it is associated with works of art; otherwise, it is merely propaganda or hype. Surprisingly, the art-exhibition poster created by artists is of relatively recent vintage, compared to other forms.

In the 1890s, it is true, Pierre Bonnard, Eugène Grasset and other members of the Salon Des Cent created posters to advertise their own exhibitions; the "artist's poster," however, is a phenomenon of the late twenties and thirties, and more so of the postwar period. Alan M. Fern writes that, "Shortly after 1945, perhaps in an attempt to call attention to the resumption of a normal cultural life, a few galleries in Paris called on their artists to provide posters. In collaboration with the lithographic studios of Mourlot and Lacourière, posters advertising exhibitions by Miro, Picasso, Matisse and Braque were issued, and these burst upon the art world with surprising results."[1]

One of the earliest Canadian art exhibition posters I have been able to locate is F. S. Challener's large colour lithograph announcing the 1896 Ontario Society of Artists' annual exhibition. In it we can detect traces of the *art nouveau* style which we know was becoming prevalent in most North American cities by the mid-nineties. Challener's chief influence would likely have been the French and Belgian *afficheurs* of the *fin de siècle*, especially Privat-Livemont, who belonged to the mystic Rose+Croix group. Privat-Livemont's style was described by Harold Hutchinson as embodying "decorative elaboration and fine draughtsmanship," qualities detectable in Challener's more modest and less stylized Lake Ontario bathing beauty. Challener introduced similarly idyllic elements into his many mural commissions, but preferred to evoke a classical golden age rather than the naughty ambience of Left Bank Paris.

If ever an artist could be said to have lived by, for and with art, it was J. E. H. MacDonald, who put all his genius for composition and feel for materials into "Canada and the Call," issued in 1914 by the Royal Canadian Academy in aid of the Patriotic Fund. Most of this poster's imagery may appear to be reminiscent of Soviet propaganda of a few years later; but the more immediate source might have been the English trade-union banners, which MacDonald could have encountered while working for Carlton Studios in London from 1903 to 1907. The bold, straightforward draughtsmanship, the vivid colours, and the somewhat simplistic symbolism are all derived from the recruitment and bond-drive posters of the early war years.

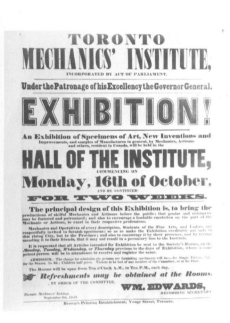

1. **Toronto Mechanics' Institute...** 1848; **C/A:** Toronto Mechanics' Institute; **P:** Brown's Printing Establishment, Toronto.

[1]Fern, Alan M. *Word and Image.* New York: Museum of Modern Art, 1968; p. 98.

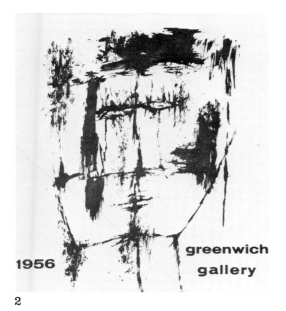

2 3 4

2. **Greenwich Gallery** 1956;
D/A: Graham Coughtry (b. 1931);
AD: Graham Coughtry;
C/A: Greenwich Gallery, Toronto.

3. **Leo Lionni's Graphics** c. 1960;
D: Allan Fleming; **AD:** Allan
Fleming; **C/A:** Cooper and Beatty,
Ltd., Toronto; **P:** Cooper and Beatty
Ltd.

4. **The Visual Craft of William
Golden. . .** c. 1962; **D/A:** Allan
Fleming; **S/A:** Cooper and Beatty
Ltd., Toronto; **P:** Cooper and Beatty
Ltd.

5. **Exposition d'art canadien** 1927
A: (?) Thoreau MacDonald (b. 1901);
C/A: National Gallery of Canada,
Ottawa/Musée du Jeu de Paume,
Paris.

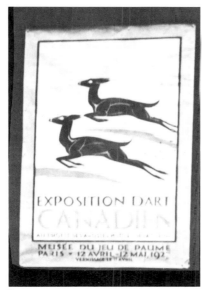

5 6 7

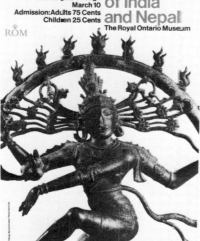

6. **Sixth Biennial Exhibition of
Canadian Painting. . .** 1965;
D: Gerhard Doerrié; **AD:** Paul
Arthur; **S/A:** Paul Arthur and
Associates; **C/A:** National Gallery
of Canada, Ottawa.

7. **Dallegret** 1966; **D/A:** Francois
Dallegret (b. 1937); **C/A:** Francois
Dallegret/Gallery Moos, Toronto.

8. **Canada Art d'Aujourd'hui** 1968;
A: Claude Tousignant (b. 1932);
C/A: Musée National d'Art
Moderne, Paris; **P:** Les Presses
Antiques, Paris.

9. **The Arts of India and Nepal** 1968;
D: Burton Kramer; **Ph:** Karol Ike;
S/A: Burton Kramer Associates,
Toronto; **C/A:** Royal Ontario
Museum, Toronto; **P:** Gregory-
Smith Offset Ltd.

10. **Exposition de rapports annuels**
1968; **D:** Guy Lalumière; **S/A:** Guy
Lalumière & Associés, Montréal;
C/A: La Papeterie Lauzier Ltée.

11. **Eye Exercise** 1969; **D/A:** Bernard
R.J. Michaleski (b. 1937);
S/A: MacDonald, Michaleski and
Associates, Winnipeg; **C/A:** Art
Directors Club of Winnipeg.

12. **Dick Painting Sculpture** 1969;
A: Dick [i.e. Gernot Dick?];
C/A: Mazelow Gallery, Toronto.

13. **'Ma ville secrète' de Jeremy
Taylor** c. 1966-67; **D/A:** Vittorio
Fiorucci; **AD:** Vittorio Fiorucci;
C/A: National Film Board of
Canada, Ottawa.

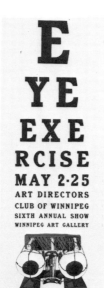

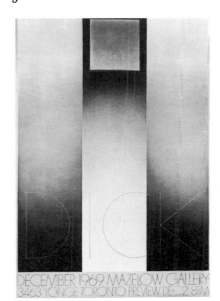

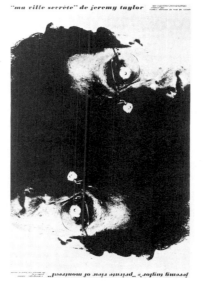

8 9 10

11 12 13

Art exhibition posters of that period are exceedingly rare; one must form conjectures as to their appearance based on British, American and French examples. For instance, the papers of Edmund Morris, Secretary of the Canadian Art Club (an association of painters and sculptors founded in 1913) include printers' bills for exhibition posters produced to announce their shows. Eric Brown, Director of the National Gallery of Canada, wrote from Paris during the course of the "Exposition d'Art Canadien" held at the Musée de Jeu du Paume in 1927, that, "The poster is so popular that people are coming to buy it and Thoreau MacDonald is quite famous here."[2] The poster in question may be the example representing a leaping deer which appears in an installation photograph of the Art Gallery of Toronto's exhibition of "British and Foreign" posters mounted in 1931.

Until after World War II, few private or public galleries had sufficient funds to produce elaborate exhibition posters, and extant examples are usually small placards devoid of illustration but giving names, dates and places. In other words, information, rather than enticement.

In the late 1950s Toronto art enthusiasts began to notice the invitations and mailers sent out by the Gallery of Contemporary Art. These small but elegant notices were the work of designer Allan Fleming, who was honoured by the gallery with his own one-man show in 1958. Fleming went on to produce excellent posters for graphic design exhibitions sponsored by Cooper and Beatty Ltd., which was his employer at the time. Most of the best exhibition posters reproduced in this section follow Fleming's own formula: to excite the viewer's curiosity by providing a tantalizing idea of what he will see, rather than just applying type to an enlarged photograph of a piece of art.

There are today a number of institutions which afford the poster artist an opportunity to experiment in this challenging and difficult discipline. The Art Gallery of Ontario's design department, headed by Scott Thornley, month after month produces posters for its exhibitions which arrest the eye and stimulate curiosity. The Royal Ontario Museum has also issued noteworthy posters which, like the AGO's, communicate directly with the transit rider or the suburban commuter.

What art historian Bradford Collins said of French exhibition posters of the 1960s and '70s is equally true of Canadian examples of the genre from the same period: "To the great masters of the tradition, a poster was not just a picture to which lettering was added: a poster was a marriage of image and text."[3]

14. Ontario College of Art Open House c. 1970s(?); **D/A:** Ernst Barenscher, Gabe Fallus; **C/A:** Ontario College of Art, Toronto.

15. Intergraphic 1972(?); **D/A:** Walter Jungkind (b. 1932), Ken Hughes; **C/A:** University of Alberta Students' Union Art Gallery, Edmonton.

16. Canadian Indian Art '74 1974; **A:** Ken Mowatt; **Ph:** Rudi Hass and Paul Balche; **C/A:** Royal Ontario Museum, Toronto.

17. The First Renaissance Dot-to-Dot Personality Poster-Puzzle... c. 1973; **D/A:** Trottier; **S/A:** Doodle Art (Frank and Glenn Anderson), Vancouver; **C/A:** The Canadian Theatre Centre/The Canadian National Commission for UNESCO.

[2]Quoted by F. Maud Brown in *Breaking Barriers: Eric Brown and the National Gallery*. Toronto: The Society for Art Publications, 1964; p. 80.
[3]Collins, Bradford. *Three Centuries of French Posters*. Ottawa: National Gallery of Canada *Journal*, No. 13, 1 May, 1976 [p. 8].

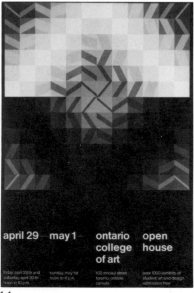

14

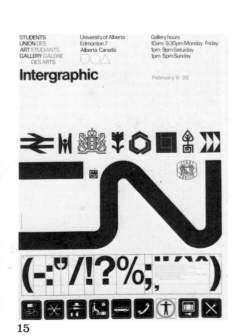

15

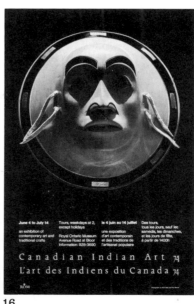

16

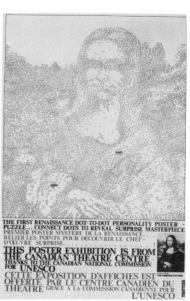

17

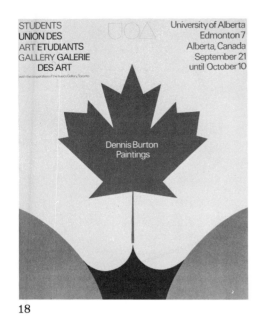

18

19

20

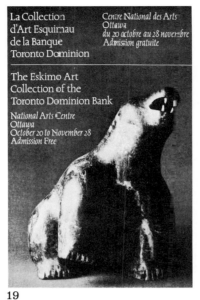

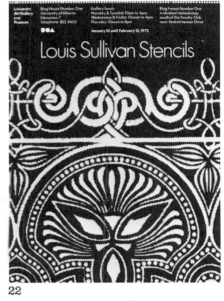

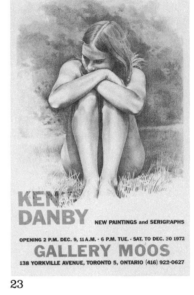

21

22

23

18. Dennis Burton Paintings
1970(?); **D/A:** Walter Jungkind
Ken Hughes; **C/A:** University
of Alberta Students' Union Art
Gallery, Edmonton.

**19. La Collection d'Art Esquimau
de la Banque Toronto Dominion**
c. 1972; **D:** Paul Berta; **W:** Paul Berta;
Ph: Gordon Meinecke; **AD:** Paul
Berta; **S/A:** TDF Artists Ltd.;
C/A: Toronto Dominion Bank.

20. Sevier 1970; **D:** Theo Dimson;
C/A: Gerald Sevier (b. 1934)/The
Merton Gallery, Toronto.

21. Illustrators 13 1971; **D/A:** Doug
Johnson (b. 1940); **C/A:** Society of
Illustrators, New York. **Note:** Orig-
inal artwork (gouache 38 x 27″) for
Society of Illustrators annual
exhibition poster.

22. Louis Sullivan Stencils 1972;
D: Ken Hughes, Walter Jungkind;
C/A: University of Alberta Art
Gallery and Museum, Edmonton.

**23. Ken Danby New Paintings and
Serigraphs** 1972; **A:** Ken Danby (b.
1940); **C/A:** Ken Danby/Gallery
Moos, Toronto.

24. First Nation c. 1972–73;
D: Matti Personen; **AD:** Matti
Personen; **S/A:** Graafiko, Toronto;
C/A: First Nation, Toronto.

25. Management of Design c. 1973;
D: Burton Kramer; **Ph:** Jim Shaw;
AD: Burton Kramer; **S/A:** Burton
Kramer Associates, Toronto.

26. Language Made Visible 1973;
D: Ken Hughes; **C/A:** Centennial
Library, Edmonton/Dept. of Art
and Design, University of Alberta,
Edmonton.

27. Opening Doors 1974; **D:** Peter
Bartl (b. 1940); **C/A:** Department of
Art and Design, University of
Alberta, Edmonton.

28. The Structure of Comics 1973;
A: Tim Rhodes; **D:** Ted Poulos;
AD: Philip Fry; **C/A:** The Winnipeg
Art Gallery.

29. Man Versus Module 1970;
D: Robert Burns (b. 1942); Paul
Sedman; **C:** Robert Burns, Gerald
Robinson; **AD:** Robert Burns;
S/A: Burns and Cooper Ltd.,
Toronto; **C/A:** York University,
Toronto. **Note:** Poster for a partici-
patory exhibition by Robert Burns
and Gerald Robinson.

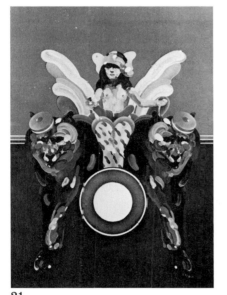

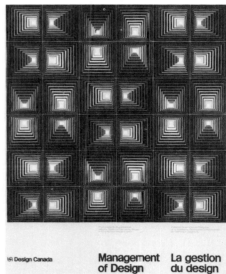

24

25

26

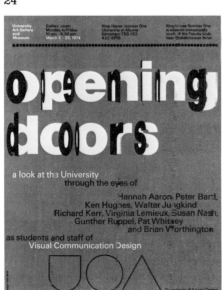

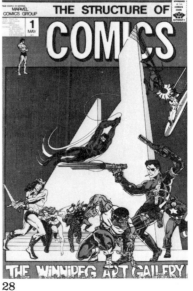

27

28

29

30. **Arnold Rockman's Shrines and Offerings** 1975; **D:** Scott Thornley (b. 1943); **C/A:** Art Gallery of Ontario, Toronto.

31. **San Murata-Posterity** 1978; **D/A:** San Murata; **C/A:** Posterity, Toronto.

32. **17th Toronto Outdoor Art Exhibition** 1978; **D:** Burns, Cooper, Hynes, Ltd., Toronto; **Ph:** David Allen; **S/A:** Burns, Cooper, Hynes Ltd.; **C/A:** Toronto Outdoor Art Exhibition; **P:** Herzig-Somerville Ltd.

33. **What Can Your Federal Government Do For You** 1976; **A:** Les Levine (b. 1936); **C/A:** M.L. D'Arc Gallery, New York.

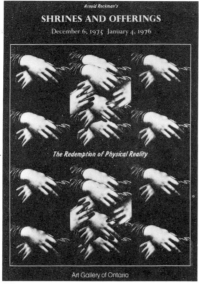

30

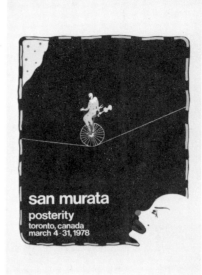

31

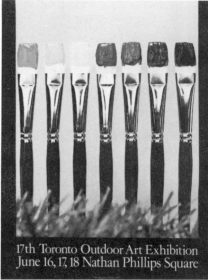

32

33

34

35

36

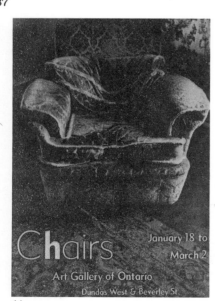

37

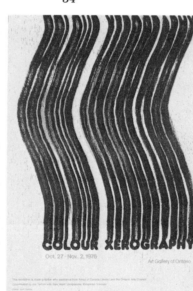

38

39

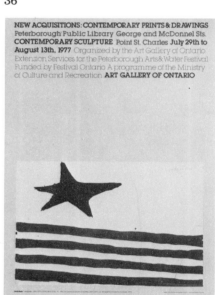

40

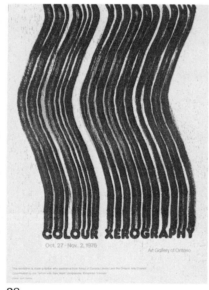

41

34. **Canadian Painting in the Thirties** 1976; **A:** Paraskeva Clark (b. 1898); **C/A:** National Gallery of Canada, Ottawa.

35. **Acrylic on Canvas** 1977; **D:** David Kilvert; **Ph:** Douglas Clark; **C/A:** Edmonton Art Gallery; **P:** Speedfast Colour Press Ltd., Edmonton.

36. **Design To Be Used** 1975; **D:** Arcand & Baupré Ltée. (Jean Arcand, Georges Beaupré); **C/A:** Design Canada, Dept. of Industry, Trade and Commerce, Ottawa.

37. **Zoo-oo-oo** 1976; **A:** R. D. Symons; **D:** Jerry Wiese; **C/A:** The Edmonton Art Gallery; **P:** Douglas Printing Co. Ltd., Edmonton.

38. **Colour Xerography** 1976; **D/A:** Scott Thornley; **C/A:** Extension Services, Art Gallery of Ontario.

39. **Osaka University of Arts** and **The University of Alberta** 1977; **D/A:** Walter Jule (b. 1940); **C/A:** Dept. of Art and Design, University of Alberta, Edmonton.

40. **New Acquisitions; Contemporary Prints and Drawings** 1977; **D:** Scott Thornley; **A:** Jack Bush (1909-1977); **C/A:** Art Gallery of Ontario Extension Services for Festival Ontario, Ministry of Culture and Recreation.

41. **Chairs** 1975; **Ph:** Miklos Legrady; **AD:** Alvin Balkind; **C/A:** Art Gallery of Ontario, Toronto.

42. **Salon des Cent. Exposition de l'oeuvre photographique de Mdme B. Rockett** 1976; **D/A:** Willi Mitschka (b. 1942); **AD:** Willi Mitschka; **C/A:** Beverley Rockett. **Note:** Original artwork for unpublished poster in the style of Alphonse Mucha.

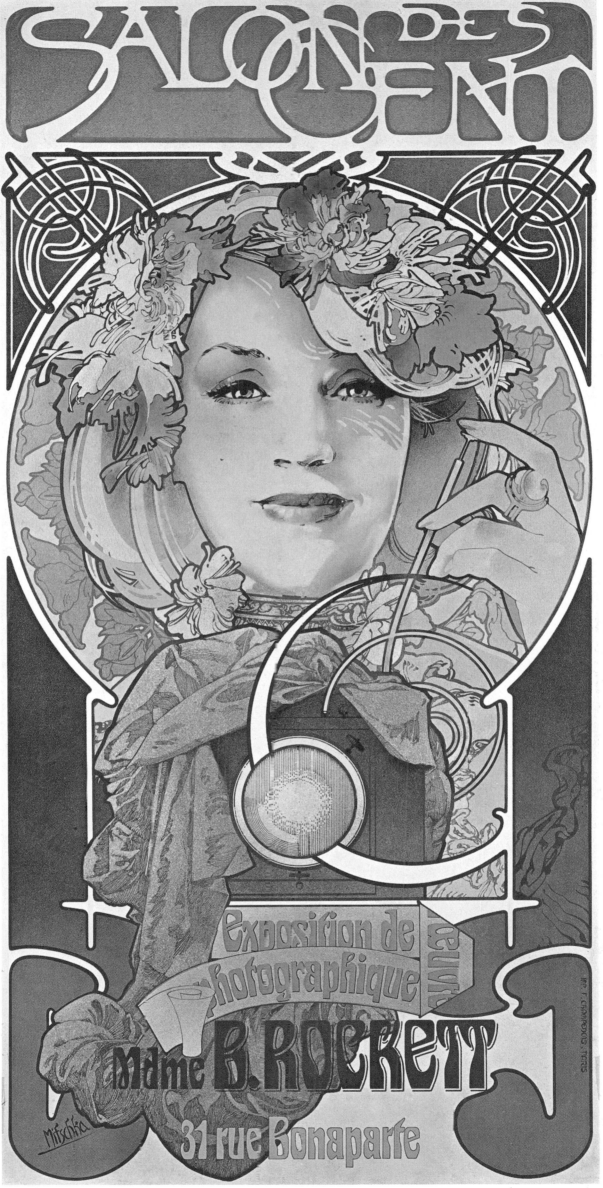

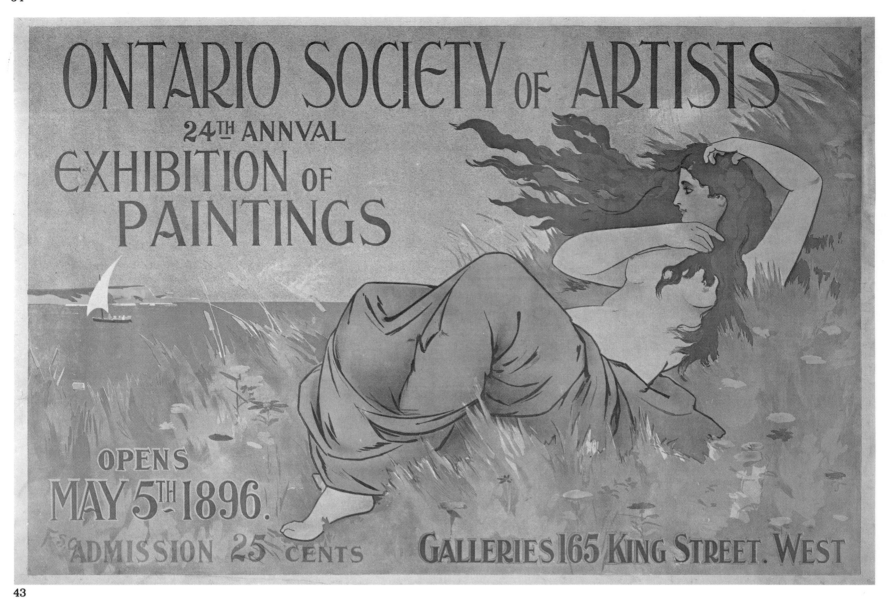

43

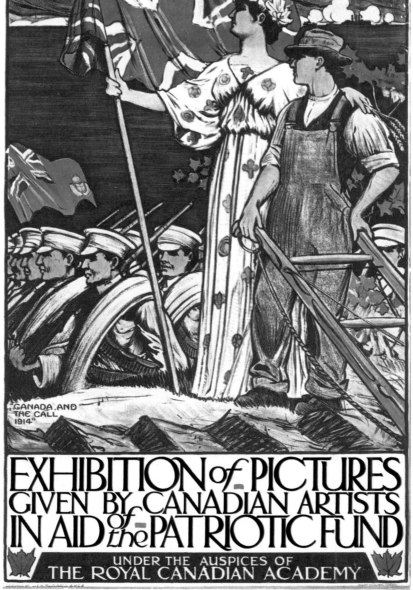

44

43. **Ontario Society of Artists 24th Annual Exhibition of Paintings** 1896; **A:** Frederick Sproston Challener (1869-1959); **C/A:** Ontario Society of Artists, Toronto; **M:** colour lithograph.

44. **Exhibition of Pictures Given by Canadian Artists in Aid of the Patriotic Fund (Canada and the Call)** 1914; **D/A:** J.E.H. MacDonald; **C/A:** Royal Canadian Academy; **P:** Rolph and Clark, Toronto; **M:** colour lithograph. **Note:** The original artwork of this poster (signed 'Bala') is in the Ontario College of Art Archives, Toronto.

45

46

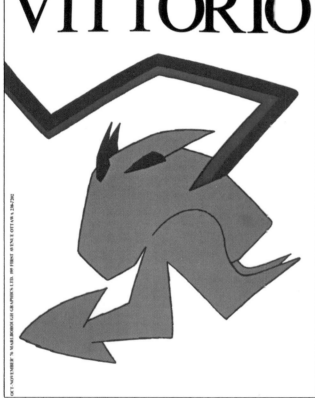

47

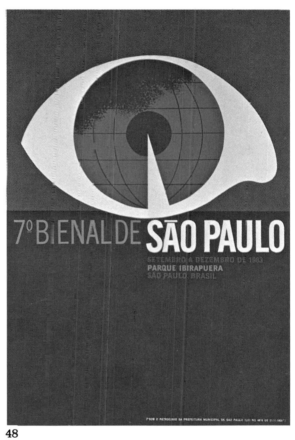

48

49

50

45-47. **Canaletto** 1965; **Confrontation '65** 1965; **Vittorio** 1976; **D/A:** Vittorio Fiorucci; **C/A:** Montreal Museum of Fine Art; Exposition Internationale de Sculpture, Montreal; Vittorio Fiorucci/Marlborough Graphics, Ottawa; **M:** silkscreen.

48. **7° Bienale de São Paulo** 1963; **D/A:** Allan Harrison (b. 1911); **C/A:** Prefetura Municipal de São Paulo, Brasil. **Note:** An unpublished Bienale de São Paulo poster contest submission by the Montreal-born artist then in charge of the Rio de Janeiro office of the J. Walter Thompson Company.

49-50 **Exposition Internationale d'Art Pornographique** late 1960s; **Peter Gnass** 1976; **D/A:** Vittorio Fiorucci; **C/A:** Vittorio Fiorucci; Peter Gnass/Galerie Gilles Corbeil, Montreal; **M:** silkscreen.

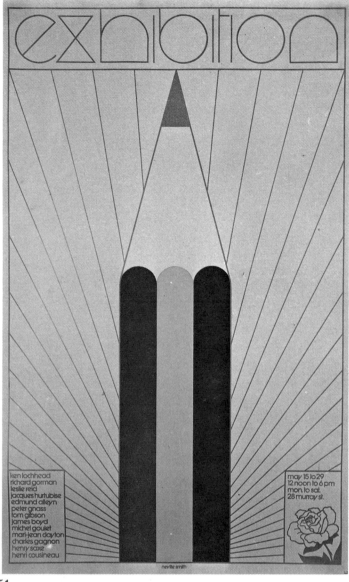

51

Exhibition of Graphic Design by Rolf Harder and Ernst Roch Design Collaborative

52

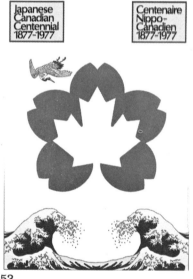

53

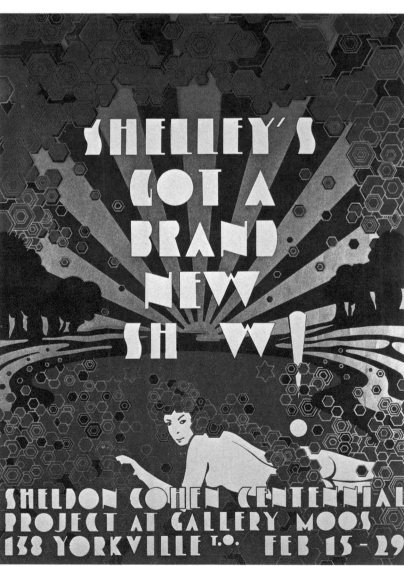

51. **Exhibition** 1977; **D/A:** Neville Smith; **AD:** Neville Smith; **Director:** James Boyd; **Producers:** Neville Smith and Peter Lamb; **C/A:** SAW Gallery, Ottawa, and the Canada Council for the Arts; **P:** Raw Ink Inc.

52. **Exhibition of Graphic Design by Rolf Harder and Ernst Roch Design Collaborative** 1977; **D/A:** Ernst Roch; **S/A:** Design Collaborative, Montréal; **C/A:** Design Canada, Department of Industry, Trade and Commerce, the National Design Council, Ottawa, and Design Collaborative.

53. **Japanese Canadian Centennial 1877–1977** 1977; **D/A:** Norman Takeuchi (b. 1937); **Symbol:** Art Irizawa; **AD:** Norman Takeuchi; **C/A:** Japanese Canadian Centennial Society, Ottawa; **M:** silkscreen.

54. **Shelly's Got a Brand New Show!** 1967; **D/A:** Clive Smith; **C/A:** Sheldon Cohen/Gallery Moos, Toronto; **M:** silkscreen. **Note:** Published as a full-sized poster and as a folding invitation.

54

11/ *Entertainment and Cultural Events*

By the end of the nineteenth century the theatre bill ceased to be a typographic broadside and had joined the ranks of the modern poster. Unfortunately, Canadian theatre posters from the early part of the twentieth century are difficult to locate; indeed, examples of those published between 1900 and 1950 are exceedingly rare. Either few posters were produced, or collectors, public archives, or the theatres themselves did not deem the majority worthy of preservation. As few of our cultural institutions bothered to keep records of their productions, it is difficult to determine where Canada stood in relation to her neighbours insofar as entertainment posters were concerned. Even so rich a resource as the Metropolitan Toronto Library's Theatre Collection is poorly endowed when it comes to posters of the first half of this century.

One of the earliest sets of pictorial theatre posters that I have been able to examine—and even then only at second hand through their reproduction in a theatre program—was commissioned to promote an Arts and Letters Club's production of Thomas Hardy's *The Dynasts*, a play performed in February 1916 at Toronto's Royal Alexandra Theatre. Colour lithographic posters had been contributed by three members of the Graphic Arts Club: J. E. Sampson, T. W. Mitchell, and C. W. Jefferys. (The program cover and title page were designed by Frederick H. Varley, one of the cast members.)

Many Canadian theatrical, operatic, and dance companies are underfinanced and their restricted budgets obviously do not allow for much in the way of promotion. The startlingly effective theatre posters by Jack Shadbolt should therefore come as a surprise even to those who are admirers of the artist's quasi-figurative, quasi-abstract expressionist paintings. He credits his diversified training for the design skills he brings to all his work. He related to me in the following letter that an invitation in 1966 to produce a series of posters for the Vancouver Playhouse struck him as sufficient challenge to branch out in a new direction:

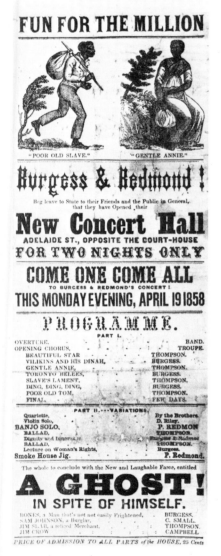

1. **Burgess & Redmond!** 1858; **C/A:** Burgess and Redmond. **Note:** Cool Burgess was an internationally famous blackface comedian and ministrel born in Toronto in 1840. The cuts are from American stereotype illustrations used on handbills offering rewards for the return of runaway slaves.

In the first season a selection of B.C. artists was asked to do one poster for a series of, I think, six. I did one for Shaw's *Candida*. For the next two seasons starting October '66 I was asked to do the whole series. The number of different impacts from diverse designers had proved to be not too effective, so I decided to keep a reasonably recognizable continuity of bold colour areas, of a human figure featured in each case and a good scale—36" × 24"—suitable for hanging in student rooms, rumpus rooms, etc., as well as competing in outdoor situations or university billboard scrambles.

I found the theatre posters tricky things to do and I wasn't always satisfied with the result. Economy was so tight that I had no chance for re-trial of a colour or adding changes or additional colours—nor any chance for afterthoughts because of deadlines.

At first I would design in paint, but later for speed, accuracy of calculating the finished effect and for specific instruction to the silk-screener about colour and quality of edges, etc., I designed with cut-out

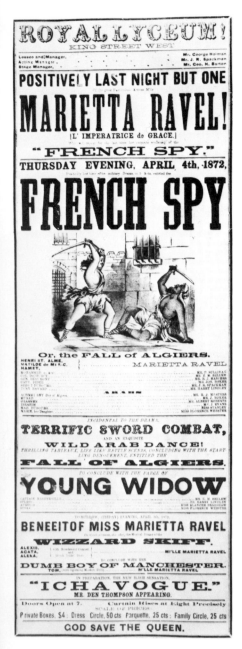

2. **French Spy** 1872; **P:** The *Leader* Steam Printing House, Toronto.

3. **The Dynasts** 1916; **D/A:** Thomas W. Mitchell (1879-1958); **S/A:** The Graphic Arts Club, Toronto; **C/A:** The Historical Production Co. Ltd., London, England/The Arts and Letters Club, Toronto; **P:** Rolph, Clark & Co., and Stone Ltd., **M:** colour lithograph.

papers. It is one thing to paint in and achieve an area of red—it is quite another to cut out an *area from* red substance. One *thinks* redness—one does not speculate about it. The more direct the process the better.

The psychological problem was what slowed down the process. I would read the actual play, consider carefully its over-all impact and then try to convey with the totality of my design something of that precise import. It's easy to make an elegant decoration, but quite another thing to evoke exact implication.

Finally the engagement was terminated for lack of funds as being not the best yielding use of advertising money. When it was started it was more an act of faith in the prestige of creating an art image in the public community eye. I think the Winnipeg theatre has been the first to use such posters seriously.

Shadbolt is referring to the posters designed for the Manitoba Theatre Centre by Bernard R. J. Michaleski, a diversely talented, wittily inventive specialist in a medium which too many of his contemporaries treat with timidity or lack of originality. The MTC's poster program puts to shame the pictorial advertising of most other Canadian theatre and opera companies. The problem, as Vittorio Fiorucci explained to me, is that the boards of such institutions deem themselves sufficiently knowledgeable to make decisions about the appearance and content of posters. Vittorio's approach is the opposite of Jack Shadbolt's, although graphically their work is similar as they both rely on flat shapes, bright primary colours, forceful draftsmanship and silkscreen reproduction. For Vittorio, "the poster ought, above all, to convey a message. If I satirize a local situation, I take a position. For me the poster is a manifesto."[1]

Theo Dimson is another important Canadian theatre posterist. His instantly recognizable style, communicated through the agency of illustrators such as Barbara Klunder and, since 1975, Ken Jackson, has graced the posters of Toronto Workshop Productions since the late sixties. Dimson is an omnivorous borrower of past styles and fashions, and his emphatically simple yet elegant posters recreate the *art déco* twenties and thirties in a contemporary idiom.

It is instructive to contrast any of Dimson's TWP posters with Heather Cooper's popular poster for the 1976 Canadian Opera Company season. If Dimson occasionally tends toward hardness by insisting on crisp outlines and two-dimensionality, Cooper's illustrations can be faulted for over-elaboration of detail. She is not so much a poster artist as an illustrator, who relies on the collaboration of designers and typographers to complement her lushly romantic paintings. What is most lacking in her work is wit, which, on the other hand, is the energizing principle of Dimson's posters; many of them consist of cleverly arranged collages of old engravings and modern letraset typefaces.

One young artist who is determined to make his mark in the theatrical poster field is Ottawa's Paul Gilbert. Since 1976 he has been designing for the Penguin Performance Company and his philosophy of restraint and making-do is shared by many of his contemporaries. Their position in the design world is roughly equivalent to that of underground theatres versus large and well-established companies.

Stefan Czernecki, a Canadian artist born in Germany, discovered early in his career the advantages of devising recognizable themes—his own favourite being bird-imagery—which he has employed in delightfully bizarre posters for the Alberta Ballet Company. Czernecki has undergone an extraordinary range of professional experiences; their effect is registered in the assured, vibrant, and arrestingly original style of his posters.

In 1966 the Neptune Theatre in Halifax, N.S. hired Barry Zaid, the now-famous alumnus of Push Pin Studios, to produce a unified thematic series of posters. Their success proves that full-colour reproduction is not always a requisite for effectiveness. Similar claims could be made for the handsomely simple posters designed in the 1960s for Le Théatre du Nouveau Monde by Gilles Robert.

[1]Quoted in "Vittorio oeuvre un paradis aux amateurs d'affiche," in *La Patrie*, 17 Nov. 1968.

4. **Black Comedy** 1969; **D/A:** Jack Shadbolt (b. 1909); **C/A:** Vancouver Playhouse; **M:** silkscreen.

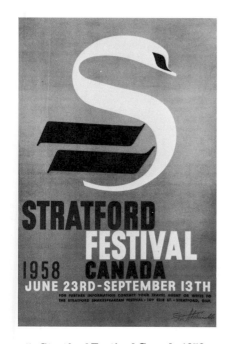

5. **Stratford Festival Canada** 1958; **D/A:** Eric Aldwinkle; **C/A:** The Stratford Shakespearean Festival, Stratford, Ontario.

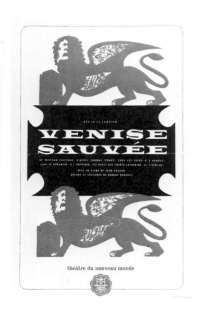

6. **Venise sauvée** c. 1959; **D/A:** Gilles Robert; **C/A:** Théâtre du Nouveau Monde, Montreal; **P:** Thérien Frères, Montreal.

A measure of vitality is detectable in the field of concert posters for underground groups, the majority of which reflect the straightened circumstances of the present. Inexpensive offset and xerographic reproduction have pushed silkscreen printing to the sidelines. Regrettably, this has deprived our streets of a radiance which blossomed briefly during the psychedelic sixties and early seventies, when Vancouver, Toronto and Montreal were the main centres of psychedelia, such as it was in Canada. In Toronto, leaders of that poster movement were John Parsons, David Chestnutt, Alex Macleod, Bruce Meek, Arnaud Maggs, Donna Brown, Harold Klunder and Brian Spence. In Vancouver, Bob Masse—who spent a season in San Francisco doing posters for the Avalon Ballroom during its heyday—acted as a prime instigator there.

At present the cultural poster in Canada vascillates in a limbo-like state of arrested development. The performing arts groups and institutions who can afford posters regard them as unimportant and often have a low opinion of the artists and designers who specialize in the medium. On the other hand, those forward-looking bodies who appreciate posters are deprived of the means to commission the kind of talent whose services could give posters a major boost towards public acceptance and financial security. Those who take them for granted may be surprised to learn of the difficulties some people responsible for advertising theatrical troupes, concert organizations, chamber and symphony orchestras, and operatic and dance companies face. They may not realize the amount of acrimonious controversy caused by an out-of-the ordinary poster if it happens to displease the more conservative members of audiences or administrations.

A Note on Film and Film Festival Posters

What one acerbic reviewer recently dismissed as "the respected tradition of naturalistic, manic-depressive Canadian cinema" could hardly be expected to contribute to the development of an exuberant, vital school of home-grown movie-poster art. Despite the establishment in recent years of a government-subsidized commercial film industry, the really important decisions are still made in the boardrooms and cutting-rooms of Hollywood, New York and London. As our own fledgling movie poster production houses and distributors are as yet without adequate promotional facilities, contacts or expertise, Canadian movie producers generally employ one of the big Hollywood poster-printers who have handled the film industry's pictorial promotion for decades.

Today's movie posters and ads are noticeably superior to those of the forties, fifties and early sixties (by which time the influence of first-rate graphic designers, animators, and title-artists such as Saul Bass was beginning to be felt). The "schmeer" tradition lingers on, however, in posters for horror pictures, porno flicks, and drive-in "B" features, and also in those for foreign language movies generally shown at "ethnic" theatres.

If the National Film Board is today actively involved in publishing posters to promote its documentaries, shorts and features, the public has had as few chances to examine these announcements as it has had to view the Board's productions. Similarly, since the middle-sixties several of our Canadian designers have created excellent posters to advertise film festivals, but rarely are examples of this specialized medium widely posted or offered for sale to enthusiasts. One of the most reputable of this small fraternity of designers is the ubiquitous Vittorio Fiorucci, whose shadowy portrait of actress Joanne Harrell caught the spirit of Claude Jutra's first full-length features, À *Tout Prendre*, in 1963. This poster inspired a minor revolution in Quebec poster art. Indeed, so many Quebec designers rushed to explore the possibilities of high-contrast photography that the style quickly became a cliché. Vittorio's Montreal International Film Festival posters won him several prizes and became instant collectors' items during the heady mid-sixties.

A few other examples are worthy of note: in 1968 the art department of Film Canada produced ten posters for Toronto's now defunct Cinecity Theatre. Most of the artwork was the responsibility of Roger Hunt who collaborated with screen printer Mike Rosenbaum. Each poster was printed in an edition of 250 copies, one hundred of which were used for display, while the remainder was offered for sale at $1.00 each. In 1973 the Revue Cinema of Toronto commissioned Theo Dimson to design a poster for a Marlene Dietrich Festival. One for a subsequent Marilyn Monroe Festival was not printed, but Dimson derived so much pleasure from the assignment that he went ahead anyway and published it, as well as an occasionless poster tribute to Fred Astaire. All three won gold medals at Toronto's Art Directors' Club 1972–3 annnual exhibition.

A first-rate film can die for lack of promotion; first-rate promotion cannot always save a bad film, but in some instances a brilliant poster can stir up curiosity about a film which otherwise may have been neglected by the critics and overlooked by the P.R. people. It is not merely a coincidence that some of the most popular and successful films in recent years were advertised by punchy, eye-catching, and even seductive posters.

7. **The Dynasts** 1916; **D/A:** J.E. Sampson; **S/A:** The Graphic Arts Club; **C/A:** The Historical Production Co. Ltd./The Arts and Letters Club; **P:** Rolph, Clark & Co., and Stone Ltd.; **M:** colour lithograph.

8. **Stratford Festival Canada** 1966; **A:** Desmond Heeley (b. 1931); **C/A:** The Stratford Shakespearean Festival.

9. **Eliza's Horoscope** 1976; **A:** Louis De Niverville (b. 1933); **C/A:** O-Zali Films Inc., Montreal; **M:** colour lithograph.

10. **Arsenic and Old Lace** 1966; **A:** Barry Zaid; **C/A:** Neptune Theatre, Halifax.

11. **Prestige de Paris** 1967; **D/A:** Ted Larson (b. 1939); **AD:** Ted Larson; **S/A:** Penthouse Studio, Montreal; **C/A:** La Compagnie de l'Exposition de 1967, Montréal; **P:** General Advertising, Montreal; **M:** silkscreen.

12-13 **The Firebugs** 1968; **The Ecstasy of Rita Joe** 1969; **D/A:** Jack Shadbolt; **C/A:** Vancouver Playhouse; **M:** silkscreen.

14. **The 1968 Stratford Festival** 1968; **D/A:** Carlos Marchiori (b. 1937); **C/A:** The Stratford Shakespearean Festival, Stratford; **P:** Commercial Print-Craft, Woodstock; **M:** colour lithograph.

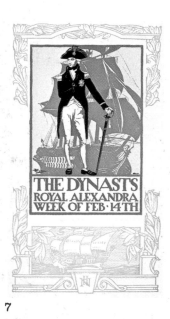

7

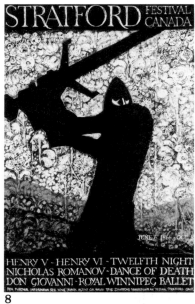

8

9

10

11

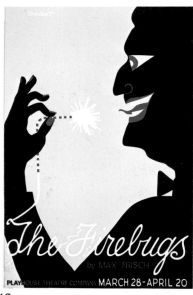

12

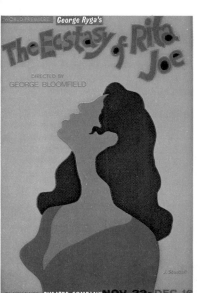

13

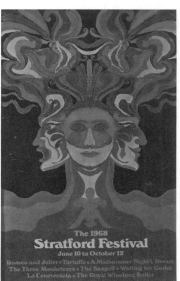

14

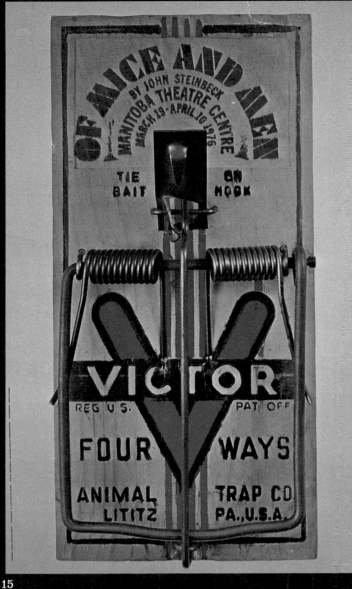

15

16

17

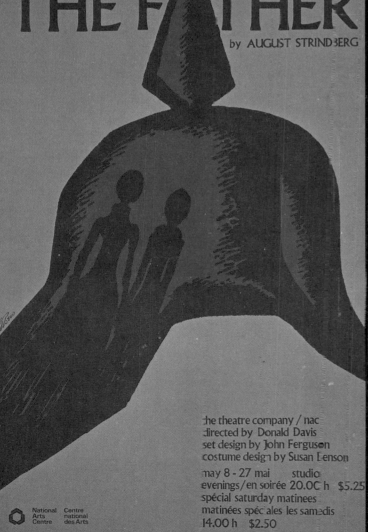

19

20

15-17. **Of Mice and Men** 1976; **Cyrano de Bergerac**
1975; **War and Peace** 1971; **D/A**: Bernard R.J.
Michaleski; **S/A**: Bernard R.J. Michaleski Graphic
Communications, Winnipeg; **C/A**: Manitoba Theatre
Centre, Winnipeg; **P**: Hignell Printing Co., Winnipeg;
T: Type Service Limited; **M**: colour lithography and
silkscreen.

18-20. **The Father** 1978; **A Soir on Fait Peur au Monde**
1963; **Le Chemin du Roi** 1971; **D/A**: Vittorio Fiorucci;
C/A: The Theatre Co., National Arts Centre, Ottawa;
L'Egregore au Gésu; **M**: silkscreen.

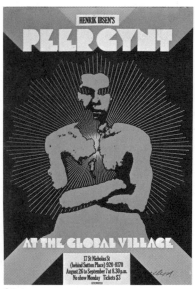

21

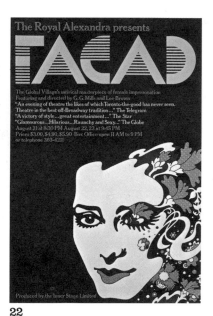

22

23

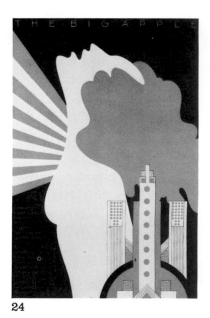

24

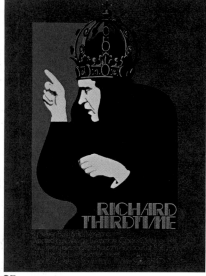

25

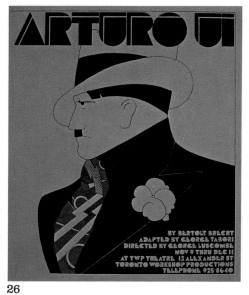

26

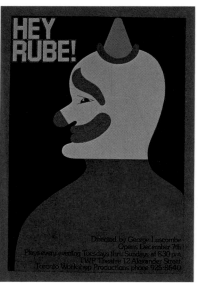

27

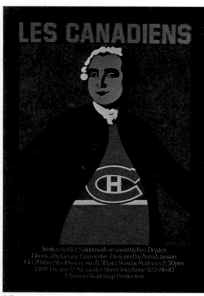

28

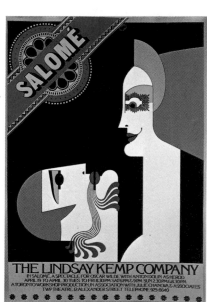

29

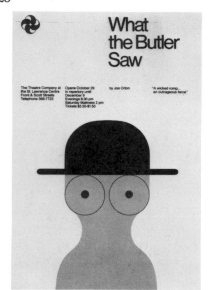

30

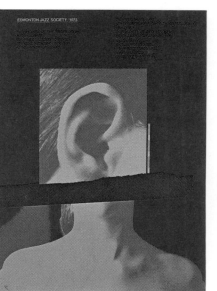

31

21-24. **Peer Gynt** 1969; **Facad** 1969; **Blue S.A.** 1969; **The Big Apple**; **D/A:** Alex Macleod; **C/A:** The Global Village Theatre, Toronto (21, 22, 23, 24); The Inner Stage Ltd. and The Royal Alexandra Theatre (22); The Modern Dance Theatre of Canada (23); **M:** silkscreen.

25-29. **Richard Third Time** 1973; **Arturo Ui** 1971; **Hey Rube** 1973; **Les Canadiens** 1973; **Salomé** 1978; **A:** Ken Jackson (25, 28, 29); Barbara Klunder (36); **D:** Theo Dimson; **S/A:** Reeson, Dimson and Smith (25, 26, 27); Dimson and Smith (28, 29); **C/A:** Toronto Workshop Productions; **P:** Robert Middleton; **M:** Silkscreen.

30. **What the Butler Saw** 1971; **D:** Stuart Ash (b. 1942); **S/A:** Gottschalk and Ash Ltd., Toronto; **C/A:** Toronto Arts Productions.

31. **Edmonton Jazz Society/1973** 1975; **D/A:** Walter Jule; **C/A:** Edmonton Jazz Society; **M:** silkscreen.

Opposite

32. **Festival of Festivals** 1976; **D/A:** Dawn Cooper Tennant (b. 1953); **AD:** Robert Burns; **S/A:** Burns, Cooper, Donoahue, Fleming & Co., Toronto; **P:** Holland and Neil Ltd., Toronto; **M:** silkscreen.

Overleaf

33. **Canadian Opera 1977** 1977; **D/A:** Heather Cooper (b. 1945); **AD:** Heather Cooper; **S/A:** Burns, Cooper, Hynes Ltd., Toronto; **C/A:** Canadian Opera Company, Toronto; **P:** Herzig-Somerville; **M:** colour lithograph.

34. **Gulliver** 1978; **D/A:** Yvan Adam (b. 1955); **C/A:** Le Théatre national pour enfants: Les Pissenlits; **M:** colour lithograph.

35-36. **Nutcracker** 1977; **Royal Winnipeg Ballet; D/A:** Stefan Czernecki (b. 1946); **C/A:** Royal Winnipeg Ballet; **M:** silkscreen.

FESTIVAL OF FESTIVALS
THE FIRST ANNUAL TORONTO WORLD FILM FESTIVAL
OCTOBER 18TH-24TH 1976

33

34

35

36

12/ *Product and Service Advertising Posters*

1. Glorious News! c. 1870s(?);
C/A: William Hood & Son,
Hoodstown, Ontario; **P:** F.T. Graffe
& Co., Bracebridge, Ontario.

2. Daisy Mills White Daisy Flour
c. 1870s(?); **C/A:** The Caledonia
Milling Co. Ltd., Caledonia, Ontario.

E. McKnight Kauffer, one of the most influential poster artists of the 1920s, '30s and '40s, argued early in his career that "the poster, commercially considered, is an advertisement of a distinct and peculiarly individual type, but is subject to the same principles which govern good advertisements. That is, it must: 1. Attract attention. 2. Arouse interest. 3. Stimulate desire. 4. Lead to buying."[1]

In McLuhanesque terms, certain posters are essentially selling themselves: by their "posterness" first of all, and secondly by their physical qualities and the nature of their design. The best poster works by indirection; by drawing attention to itself, its colours, its draftsmanship or photography, its layout, slogans and copy; in short, the overall appearance and the impression or psychological state induced by these components subtly persuade us to buy whatever is advertised.

The spectator absorbs contemporary information through a medium that has changed radically from the typographic broadsides of the eighteenth and nineteenth centuries. Such change has not always been for the better. The compositors of antique notices may not always have handled display types and printers' ornaments with genteel sensitivity, but they knew how to catch the eye and force it to read on. With the development of modern photo-reproductive techniques, however, advertising became increasingly pictorial. As we can see in the White Daisy Flour label of around the mid-nineteenth century, various devices were introduced to affect the integration of text and visual matter, in this case through the adaptation of the heraldic belt or banner. Other posters, placards and signs tried to emphasize the written matter with the related images: Tiger Tea had naturally to be advertised not just by name but also by an identifying specimen of the brand's namesake. By the mid-nineteenth century chromo-lithography was being adapted to the printing of small trade-cards passed out by manufacturers and retailers to customers and suppliers. These cards, packed with as much illustrative and written matter as possible, were often seconded to humble printer-apprentices.

The early posters of the Toronto Industrial Exhibition were in many ways similar in composition and mode of reproduction to slightly enlarged trade-cards. Many advertising posters from that period belong to the class of printed ephemera known to antique dealers and memorabilia collectors as "paper under glass": they consist of a lithographed print framed in wood, papier mâché, or tin, protected by glass. In the case of the paper-under-glass issued by the Granby Rubber Co., the company's name appears in the poster itself; in other examples of the genre, the name might be embossed or carved in the frame. Breweries and distilleries produced quantities of such advertisements to be hung in hotels and bars; text and image would sometimes be printed on or engraved in the mirror-backed glass.

The first large sales campaigns anywhere to employ illustrated advertising on an international scale were those by the manufacturers of Pears,

[1]Kauffer, E. McKnight. *The Art of the poster*. London:
Cecil Palmer, 1924; p. 39.

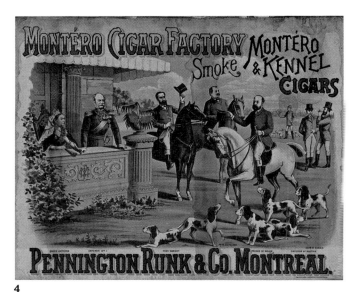

4

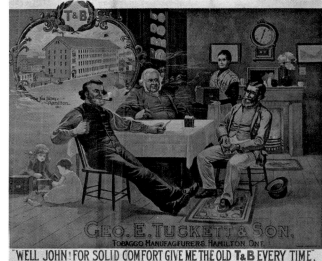

5

6

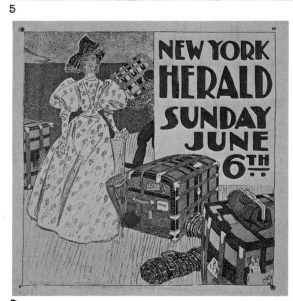

7

8

9

10

Opposite

3. **Massey-Harris...Fiftieth Anniversary** 1887; **C/A:** Massey-Harris Ltd.; **M:** colour lithograph. **Note:** Cover for Massey-Harris catalogue.

4. **Montéro Cigar Factory** c. 1890s; **C/A:** Pennington Runk and Co., Montreal; **P:** The Burland Lithographing Co., Montreal; **M:** colour lithograph in frame.

5. **Geo. E. Tuckett & Son...** c. 1890s(?); **C/A:** George E. Tuckett and Son, Tobacco Manufacturers, Hamilton; **P:** Toronto Lithographing Co.; **M:** colour lithograph in frame.

6. **A Song We Sing, A Song of Hope...** c. 1880s or '90s; **C/A:** Comfort Soap; **P:** Toronto Litho. Co.; **M:** colour lithograph.

7-8 **Two bill-posters for Sunday editions of** *The New York Herald,* 1898; **D/A:** C.W. Jefferys; **C/A:** *New York Herald;* **M:** colour lithograph (photographic reproduction of line drawings).

9. **Robin & Sadler Manufacturers...** c. 1890s(?); **C/A:** Robin and Sadler Manufacturers, Montreal; **P:** Toronto Lithographing Co.; **M:** colour lithograph.

10. **The Cosgrave Brewery Co** c. 1890s(?); **C/A:** The Cosgrave Brewery Co. Ltd., Toronto; **P:** Rolph, Smith & Co., Toronto; **M:** colour lithograph.

11

12

13

14

15

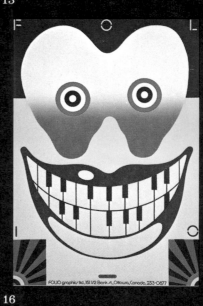

16

17

18

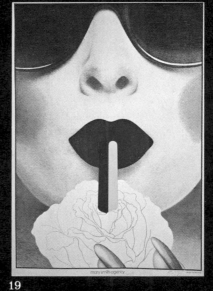

19

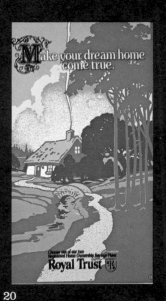

20

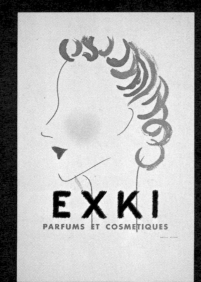

21

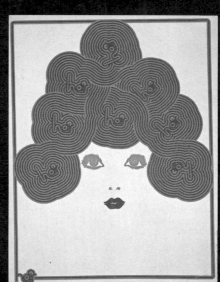

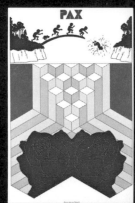

23

Sunlight and Ivory soaps Indeed, Thomas Barratt, director of Pears, has been described as the "Father of Modern Advertising."

Among the late nineteenth-century companies which maintained particularly high profiles through their creative use of posters, paper-under-glass, billboards, placards, pamphlets, calendars, press ads, house organs, and various souvenirs and give-aways were Massey-Harris Ltd. (now Massey-Ferguson), the McLaughlin Carriage Co., C.N. Huether's Beers and the Tuckett Tobacco Co.

Massey-Harris's diversified range of products required an equally diversified range of advertising techniques. Their posters introduced more pictorial matter, in the form of line blocks, lithographic inserts and, finally, halftone photographs. Type became secondary to the pictures.

These graphics are typical of the advertising art of their day; finely drawn in a representational manner with lithocrayon, they depicted rustic scenes focusing attention on farm equipment in operation. Most of Massey's posters and paper-under-glass are unsigned, but one patriotic example (around 1904 or '05), representing a mower against a Union Jack, was the work of the prolific A. H. Hider of Toronto Litho. Co. His only rival in Toronto was J. D. Kelly, who produced lithographic illustrations for Labatt's Brewery, Corby Distilleries Ltd. and Confederation Life.

The paucity of surviving specimens makes it difficult to distinguish the gradual transition from the cluttered, overly detailed representational style of the Victorian era to the cleaner, leaner and more stylized approach of the 1920s and '30s. The rigours of World War I must have influenced the change, as it brought about a paring and honing of techniques by the commercial artists who had been involved in war-poster campaigns. Other formative factors applied, such as the influence of modernesque European art and design movements, and that of the Group of Seven, in whose work pattern and design predominated over "atmospherics." Through their association with prominent Toronto printing firms such as Grip Ltd., Rous and Mann, and Sampson, Matthews, the Group's members managed to instigate a minor revolution, freeing commercial illustration from the straightjacket of photographic realism.

Canadian illustrators and designers of advanced tastes did exist during the decades which saw the establishment in Germany of the Bauhaus in Weimar and in Dessau, the recognition of various *avant garde* art and design movements and groups, and the introduction to printing of photograms, asymetric typography, *sans serif* alphabets, and the idea of type without capitals. But these Canadian pioneers were isolated and without leadership; many of them were forced to earn a living in litho houses and silkscreen plants, or in stultifying advertising studios. The most forward-looking ones headed for Europe.

One of these fugitives was Raoul Bonin, a Montreal native and student of A. M. Cassandre who deserves credit as perhaps the first Canadian designer-illustrator to respond to the challenge of the new "purist" style. Bonin's work is characterized by its use of visual shorthand to convey information and create a mood, by relying on airbrush and *sans serif* typefaces and hand-lettering. If ever a poster artist summed up the jazz age as it affected Canada, it was Raoul Bonin.

Despite the crisis climate of the Second World War, some idealistic Canadian designers demanded a revolution if Canada hoped to keep pace with Europe and the United States in its commercial art. In 1942 Eric Aldwinkle, author of some of Canada's best war posters, was reported by the *London Free Press* of having charged that "most of the commercial art, as displayed in street advertising, was responsible for the mistaken conceptions of true art prevalent with Canadian citizens. Art schools should be encouraged to replace the old apprentice system and above all, a society of commercial artists . . . should be organized." In 1949 the Art Directors' Club of Toronto was founded and similar professional societies sprang up in Montreal, Winnipeg and Vancouver. By then, Canada possessed the talent and resources; what was still lacking was initiative on the part of industry and the retail trade. Both, for the

of prestige advertising in the early 1960s. He helped to make the poster an integral element of self-promotion campaigns, and the pieces he created, few of which were printed in colour, remain fresh and invigorating. Fleming was able to see the poster's potential and succeeded in proving its ability as an attention-getter and a reminder. Although his style changed subtly over the years, as he moved away from the somewhat affected English cleverness he had emulated in the 1950s, he remained true to his roots and inspirations. When he left C. and B. for MacLaren Advertising, his place was taken first by Anthony Mann, who during the mid-sixties injected into promotion pieces the Helvetica style of Swiss design popular in Europe; then by Jack Sneep; and finally by Jim Donoahue, from 1969 to 1974. Fleming had passed on his love of verbal-visual puns to James Donoahue, who in turn developed his own individual approach. A graduate of the Ontario College of Art, Donoahue is one of the most distinguished typographic designers of his generation. That he is not an illustrator has not impeded his success as a creator of affectionately nostalgic, immediately recognizable posters.

As heir to Allan Fleming he takes his rightful place as Canada's preeminent designer of logotypes and printing promotion. His poster-style involves a composite of tongue-in-cheek, mock-erudite text with a collage of visual material from numerous sources: old woodcuts and engravings, type specimens, antique artifacts such as tobacco tins, orange-crate labels, or wooden letters, printer's devices, originally commissioned artwork and photographs. Donoahue's intention is to draw the viewer's eye to the quality of the typography, the paper, the presswork, or the colour reproduction through attractive juxtapositioning of text and images. His method of employing old applications of lettering in one form or another to sell new typographic or reprographic services has been frequently imitated.

The 1960s and early seventies were the apogee of this kind of promotion. Advertising and the economy in general were expanding, and a mood of optimism (helped in considerable measure by such market-stimulators as Expo 67 and the discovery of the whole "youth" and "underground" market) encouraged many firms and individuals to try this approach to consumer relations. Much of the material published was self-indulgent and sometimes fatuous, but the best reveals the relaxing of formerly stringent rules about attitudes and behaviour in the enclosed worlds of graphic art and advertising. The influence of rock culture and psychedelia, particularly for freelance illustrators and designers, is immediately detectable.

But the irreverent atmosphere of the sixties has forever passed. In the middle seventies a mood of corporate caution rendered, at least temporarily, so obstensibly frivolous a form of advertising as the self-promotion poster a thing of the past.

There are, of course, exceptions, such as the brilliant annual calendars published by Rolland Paper of Montreal; they feature visual puns designed and photographed by Studio 2+2's Richard Mallette and Robert Laporte. When work is publicly remarked on, publishers are often inundated with requests for copies, which suggests that through proper marketing self-promotion posters could help to pay for themselves. Quality direct mail advertising itself is being phased out, possibly because of the high throw-away factor, rising postal rates and the unpredictability of the service, and spiralling printing costs. In other areas, however, the direct mail market is growing. In 1962 Edsall Research Ltd. estimated that Canadian advertisers invested $231,580,000 in direct mail, as opposed to $52,152,000 in outdoor advertising. In 1975-76 over six hundred million pieces of advertising were delivered, fifty million more than in 1976-77. The direct mail industry which now has its own pressure group, The Direct Mail/ Marketing Association, presently earns around $400 million annually in Canada, which represents one per cent of retail sales.

Amid this ever-increasing glut of material, the design and printing industries' own occasional mailers and handouts remind one that all such advertising need not necessarily be a bothersome waste of paper.

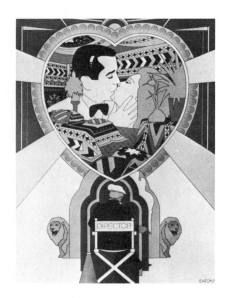

33. **Eaton's** c. 1972-73; **A:** Gerald Sevier; **D:** Jack Parker; **AD:** Jack Parker; **S:** Hothouse, Toronto; **S/A:** Eaton's City Advertising; **C/A:** Eaton's City Advertising, Toronto.

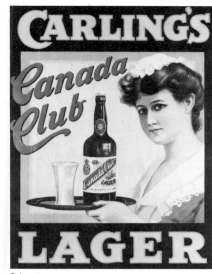

34

35

POSTERS

SHEWING

EXCEPTIONAL
STRENGTH IN
DESIGN AND
COLOR

HUBERT ROGERS

30 IPSWICH ST.
BOSTON

36

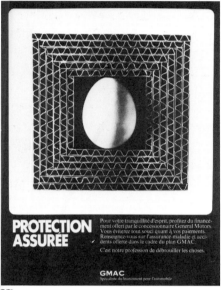

PROTECTION
ASSURÉE

37

38

39

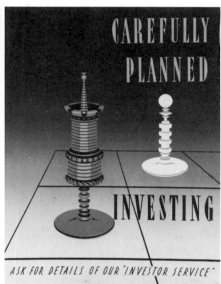

CAREFULLY
PLANNED

INVESTING

ASK FOR DETAILS OF OUR "INVESTOR SERVICE"

40

41

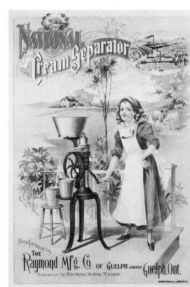

42

34. Carling's Canada Club Lager c. 1900(?); **C/A:** Carling Brewing and Malting Co., London, Ontario.

35. Crush Thirst 1976; **A:** Roger Hill; **AD:** Bob Pearson; **C/A:** Orange Crush Ltd.

36. Hubert Rogers' advertisement for his own poster-art service, published in the 1926 volume of *The National Edition of Advertising Arts and Crafts* (New York: Lee & Kirby).

37. Protection Assurée c. 1974; **D:** Burton Kramer; **Ph:** Jim Shaw; **AD:** Burton Kramer; **S/A:** Burton Kramer Associates Ltd.; **C/A:** General Motors Acceptance Corporation of Canada, Ltd., Toronto.

38. Francine Vandelac Tricots 1967; **D:** Raymond Bellemare; **C/A:** Francine Vandelac Tricots, Montreal.

39. Imperial Tobacco c. 1975; **D:** Jean Morin; **S/A:** Public Relations Dept., Imperial Tobacco Ltd.; **C/A:** Imperial Tobacco Ltd., Montreal.

40. Carefully Planned Investing 1950; **D/A:** Eric Aldwinkle; **AD:** C.S.W. Carter; **C/A:** Toronto General Trusts Corp.; **P:** Holland and Neil Co. Ltd.

41. A&T c. 1964–65; **D/A:** Arnaud Benvenuti Maggs (b. 1927); **AD:** Arnaud Maggs; **C/A:** Antiques and Things, Toronto. **Note:** Three small bills for posting on lampposts, etc.

42. National Cream Separator 1908; **C/A:** The Raymond Mfg. Co. of Guelph, Ltd., Guelph, Ontario; **P:** Duncan Litho. Co. Ltd., Hamilton.

43. Try a "Little Touch" 1910; **A:** J.D. Kelly (1862-1958); **C/A:** Corby Distilleries Ltd.; **P:** Stone Ltd.

44. Seagram's Ginger Ale c.1930s(?); **C/A:** Seagrams Distillers (Ont.) Ltd., Toronto.

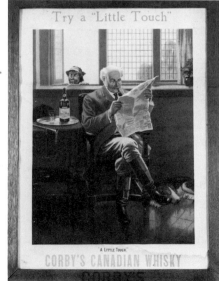

43

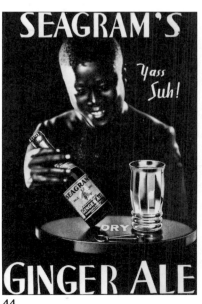

44

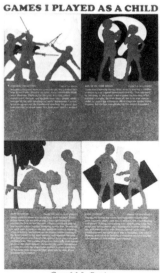

45

46

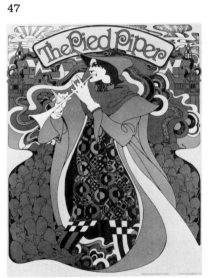

47

45. **Hot Lead** mid-1970s;
D/A: Stanley R. Berneche;
C/A: Stanley R. Berneche/Criterion art company ltd., Québec.

46. **Ted Larson, Designer-Illustrator**
c. 1972; **D/A:** Ted Larson; **Ph:** Hugh Thompson; **AD:** Ted Larson;
S/A: Sherman Laws Ltd., Toronto;
C/A: Ted Larson/Sherman Laws.

47. **Communicate To the World**...
c. 1960; **D/A:** Allan Fleming;
AD: Allan Fleming; **C/A:** Cooper & Beatty Ltd.

48. **Superlative RGB** c. early 1970s(?); **D/A:** Harold Klunder (b. 1943); **C/A:** Rapid Grip and Batten Ltd., Toronto; **P:** Rapid Grip and Batten Ltd.

49. **The Pied Piper** early 1970s;
A: David Chestnutt; **C/A:** David Chestnutt, Stewart & Capraru, Toronto; **P:** Chromo Lithographing Co. Ltd.

50. **1956 Sherman's Line of Craft**
1956; **S/A:** Sherman Laws Ltd., Toronto; **C/A:** Sherman Laws Ltd.

51. **Christmas Joys and Christmas Toys**... c. 1972; **D:** Roger Hill;
C: Roger Hill; **Ph:** John Stephens;
AD: Paul Berta; **S/A:** TDF Artists Ltd., Toronto; **C/A:** TDF Artists Ltd.

52. **Letraset** 1977; **A:** Willi Mitschka;
C/A: Letraset (Canada) Ltd., Toronto.

53. **Games I Played As a Child**
c. 1972; **D/A:** Gerald L. Sevier;
C: Gerald Sevier; **AD:** Gerald Sevier; **S/A:** Hothouse, Toronto;
C/A: Gerald Sevier.

48

49

50

51

52

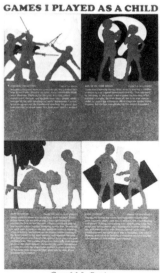
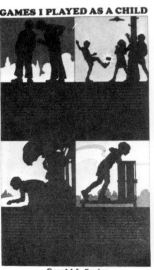

53

13/Health and
Safety Posters

Among the earliest posters that cautioned people about their health and welfare was a series of anti-drinking broadsides full of lurid statistics and dire predictions. Published by Les Clercs de St.-Viateur, Montreal, this numbered series depicted in words and images topics such as "*L'Alcool et l'hérédité*," and revealed such data as the interesting fact that while in 1870 the average annual beer consumption in Canada was two gallons per person, by 1914 it had risen to seven. When the popular Toronto illustrator and cartoonist E. J. Dinsmore won the Safety First poster contest in 1920, the automobile was just beginning to challenge the supremacy of drink as the number one cause of accidental deaths. The interdependency of these two menaces remains predominant in messages posted in buses, subway cars, liquor stores, and government offices, in fact everywhere *except* where both these activities usually take place.

Arthur Keelor, a contemporary of Dinsmore's, was commended in the early twenties on his series of placards and folder-covers for the Industrial Accident Prevention Associations of Toronto. At least two of them were exhibited at the Canadian Poster Exhibit, in Wembley, England, and reproduced in Walter S. Sparrow's *Advertising and British Art*.

During both world wars numerous posters were printed by government agencies and private industry to promote health care and safety on the job. These posters often used humour to convey important messages, to avoid being ignored or scorned by the workers. Such posters had to get their message across with maximum impact and minimum verbiage. Since that time health and safety posters have relied on photographs and illustrations supported by only brief explanatory texts. It is text that has to be severely restricted in billboards aimed at reducing traffic deaths; such signs must never distract the motorist's attention to the point where they might cause an accident.

In 1964 the Ontario Ministry of Transport sponsored its first traffic safety poster competition. Professional and amateur artists submitted a total of 275 entries and the judges were members of the Art Directors' Club of Toronto: Dr. Charles F. Comfort, chairman; Allan R. Fleming, D. Mackay Houston, Clair C. Stewart, and Leslie J. Trevor. The winner was Robert S. Wright of Orillia, Ontario; second prize went to Ed Nakamura of Hamilton, Ontario. The poster—presumably the winning entry in the group-photograph of the judges—is an admirably concise statement calculated to evoke gut-reaction. An even more successful safety poster is T. F. Pifko's terse "Stop" billboard of around 1965, a good example of how verbal visual-wit can hit home with a power denied the more verbose and melodramatic appeal. The idea of the twisted stop-sign is derived, in fact, from the Swiss designer Herbert Leupin's famous poster of 1954, "... *trink lieber Eptinger*," showing a bent triangular traffic-sign whose only copy is an exclamation point.

Hardly surprising is the contrast between posters warning the public against harmful habits and environmental hazards, and the far more up-tempo advertising by provincial and federal agencies which feel compelled to show off their achievements in improving our lot.

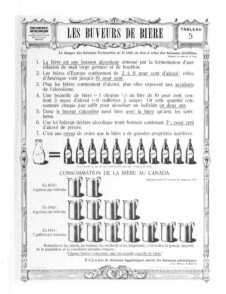

1. **Les Buveurs de bière** 1917; **C/A:** Les Clercs de St.-Viateur, Montreal. **Note:** part of a series of "Enseignements Antialcooliques" published with the recommendation of Le Conseil de l'Instruction Publique de la Province de Québec.

Charitable societies have also produced effective posters in recent years. The distinctive anti-smoking poster of 1974 designed by Ernest Czelko for the Canadian Cancer Society received international recognition, as did Roger Hill's "We're looking for Water Bugs" commissioned by the Canadian Red Cross. It won a Clio Award for the best international poster in 1976. Recently the Ontario Ministry of Health has issued a series of mini-posters advocating, with cartoon-like airbrush illustrations, a decrease in alcoholic consumption, especially among adolescents who have been given the right to drink by the very government which published the posters. Ironically, the liquor stores of Ontario are among the few places where the public may see such posters.

2-3. **Water; Pesticides; D:** Dennis McManus; **S/A:** Dennis McManus and Associates Advertising Ltd.; Toronto; **C/A:** Ontario Ministry of the Environment.

4. **Monkey See. . . Monkey Do** c. 1978; **C/A:** Ontario Ministry of Health.

5. **Milk. Before You Get Into the Spirit** 1972; **D:** Terry Iles; **C:** Robert J. Canning; **Ph:** Bert Bell; **AD:** Terry Iles; **S:** Bob McPartlin Ltd.; **S/A:** McKim/Benton & Bowles Ltd.; **C/A:** Ontario Milk Marketing Board.

6. **Société Canadienne du Cancer** 1974; **D:** Ernest Czelko; **S/A:** Communicad, Toronto; **C/A:** Canadian Cancer Society, Toronto.

7. **We're Looking for Water Bugs** 1976; **A:** Roger Hill; **AD:** Gene Turner; **C:** Jerry Kuleba; **C/A:** Canadian Red Cross.

8. Ontario Ministry of Transportation Traffic Safety Poster. Competition, 1965. The judges, from left to right, are: Clair Stewart, D. Mackay Houston, Charles Comfort, Leslie J. Trevor, Allan Fleming.

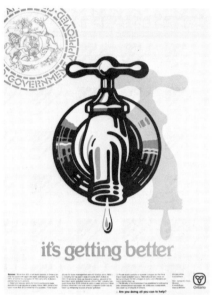

it's getting better

2

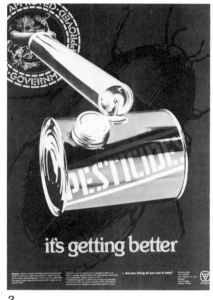

it's getting better

3

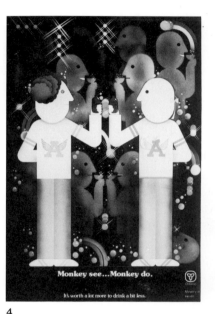

Monkey see...Monkey do.

It's worth a lot more to drink a bit less.

4

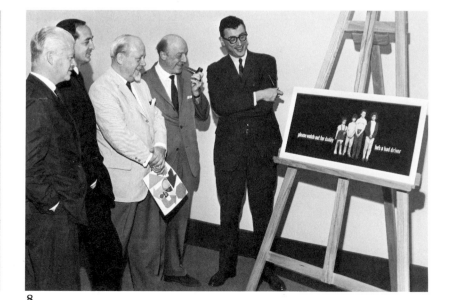

Milk. Before you get into the spirit.

5

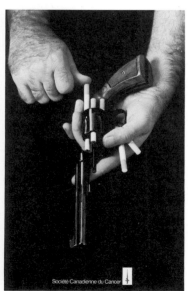

Société Canadienne du Cancer

6

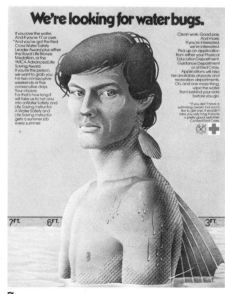

We're looking for water bugs.

7

8

14 / *The Billboard Jungle*

1. Billboard stands at College and Robert Streets, Toronto, in 1922.

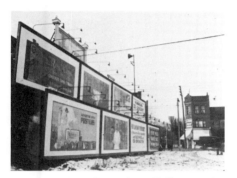

2. E.L. Ruddy billboard-installation truck, 1920s. Poster in background advertises the appearance of Bob Morton's Circus at Maple Leaf Gardens, Toronto.

Billboards have been described as "the invasion of the landscape by advertising." Purists might deny that a discussion of "outdoor advertising" has any place in a serious study of the poster, but such short-sightedness can no more remove the eyesores they abhor than displace the billboard from its position as the most American of all forms of pictorial advertising. To ignore it is to ignore a central chapter in the recent history of graphic media.

The story of the poster in America is also the story of the outdoor board. It was the large-scale circus poster which introduced the medium as we know it to the United States and to Canada in the middle and late nineteenth century. The first large outdoor posters were three-sheet billboards (each measuring 28″ × 42″) published by P. T. Barnum and his associates to advertise their travelling shows. Regular poster stands were erected in the United States around 1872, and Matt Morgan, a Strobridge Litho. Co. artist, is credited with producing the first 24-sheet poster in 1878.

In 1912 a joint committee of the Poster Advertising Association, the Painted Bulletin Advertising Association, and the National Association of Employing Lithographers agreed on a uniform size for American billboard posters: a 26″ × 39″ work size and a 28″ × 41″ paper size. Billboard dimensions were based on multiples of these standard sizes. Modern outdoor posters, printed on quality paper with good wet-strength, consist of twelve separate sheets of paper which are glued to the billboard in a predetermined order. If fewer than five copies of a design are to be reproduced, they are hand-printed, while larger runs are lithographed or silkscreened.

Standards are determined in Canada by the Poster Advertising Association of Canada, which is an affiliate of the Poster Advertising Association of America.

Ruddy Signs of Toronto and Claude Neon Ltd. of Montreal were the two major Canadian outdoor advertising companies of the 1920s. Their merger was inevitable, since together they were able to cover the national market with an unbeatable combination of neon-illumination, lithographic printing, advertising staffs and poster-designing and distributing facilities organized on a scale no rival could match. Another important billboard producer of the late twenties and thirties was the Canadian Poster Company Ltd. of Montreal.

The age of the privately owned automobile was also the beginning of modern outdoor advertising. Cars and billboards were mutually dependent, as billboards advertised not only the latest car models but also the products and services they required and consumed. The ensuing proliferation of highways provided outdoor advertisers with a whole new venue. The zeal to construct stands in cities, towns and in the open countryside soon got completely out of control, to the point when, in 1922, there were no less than nineteen full-size E. L. Ruddy boards in position at the northeast corner of Toronto's Front and York Streets. Over the years the number of outdoor stands has been drastically reduced through the application of government restrictions, while the industry itself has imposed rigorous criteria to control the quality and quantity of its service.

If the first two decades of the twentieth century saw the establishment of the billboard as a universally accepted advertising medium, the next twenty years strengthened the position of outdoor posters as perhaps the most effective means of visual promotion available to the advertiser.

Even as early as the 1920s poster printers and distributors were conducting studies to determine correct standards of visibility and legibility for outdoor boards. The "fair-weather" average minimum visibility of a double-crown or sixteen-sheet poster was calculated to be eighty feet, twenty feet for a 20″ by 30″ poster. With these figures in mind outdoor advertisers concluded that the bigger the poster, the broader would be its "target" area, and the bolder its letters and images, the quicker passing motorist or pedestrian will absorb the message. The best billboards of the period between the two world wars made the most of the horizontal structures by broadening and flattening illustrated matter, and emphasizing colours and recognizable shapes without distracting the motorist. Poster-painters such as J. E. Sampson worked their designs rhythmically, relying on subtle repetition of basic forms, undiluted colours, and muscular draughtsmanship to get the message across. Other poster-artists put their faith in suggestive sex, luxuriating in the opportunity to explore their own fantasies and fetishes in public. More outwardly innocent were the imitations of the English "pastoral" style popularized by Frank Newbould and his contemporaries at the behest of railway companies and, later, of oil companies, such as Shell. O'Keefe's Beverages Ltd sponsored two series in the late thirties and forties depicting "the beauty spots of Ontario" and England; their style is highly derivative of their British models.

Although the majority of Canadian billboards during the thirties were staid and conservative, befitting a country severely suffering from the effects of the Great Depression, occasional outbursts of exuberance appeared as if to alleviate the general gloom. A native strain of surrealism manifested itself in billboards which defied their own two-dimensionality by adding projections.

The billboard enjoyed a renaissance of kinds during World War II, when it was recalled into service to sell Victory Bonds and War Savings Stamps, and to solicit donations and seek volunteers for the Red Cross and other charitable organizations. The war reaffirmed our close ties with Britain, and many billboards exploited sentimental themes and patriotic symbols. The older-style signs—especially those advertising resorts, motels, and eateries, or prophesying the doom of religious unbelievers—are yet in view along secondary roads which have been bypassed by multi-laned throughways. Fortunately, Canada's highways have been spared the visual pollution which was allowed to assault the eyes of the American motorist, as our Departments of Highways had the foresight to ban billboards altogether from major routes. Defenders of the medium proclaim that billboards have a place along these routes as they alleviate the monotony which may cause motorists to fall asleep at the wheel; they also maintain that they induce speeders to slow down to read the messages. On the other hand, Peter Blake, the author of God's Own Junkyard, declares that "it has been clearly established, through careful engineering studies carried out in several states, that highways with billboards experience about three times as many automobile accidents as do highways without billboards."[1]

The Canadian Outdoor Measurement Bureau, a non-profit organization independently operated by representatives from advertising agencies and the outdoor advertising industry, has carefully audited "outdoor circulation" since 1970. It annually measures the total volume of pedestrian and vehicular traffic that is exposed to a poster panel or a similar type of display, to verify previous counts. In 1976, the expenditures for billboards and mall posters recorded by the Outdoor Advertising Association of Canada totalled over $12 million, as opposed to only $4.6 million for bulletins. The number of billboards and mall posters in use in Canada is staggering; the percentage of any town's or city's total population exposed to this form of advertising in the course of a day vies with the number of people watching television and listening to the radio.

Industry statisticians argue that the retention-period of visual is far longer than that of aural material, the recognition factor being far greater.

[1]Blake, Peter. God's Own Junkyard. New York: Holt, Rinehart and Winston, 1964; p. 14.

3

4

5

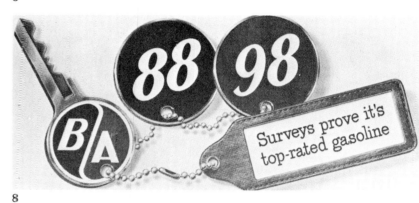

6

7

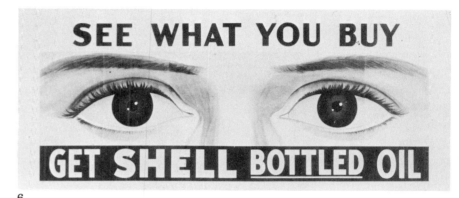

8

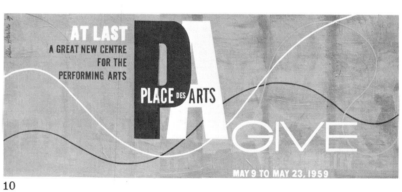

9

10

11

12

3. **Neilson's** c. 1920s(?); **C/A:** Wm. Neilson Co. Ltd., Toronto.

4. **Imperial Gasoline** c. 1929; **C/A:** Imperial Oil Ltd., Toronto.

5. **The Mutual Life Assurance Company of Canada** c. 1929; **C/A:** The Mutual Life Assurance Co. of Canada, Waterloo, Ontario.

6. **See What You Buy** c. 1930s or '40s; **C/A:** Shell Oil Ltd.

7. **British Consols** c. 1930s or '40s; **A:** Rex Woods; **C/A:** MacDonald Tobacco Inc., Montreal.

8. **B.A. 88 98** 1950; **A:** TDF Advertising Artists Ltd.; **AD:** Clair Stewart; **S/A:** James Lovick & Co. Ltd., Toronto; **C/A:** British American Oil Co. Ltd., Toronto.

9. **Backlights** 1978; **A:** Zigi Kucharski; **C/A:** Claude Neon Ltd., Toronto.

10. **Place des Arts** 1959; **D/A:** Allan Harrison; **C/A:** Place des Arts, Montreal.

11. **Quick! The Elmer's Glue** 1972; **D/A:** Oscar Ross; **C/A:** Borden Co. Ltd., Toronto.

12. **Cardinal** 1977-78; **A:** Marcelin Cardinal (b. 1920); **C/A:** "L'Art Dans la Rue" project. Benson and Hedges (Canada) Ltd., Montreal.

Billboards are intended to leave no more than two ideas in the minds of viewers: the name of the product or service and the reason for buying.

Are outdoor posters actually getting better in Canada? Yes, according to the industry, which has begun to take a more aggressive stand in defence of its business against municipal government determination to eliminate all billboards and posters from streets and highways, and against other detractors. Despite the efforts by such leaders of the business as Claude Neon Ltd. and Urban Outdoors, billboard and outdoor posters lag behind other types of signs in terms of aesthetics, if not of selling power. The fault partially lies with critics and friends of the medium who fail to consider the billboard in the broader contexts of society, the economy and the environment. Viewed from this standpoint, billboards admittedly still take away more from a city or town than they contribute. As Toronto arts journalist Stephen Godfrey recently remarked, "As part of our 'bigger is better' advertising philosophy, posters have been subverted by billboards, which are usually no more than isolated frames taken from television ads and (are) the most consistently unimaginative graphic medium around."[2]

Professor Abraham Moles of the University of Strasbourg, a demographic theorist of the poster, detects in modern billboards a struggle between the quality of the image and the quality of the text, the image generally being the stronger of the two. Posters, he decided, should be intelligible, give pleasure, and contribute to "consumer education and general education" in the "town maze." Professor Moles maintains that if the outdoor advertising industry ignores these long-term purposes and concentrates exclusively on short-term objectives, the medium is doomed.

Let us watch where the billboard goes in the next few years. For wherever it goes, the poster will go in all its numerous applications and forms.

13. "Add a coat of Bapco" (c.1967); **D/A:** Ted Bethune; **AD:** Ted Bethune; **C:** Ted Bethune; **S/A:** Cockfield, Brown and Co. Ltd., Vancouver; **C/A:** British American Paint Co.

[2]Godfrey, Stephen. "The Poster Comes of Age", in *The Globe and Mail*, 14 January 1978; p. 31.

14. Oil sketch of Buckingham Cigarettes poster by J. E. Sampson. Finished artwork was printed by Sampson-Matthews and distributed by E. L. Ruddy Ltd.

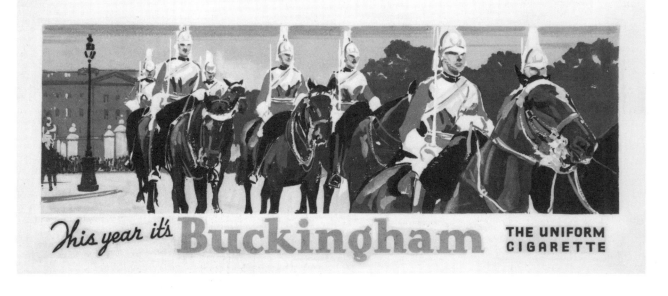

Selected References

The literature on posters and poster artists is surprisingly extensive. Adequate lists of references are appended to a number of exhibition catalogues and standard histories of the subject. For general information, the reader is advised to consult Sections I and II. Starred (*) entries in Section I reproduce examples of Canadian poster art, or discuss them; entries marked with a dagger (†) in the margin are exhibition catalogues, or accompanied exhibitions.

Section I: General

Abdy, Jane. *The French Poster from Chéret to Cappielo*. New York: Clarkson N. Potter, 1969.

Alexandre, Arsène, M. H. Spielmann, H. C. Bunner, and August Jaccari. *The Modern Poster*. New York: Charles Scribner's Sons, 1895.

†*Alliance Graphique Internationale. *107 Graphic Designers of A.G.I.* Presented by Olivetti in cooperation with the Art Gallery of Ontario. Forewords by William J. Withrow, Renzo Zorzi, and Rolf Harder. [Milano: Alliance Graphique Internationale/Olivetti, 1974].

†*American Art Through Posters*. Introduction by André Vigeant. Ottawa: National Gallery of Canada, 1976.

*Barnicoat, John. *A Concise History of Posters*. London: Thames and Hudson, 1972.

*Biegeleisen, J. I. *Poster Gallery. The Best Posters of 1946*. New York: Greenberg, 1947.

Black, Mary. *American Advertising Posters of the Nineteenth Century from the Bella C. Landauer Collection of The New York Historical Society*. New York: Dover Publications, 1976.

*Bradshaw, Percy V. *Art in Advertising*. London: The Press Art School, 1925.

†*British Posters*. Ottawa: National Gallery of Canada, 1935.

†Cate, Philip Dennis, and Sinclair Hamilton Hitchings. *The Color Revolution. Color Lithography in France 1890-1900*. Rutgers: Rutgers University Art Gallery, The State University of New Jersey, in cooperation with The Boston Public Library, 1978.

Cirker, Hayward and Blanche. *The Golden Age of the Poster*. New York: Dover Publications, 1971.

*Claus, R. James and Karen E. *Visual Environment. Sight, Sign, and By-law*. Toronto: Collier-Macmillan Canada, Ltd., 1971.

†Cogswell, Margaret, and Edgar Brietenbach, *The American Poster*. New York: October House, 1967.

†Collins, Bradford. *Three Centuries of French Posters*. Ottawa: National Gallery of Canada Bulletin No. 13, 1976.

†Constantine, Mildred, and Alan M. Fern. *Word and Image. Posters from the Collection of The Museum of Modern Art*, 1968.

Cooper, Austin. *Making a Poster*. London: The Studio Ltd., 1938. 2nd ed. 1945. Reprinted 1949.

Darracott, Joseph. *First World War Posters from the Imperial War Museum, London*. New York: Dover Publications, 1974.

†_____ and Belinda Loftus. *First World War Posters*. London: Imperial War Museum, 1972.

†_____ and Belinda Loftus. *Second World War Posters*. London: Imperial War Museum, 1962.

†*European Posters*. Text by André Vigeant. Ottawa: National Gallery of Canada, 1968.

Farren, Mick, editor. *Get On Down. A Decade of Rock and Roll Posters*. London: Big O Publishing Ltd., 1977.

Gallo, Max, and Carlo Arturo Quintavelle. *The Poster in History*. New York: American Heritage [1974].

Gowans, Alan. *The Unchanging Arts*. Philadelphia and New York: J. B. Lippincott, 1971.

*Graffé, W. G. *Poster Design*. London: Chapman and Hall, 1929.

*Hardie, Martin, and Arthur K. Sabin. *War Posters Issued by Belligerent Nations 1914-19*. London: A. and C. Black, 1920.

Hiatt, Charles. *Picture Posters*. London: George Bell and Sons, 1895.

Hutchinson, Harold. *The Poster. An Illustrated History from 1860*. London: Studio Vista [1968].

Hillier, Bevis *100 Years of Posters*. London: Pall Mall, 1972.

_____ *Posters*. London: Spring Books, 1969.

_____ *Travel Posters*. London: Phaidon Press, 1976.

Houck, John W., editor. *Outdoor Advertising: History and Regulation*. Notre Dame: University of Notre Dame Press, 1969.

†*Images of an Era: the American Poster 1945-75*. Introduction by John Garrigan. Washington, D.C.: National Collection of Fine Arts, 1975.

*Jones, Barbara, and Bill Howell. *Popular Arts of the First World War*. London: Studio Vista, 1972.

Jones, Sydney P. *Art and Publicity*. London: The Studio Ltd., 1925.

*_____ *Posters and Publicity*. London: The Studio Ltd., 1926.

_____ *Posters and Their Designers*. London: The Studio Ltd., 1924.

*Judd, Denis. *Posters of World War Two*. London: Wayland Publishers, 1972.

Kauffer, E. McKnight *The Art of the Poster, Its Origin, Evolution and Purpose*. London: Cecil Palmer, 1924.

Keay, Caroline. *American Posters of the Turn of the Century*. London: Academy Editions, 1975.

*Lerner, Daniel. *Great Propaganda Posters, Paper Bullets, Axis and Allied Countries W.W. II*. New York and London: Chelsea House Publications, 1977.

Lewis, John. *Collecting Printed Ephemera*. London: Studio Vista, 1976.

_____ *Printed Ephemera*. London: Faber and Faber, 1969.

Maindron, Ernest. *Les Affiches Illustrées*. Paris: H. Launette et Cie., 1886.

_____ *Les Affiches Illustrées*. Paris: G. Boudet, 1896.

Malhotra, Ruth, and Christina Thon, et al. *Das Fruhe Plakat in Europa und den U.S.A. Ein Bestandkatalog*. Band I: *Grossbritannien. Vereinigten Staaten von Nordamerika*. Band II: *Frankreich und Belgien*. Berlin: Gehr. Mann Verlag, 1973, 1975. Two volumes.

Margolin, Leo. *Paper Bullets*. New York: Froben Press, 1946.

Margolin, Victor. *American Poster Renaissance*. New York: Watson-Guptill Publications, 1975.

_____ *The Golden Age of the American Poster. A Concise Edition of The American Poster Renaissance*. New York: Ballantine Books, 1975.

Marx Roger. *Masters of the Poster 1896-1900*. Preface by Roger Marx Introduction by Alain Weill. Notes by Jack Rennert. New York: Images Graphiques, Inc., 1977. Reproduces the complete text and all the plates of the series *Les Maitres de l'Affiche* (See Section I: Periodicals and Annuals).

Metzl, Ervine. *The Poster. Its History and its Art*. New York: Watson-Guptill, 1963.

Moles, Abraham. *L'Affiche dans la Société Urbaine*. Paris: Dunod, 1970.

Müller-Brockmann, Josef and Shikuzo. *History of the Poster*. Zurich: ABC Verlag [1971].

The Poster. War Souvenir Edition. Chicago: The Poster Advertising Association, Inc. [1919].

†*Poster Art of the World*. A travelling exhibition organized by the Royal Ontario Museum. Edited by John C. Lunn. Forward by A. D. Tushingham. Introduction by John Hillen. Toronto: Royal Ontario Museum, 1960.

†*Posters from Three Wars*. Prepared by Rosemary Tovell and Karl Schutt under the supervision of Pamela Osler. [Catalogue of an exhibition] circulated by the Extension Services of the National Gallery of Canada, Ottawa, 1969-1970. Ottawa: National Gallery of Canada, 1970.

Price, Charles Matlack. *Posters*. New York: G. W. Bricka, 1913. New and enlarged edition (entitled *Poster Design*), 1922.

Purvis, Tom. *Poster Progress*. Introduction by Tom Purvis, edited by F. A. Mercer and W. Gaunt. London: The Studio Ltd. [1939]

Rennert, Jack. *100 Years of Circus Posters*. New York: Flare Books/Darien House, 1974.

Reynolds, Charles and Regina. *100 Years of Magic Posters*. New York: Darien House, 1978.

*Rhodes, Anthony. *Propaganda. The Art of Persuasion: World War II*. Edited by Victor Margolin. London: Angus and Robertson, 1976.

Rickards, Maurice. *Banned Posters*. London: Evelyn, Adams and Mackay, 1969.

_____ *The First World War: Ephemera, Mementoes, Documents*. London: Jupiter Books, 1975.

_____ *Posters at the Turn of the Century*. New York: Walker and Co., 1968.

_____ *Posters of the First World War*. New York: Walker and Co., 1968.

_____ *Posters of the Nineteen-Twenties*. New York: Walker and Co., 1968.

_____ *Posters of Protest and Revolution*. New York: Walker and Co. 1968.

_____ *The Public Notice. An Illustrated History*. New York: Clarkson N. Potter, 1973.

_____ *The Rise and Fall of the Poster*. Newton Abbot: David and Charles, 1971.

_____ *This Is Ephemera*. Brattleboro, Vermont: The Stephen Green Press, 1977.

Rogers, William S. *A Book of the Poster*. London: Greening and Co., 1901.

Rossi, A. *Posters*. London: Paul Hamlyn, 1969.

Stanton, Roger. *Art Nouveau Posters and Graphics*. London: Academy Editions, 1977.

*Shackleton, J. T. *The Golden Age of the Railway Poster*. London: New English Library, 1976.

*Sparrow, Walter Shaw. *Advertising and British Art*. London: John Lane The Bodley Head, 1924.

†Spielmann, Dr. Heinz. *Internationale Plakate 1871-1971*. Munchen: Haus der Kunst, 1971.

†*Stacey, Robert. *American Posters. Part I: 1890-1910: Magazine Postbills and Covers. Part II: Book Advertisements*. Toronto: Pan Gallery, 1974. Two catalogues with introductions.

†_____ *Posters 1890-1930*. Whitby: Whitby Station Gallery, 1975.

Tschichold, Jan. *Asymmetric Typography*. Translated by Rauri McLean. Introduction by W. E. Trevett. London: Faber and Faber Ltd. . . . in cooperation with Cooper and Beatty Ltd., Toronto, 1967. (Originally published 1935.)

†*Typomundus 20*. A Project of the International Center for the Typographic Arts (I.C.T.A.). New York: Reinhold Publishing Corp. [1965] Catalogue of an exhibition of work compiled in Toronto and shown in New York in October 1965.

†*United Hemisphere Posters*. New York: Museum of Modern Art, 1942.

†Wong, Roberta. *American Posters of the Nineties*. Posters from the collections of The Boston Public Library, Currier Gallery of Art, and Dartmouth College. N.p, n.d. [1974]

*Yanker, Gary. *Prop Art. Over 1000 Contemporary Political Posters*. New York: Darien House [ca. 1972].

Section II: Periodicals and Annuals (Non-Canadian)

†*Annual of Advertising, Editorial Art and Design* (New York: Art Directors' Club of New York) Vol. 1, c. 1921 - to date. Title varies.

Biennale International de l'Affiche. (Varsovie, Poland: Bureau Centrale des Expositions d'Art) 1966 - to date.

†*Biennale of Graphic Design*. (Brno, Czechoslovakia: Sbirek Morgvske Galerie v Brno) 1974 - to date.

C.A. The Magazine of Communication Arts. (Palo Alto, California) Vol. 1, 1959 - to date. November/December issue published as *C.A. Annual*.

The Ephemerist: Journal of the Ephemera Society (London: The Ephemera Society) Vol. I, 1978 - to date.

L'Estampe et l'Affiche. (Paris) 1897-99.

Graphis (Zurich: Graphis Press) 1944 - to date.

Graphis Annual. International of Advertising Graphics. (Zurich: Graphis Press/Edmonton: M. G. Hurtig) 1952 - to date.

Graphis Posters (Zurich: Graphis Press/Edmonton: M. G. Hurtig) 1975 - to date. (Annual).

Idea: International Advertising Art. (Tokyo) Vol. 1, No. 1, 1953 - to date.

International Poster Annual. (St. Gall, Switzerland, and New York) 1948/49 - to date.

Modern Publicity. (London) 1924 - to date. Title varies.

Moderne Reklame. (Berlin) 1902-04.

Novum Gebrauchsgraphik (Munich) 1925 - to date. (Formerly *Gebrauchsgraphik*).

Outdoor Annual. (Chicago and New York: Outdoor Advertising Association, Inc., and The Art Directors' Club of Chicago) 1930-60. Title varies.

Pan. (Berlin) 1895-1900.

Das Plakat. (Berlin) 1910-21.

The Poster. (Chicago: Poster Advertising Association) 1912-36. Title varies.

The Poster. (London) Vol. 1, June 1898 - Vol. 4, August 1900. Supplement, *Modern Advertising,* started in June 1900.

The Poster Annual. New York) 1940 - to date.

Print Casebook I/First Annual Edition. The Best in Covers and Posters. Washington, D.C.: RC Publications Inc., 1976.

**Print Casebook II/Second Annual Edition. The Best in Covers and Posters.* Washington, D.C.: RC Publications Inc., 1977.

**Print Casebook III/Third Annual Edition. The Best in Covers and Posters.* Washington, D.C.: RC Publications Inc., 1978-9.

The Studio. (London: The Studio Ltd.) Vol. 1, 1893 - Vol. 167, No. 853, 1964. (Occasionally featured articles on posters and graphic design.)

Ver Sacrum. (Vienna) 1898, (Leipzig) 1899, (Vienna) 1900-03.

Section III: Canadian References (General)

Art and the Graphic Arts: a Series of Lectures. Edited by Paul G. Masterson. A special issue of *Provincial's Paper* (Toronto: Provincial Paper Co.), Vol. 25, No. 2, 1960. Lecturers: A. Stanley Furnival, Graham Coughtry, Jack Birdsall, Will Davies, Duncan MacPherson, Theo Dimson.

Arthur, Paul. "Advertising Design—As Seen from Europe," in *Canadian Art,* Vol. X, No. 1, October 1952; pp. 31-2.

_____ "Canada," in *Who's Who in Graphic Art,* edited by Walter Amstutz. Zurich: Amstutz and Herder, Graphis Press, 1962; p. 83.

Beauchamp, Colette. "Quebec," in *Creativity. A Supplement to Marketing Magazine* (Toronto), September 1978, pp. 65-7.

Bednarska, Ewa. "Poster Art." 8 pp. duplicated typescript. [Ottawa: Public Archives of Canada, 1978].

†Bovey, Patricia. *Canadian Political Cartoons.* Winnipeg: The Winnipeg Art Gallery, 1977.

Burns, Robert. "ADC Toronto 1974," in *Novum Gebrauchsgraphik,* Issue 12/1974.

Canada's Illustrated Heritage. Toronto: Natural Sciences of Canada, 1977 - to date. A series of histories by various authors, each covering a period of Canadian history, and reproducing many broadsides and posters.

Canadian Art. Special Issue on Graphic Design. Edited by Alan Jarvis, Vol. XVII, No. 3, May 1960.

†Canadian Society of Applied Art, The (formerly The Arts and Crafts Society of Canada). *Catalogue of the First Exhibition Held at the Galleries of The Ontario Society of Artists . . .* April 7th to April 23rd, 1904.

†_____ Catalogue of the Second Exhibition Held at the Galleries of The Ontario *Society of Artists . . .* Dec. 9th to Dec. 23rd, 1905.

†*Canadian Graphic Design.* Tokyo: Design Gallery, 1965.

†Careless, J. M. S., editor. *Our Parliamentary Heritage.* Toronto: Ontario Ministry of Culture and Recreation/Archives of Ontario [1976]

†*A Century of Ontario Broadsides 1793-1853.* A Typographic exhibition in The Toronto Public Library June, 1965. Introduction by H. C. Campbell. Toronto: Toronto Public Library, 1965.

†Cohen, Byrna Polonsky. *Contemporary Canadian Poster Art from 1960 to the Present: A Collection.* Ottawa: Sussex Annex Works, 1976.

Colgate, William. "Pointers for Students of Early Canadian Printing," in *Printing and the Graphic Arts* (Lunenburg, Vermont), Vol. II, No. 2, May 1959.

_____ *The Toronto Art Students' League.* Toronto: Ryerson Press, 1954.

Crabtree, Graham. "A.G.I. Canada," in *The Penrose Annual,* 1976; pp. 202-14.

Dair, Carl. *Design With Type.* New York: Pellegrini and Cudahy, c. 1952. Reprinted Toronto: University of Toronto Press, 1967.

_____ "New Patterns in Canadian Advertising," in *Canadian Art,* Vol. IX, No. 4, Summer Number, 1952.

_____ "Typography Can Be Creative: A Discussion of Graphic Trends in Canadian Printing," in *Canadian Art.* Vol. V, No. 4, Spring-Summer 1948, pp. 184-8.

†*Dans le Cadre des Sept Jours du Cinéma à Quebec Le Musée du Quebec Presente une Exposition d'Affiches de Cinéma sous les Auspices de la Cinémathéque Canadienne.* [Québec: Musée de la Province de Québec, 1965].

Dexter, Gail. "The Poster People," in *The Toronto Star,* 24 August 1978; p. 25.

Doyle, Lynn C. "Art Notes" in *Toronto Saturday Night,* Vol. IX, No. 7, 14 March 1896.

_____ "Art Notes," *ibid,* Vol. IX, No. 18, 21 March 1896.

Dumas, Antoine. A *L'Enseigne d'Antan. Aperçu des Enseigns en Usage aux Xviie, Xviiie, et xixe Siècles à Québec et à Montréal.* Québec: Editions du Pelican, 1970.

Fainmel, Charles, and Henry Eveleigh. "The Proper Function of Advertising," in *Canadian Art,* Vol. IV, No. 4, Summer 1947; pp. 157-9.

Fauteux, Aegidius. *The Introduction of Printing into Canada.* Montreal: Rolland Paper Co., 1930. Reprinted c. 1950.

Firth, Edith. "Books and Broadsides," in *The Book of Canadian Antiques,* edited by Donald Blake Webster. Toronto: McGraw Hill-Ryerson Ltd., 1974; pp. 313-26.

Fleming, Allan. "Creativity and Direct Mail," in *Direct Mail:* special issue of *Provincial Paper,* Vol. 25, No. 1, 1960.

_____ "Typographic Design," *Graphicaids* (Montreal: Domtar Fine Papers), Vol. 1, No. 1 [1977].

Focus on Graphic Design. Special issue of *Creativity. A Supplement to Marketing Magazine,* September 1978.

Fox, Hyla Wults, "Canadian Posters are Few and Far," in *Toronto Sunday Star,* 18 February, 1979.

Godfrey, Stephen. "The Poster Comes of Age," in *The Globe and Mail,* 14 January 1978.

Gottschalk, Fritz. "The Image of Montreal's 1976 Olympic Games," in *Graphis,* No. 185, Vol. 32 (Nos. 183-188), 1976/77; pp. 268-79.

Graphic Design in Canada. Extra issue of *Idea,* 1975. Includes "Graphic Design in Canada" by Burton Kramer, p. 110; and "Toward Successful Visual Communications" by William Mantle, pp. 111-12.

Grenier, Serge. *La Québec Mur à Mur.* Montréal: Les Editions Quinze, 1976.

Hambleton, Josephine. "Poster Art in Canada," in *The Ottawa Citizen,* 20 June 1947.

Hannon, Leslie F. *Canada at War. The Record of a Fighting People.* Toronto: McClelland and Stewart/The Canadian Illustrated Library, 1968. Includes reproductions of war posters, pp. 54-5. Other volumes in The Canadian Illustrated Library also include reproductions of broadsides, posters, and early advertising graphics.

Harrison, Allan. "Advertising Design in Canada," in *Canadian Art,* Vol. II, No. 3, February-March, 1945.

Havinden, Ashley. "An Appreciation: in Response to a Request for Critical Comments on this Annual," in *Eighth Annual of Advertising and Editorial Art 1956.* Toronto: The Art Directors' Club of Toronto, 1956.

Hogan, Bill, and Rollo MacDonald. "The Tuckett Tobacco Company," in *Memorabilia,* a supplement to *Circa '76,* Vol. 1, No. 1, February 1978.

"How Plant Posters Can be Used to Speed the Day of Victory," in *News Letter* of Howard Smith Paper Mills Ltd., Montreal, No. 14, February 1943.

Idea: This Issue: "Visual Communications in Canada." Special issue of *Idea,* Vol. 7, No. 41, June 1960. Foreword by Arnold Rockman.

Jackdaw series. Toronto: Clarke Irwin, various dates. Portfolios of historical documents and ephemera in facsimile form, edited and introduced by various authors, and occasionally including reproductions of broadsides and posters.

King, Andrew. *Pen, Pencil, and Printing Ink.* Foreword by Douglas Lochhead. Saskatoon: Western Producer Prairie Books, 1970.

Kleefeld, Hans. "Graphics and the Eye of the Beholder," in *Creativity. A Supplement to Marketing Magazine,* September 1978; pp. 2, 24.

†Kotin, David B. *Reader, Lover of Books, Lover of Heaven.* A catalogue based on an exhibition of the book arts in Ontario compiled by David B. Kotin with a checklist of Ontario private presses by Marilyn Rueter with an introduction by Douglas Lochhead. Willowdale: North York Public Library, 1978.

Kritzwiser, Kay. "The Posters that Outpop the Art," in *The Globe and Mail,* 2 November 1968.

Lande, Lawrence. *The Lawrence Lande Collection of Canadiana in the Redpath Library of McGill University.* A bibliography collected, arranged and annotated by Lawrence Lande with an introduction by Edgar Andrew Collard. Montreal: The Lawrence Lande Foundation for Canadian Historical Research, 1965. Supplement, 1971. Two volumes.

Levin, Dr. Ray. "Olympic Poster Art," in *Artmagazine,* Vol. 7, No. 28, Summer/Eté 1976; pp. 8-11.

_____ "A Plea for a Poster Programme for the Canadian Olympics," in *Artmagazine,* Vol. 6, No. 20, Winter, 1975; p. 7.

Linton, Marilyn. "Discovering the Art of the Poster," in *The Toronto Sun,* 12 January 1979; p. 77. A review of the Art Gallery of Ontario travelling exhibition *100 Years of the Poster in Canada.*

Lismer, Arthur. "Art and the Average Canadian," in *Canadian Courier,* Vol. XXIV, No. 9, February 1919; p. 13.

McInnes, Graham. "Posters Line up for War Duty," in *Saturday Night,* Vol. 54, No. 2, 1940; p. 27.

McRae, Earl. "Yesterday for Sale," in *Canadian Magazine,* 11 January 1975. *Re* The Nostalgia Factory, Montreal.

Massey-Ferguson Ltd. *Heritage: Our One Hundred and Twenty-Fifth Year. 1847-1972.* Toronto: Massey-Ferguson Ltd., 1972. Reproduces examples of Massey-Harris's pictorial advertising.

Mayerovitch, Harry. "Crisis in Canadian Art," in *World Affairs* (Toronto), Vol. 9, No. 3, November 1943; pp. 16-17.

The Measure of Typography. A special issue of *Provincial's Paper* devoted to a series of Ontario College of Art lectures 1957-1958. Edited by Byron Matatall. *Provincial's Paper,* Vol. 23, No. 2, Third Quarter, 1958. Lecturers: Carl Dair, Allan Fleming, A. J. Casson, Leslie J. Trevor.

Michaelson, Peter. "Design at the Olympics," in *Canadian Design* (Ottawa), No. 15, January 1976; pp. 5-20. Includes comments by Georges Huel, Director General of Graphics and Design, C.O.J.O.

Mika, Nick and Helma. *Friendly Persuasion. Canadian Advertising of Yesteryear.* Belleville: Mika Publishing, 1974.

Outdoor Advertising Association of Canada. *Outdoor Advertising in Canada: the Modern Marketing Force.* Toronto: The Outdoor Advertising Association of Canada, 1966.

Oxorn, Pearl. "Poster: Collecting the Art of the Street," in *The Ottawa Journal,* 4 November 1978.

Panneton, L. P. "The Poster Design Studio," in *Communication Art Careers.* Montreal: The House of Seagram, 1963.

Pantazzi, Sybille. "Book Illustration and Design by Canadian Artists 1900-1940," in National Gallery of Canada *Bulletin,* Vol. IV, No. 1, 1966.

Powers Ned. "Posters Plague Saskatchewan," in *The Globe and Mail,* 1 July 1978.

Quarryposters. Kingston: Quarry Press [196-?]. Series of poem-posters designed by David Brown.

The Rebellion of 1837. A bibliography of the sources of information in The Public Reference Library of Toronto, Canada. Toronto: The Public Library, 1924.

Rockman, Arnold. "The Artist in the Market-Place," in *Canadian Art,* Vol. XXII, No. 2, Issue No. 96, March-April 1965; pp. 44-5.

†Royal Canadian Academy of Arts. *Canadian Industrial Arts Exhibition Under the Auspices of The Royal Canadian Academy.* [Toronto:

Art Gallery of Toronto/Royal Canadian Academy, 1938].

†_____ Spectrum Canada. [Ottawa: Royal Canadian Academy of Arts, 1976]. Graphic Design: nos. 112-31.

†Society of Graphic Designers of Canada. Graphic Design Canada. A comprehensive exhibition of the best in Canadian graphic design covering the period from 1966-68, sponsored by the Society of Graphic Designers of Canada in cooperation with The National Design Council, Canadian Department of Industry. Toronto: Methuen, 1970.

Stacey, Robert, "Circus '76," in Artmagazine, Vol. 6, No. 20, Winter 1975; p. 8.

†_____, and Constantinidi, Mela. 100 Years of the Poster in Canada. Toronto: Art Gallery of Ontario, 1978. Exhibition brochure.

_____, and Constantinidi, Mela. "The Poster in Canada," in Canadian Collector, Vol. 14, No. 1, January-February 1979; pp. 11-15. (Notice of Art Gallery of Ontario exhibition, 100 Years of the Poster in Canada, p. 39).

Stephenson, H. E. and Carlton McNaught. The Story of Advertising in Canada. Toronto: Ryerson Press, 1940.

Stermer, Dugald. "Canada, Ltd.," in C.A. The Magazine of Communication Arts, Vol. 15, No. 1, 1973; pp. 33-7. Profiles of Gottschalk and Ash Ltd., Raymond Lee and Associates, and Theo Dimson.

Stewart, Clair. "Advertising Design in Canada," in Canadian Art, Vol. VI, No. 1, Autumn 1948; pp. 2-7.

_____ "Canada Advertises," in Journal, Royal Architectural Institute of Canada, Vol, 48, Serial 316, No. 12, December 1951.

"Story Behind New Victory Loan Posters," and "Artists Dramatize the New Victory Loan," in Mayfair (Toronto), Vol. XVII, No. 10, October 1943; pp. 18-19, 69.

Tremaine, Marie. A Bibliography of Canadian Imprints, 1750-1800. Toronto: University of Toronto Press, 1952.

†_____ Canadian Book of Printing: How Printing Came to Canada. Toronto: Published by The Toronto Public Libraries and The 500th Anniversary Committee, 1940.

_____ Early Printing in Canada. Toronto: The Golden Dog Press, 1934.

Vézina, Raymond. "The National Poster Collection," in The Archivist (Ottawa: Public Archives of Canada), Vol. 5, No. 5, September-October 1978; pp. 4-5.

"Wanted Posters," in Weekend Magazine (Toronto), Vol. 29, 6 January 1979; pp. 8-9. Re the Art Gallery of Ontario exhibition 100 Years of the Poster in Canada.

"When the Artists Went to War," in The Canadian, 11 November 1967; pp. 18-19.

Williams, Herbert A. "Canada's Flaming War Posters Stirred Dominion to Action," in The Poster. War Souvenir Edition. Chicago: The Poster Advertising Association, Inc. [1919] pp. 59-61.

Section IV: On Individual Canadian Poster

Designers, Design Firms, and Illustrators

[Aldwinkle, Eric] "Commercial art branded shoddy," in London Free Press, 12 March 1942.

[Arthur, Paul, and Associates] Paul Arthur and Associates—Graphic Design Consultants. Ottawa: Paul Arthur and Associates, 1965.

[Bonin, Raoul] Harrison, Allan. "Raoul Bonin 1904-1949," in Vie des Arts, 10, Printemps, 1958; pp. 3, 32.

_____ "L'Affiche française. La Salle Bonin chez 'Ogilvy'," in unidentified Montreal newspaper, 16 November 1932.

[Brigdens Ltd., Toronto] "Brigdens Looks Back on Eventful Century," in Applied Graphics, Vol. 10, No. 6, June 1971; p. 9 and cover.

_____ "Canadian Illustrators," in The Printer and Publisher (Toronto), June 1895; pp. 12-13.

_____ Nicholson, Edward J. Brigdens Limited, the First One Hundred Years. Toronto: Brigdens Ltd., 1970.

[Burns, Cooper, Hynes Ltd., Toronto] (formerly Burns and Cooper Ltd., and Burns, Cooper, Donoahue, Fleming and Company Ltd.) "Committed to good design—'it helps people communicate with clarity, economy and ingenuity'," in Mark II, January-February 1976; pp. 20-1.

_____ "Good Direct Mail Solves Problems. Bad Direct Mail Wastes Money," in Mark II, October 1973; pp. 16-17.

_____ Images and Intentions: the Work of Burns and Cooper Ltd. Toronto: Burns and Cooper Ltd., 1975.

_____ McConnell, John. "Robert Burns and Heather Cooper, Toronto," in Novum Gebrauchsgraphik, December 12/1977; pp. 24-34.

_____ Slopen, Beverley. "A Graphic Design Group With a High Profile," in Fashion Magazine. Autumn 1977; p. 40.

_____ Snyder, Jerome. "Burns and Cooper," in Graphis, No. 183, Vol. 31, (Nos. 177-182), 1975/6; pp. 556-63; 583.

_____ Stermer, Dugald. "Burns, Cooper, Donoahue, Fleming & Company Limited," in C.A. The Magazine of Communication Arts, Vol. 18, No. 4, September-October 1978; pp. 24-35.

[Burns, Robert] "Robert Burns," in Etc (Scarborough, Ontario: Lettraset Canada Ltd.), Vol. 2, No. 3, December 1978; pp. 1, 6-7.

[Caines, Derek] Freedman, Adele. "The Lure and the Power of the Poster Artist," in The Globe and Mail, "Fanfare" section, 27 June 1978.

[Carlton Studios, London] Howard, S. H. "Three Guardsmen from Toronto Led English Revolution in the Design of Type," in The Globe and Mail, 8 December 1956. Re A. A. Martin, T. G. Greene, Arthur Goode, and Norman Price.

_____ Wallace, William T. "The Genesis of the Studio Idea of Advertising Service," in Penrose's Annual. Vol. XX, 1915; pp. 115-9.

[Casson, A. J.] "For Victory Loan," in The Ottawa Journal, 15 May 1941.

_____ "Toronto Artist's Victory Loan Poster Takes First Prize," in The Toronto Star, 13 May 1941.

[Claude Neon Ltd., Toronto] Daw, James. "Michaelangelo Too Slow for This Work," in The Toronto Star, 30 January 1979. Re billboard artist Carl Jessen and takeover of Claude Neon Ltd. by Mediacom Ltd.

[Coach House Press, Toronto] Coleman, Victor. "Technical Difficulties," in artscanada, August 1969; pp. 19-20.

[Cooper, Heather] "The Art of the Illustrator" and "Images and Intentions," in Print Casebook II/Second Annual Edition. Washington, D.C.: RC Publications Inc., 1977.

_____ Belanger, John. "Putting Beauty in Boardroom," in The Toronto Sun, 4 November 1975.

_____ Burns, Robert. "Heather Cooper, Profile," in Idea, No. 139, 1976, II; pp. 48-55.

_____ "Canadian Opera 1977," in Print Casebook III/Third Annual Edition. Washington, D.C.: RC Publications Inc., 1978-9.

_____ Govier, Katherine. "The Illustrated Heather Cooper," in Toronto Life, 1 February 1976; pp. 118-20

†_____ Heather Cooper. The Art of the Illustrator. An exhibition of drawings, paintings and collages by Heather Cooper sponsored by The Abitibi Paper Company Ltd. in cooperation with Olympia and York Developments Ltd. With an introduction by Allan Fleming. Toronto: Burns and Cooper Ltd., 1975.

_____ "Heather Cooper (Canada)" in Idea: International Advertising Art, No. 150, 1978-9; pp. 150-1.

_____ "Heather Cooper Has One Thing Left to Draw," in Newsprint (Toronto: Southam Press), Issue Five, 1975; pp. 2-3.

_____ Morrison, Suzanne. "Heather Cooper Illustrator/Executive," in "Profile," in Journal, March 1976; pp. 42-4.

_____ "Three Artists," in "What's New at Chatelaine," in Chatelaine, July 1977; p. 4.

†[Design Collaborative, Montreal] Rolf Harder, Ernst Roch, Design Collaborative. A circulating exhibition of international award-winning graphic designs inaugurated at The Montreal Museum of Fine Arts November 5-19, 1970. Introduction by Bill Bantey. Montreal: The Montreal Museum of Fine Arts, 1970.

†_____ Graphic Design by Rolf Harder and Ernst Roch. This exhibition is presented in collaboration with Design Canada, Department of Industry, Trade and Commerce, and The National Design Council. With "An Appreciation" by Allan Harrison. Montreal: Design Collaborative, 1977.

_____ Kuh, Hans. "Design Collaborative of Montreal Limited . . .," in Gebrauchsgraphik, June, 1970; pp. 12-19.

_____ Neuburg, Hans. "Rolf Harder, Ernst Roch," in Graphis, No. 143, 1969; pp. 230-9.

[Dimson, Theo] "Award Winning Designer to Study Japanese Graphics," in Product Design and Engineering, April 1961.

_____ Stermer, Dugald. "Theo Dimson," in "Canada, Ltd.," in C.A. The Magazine of Communication Arts, Vol. 15, No. 1, 1973.

_____ "Theo Aeneas Dimson, R.C.A., A.O.C.A., R.G.D.C. . . .," in Who's Who in Canadian Graphic Arts. Toronto: Trans-Canada Press Ltd./Advance Press Service, 1977. Revised edition 1979.

_____ Wood, Ted. "Two Sides of the Designer Coin. Theo Dimson," in Creativity. A Supplement to Marketing Magazine, September 1978; p. 62.

_____ "Young Canadian Hailed in Japan," in The Sun (Brandon, Manitoba), 29 March 1962.

[Donoahue, James] Snyder, Jerome. "Jim Donoahue," in C.A. The Magazine of Communication Arts, Vol. 14, No. 6, 1973.

_____ Thompson, Tony. "Creativity Profile," in Creativity. A Supplement to Marketing Magazine, September 1978; pp. 70-1.

[Eveleigh, Henry] "Coast to Coast in Art," in Canadian Art, Vol. V, No. 1, Autumn 1947; pp. 39-40. Re 1947 United Nations poster contest.

_____ Forster, Michael. "'Fine' and 'Commercial' Closely Related in Art," in Montreal Standard, 22 July 1950.

[Fainmel, Charles] Gallant, Mavis. "Commercial Drawings are Next to Rembrandt," in Montreal Standard, 12 October 1946.

[Fifty Fingers, Toronto] Craig Sheri. "Creativity Portfolio," in Creativity, December 1978; p. 18-19.

[Fiorucci, Vittorio] Bardo, Arthur. "Scorpio Rising," in Montreal Star, 11 April 1970.

†_____ Chicago '76. Chicago Art Directors' Club of Chicago [1976?].

†_____ Chicago '77. Chicago: Art Directors' Club of Chicago [1977?].

_____ Lamontagne, Christian. "Un 'Afficheur' S'Affiche: Vittorio," in Décormag, No. 59, November 1977.

_____ Mosher, Terry. Interview with Vittorio Fiorucci in Vanguard (Vancouver: The Vancouver Art Gallery), February 1978.

_____ "National Arts Centre Donates Posters to The Public Archives. Vittorio Fiorucci at The Public Archives." Public Archives of Canada Information Services News Release, 31 October 1978.

_____ "Poster History," in The Ottawa Citizen, 1 November 1978.

_____ Smythe, Robert. "Poster Exhibit Blends Style and Cheekiness," in The Ottawa Citizen, 5 November 1976.

_____ "Vittorio Ouvre un Paradis aux Amateurs d'Affiches," in La Patrie, semaine du 17 novembre, 1968.

_____ Walker, Kathleen. "A Graphic View of Addiction," in The Ottawa Citizen, 31 May 1977.

_____ White, Michael. "Posters that Transcend Barriers," in Montreal Gazette, 5 February 1971.

†[Fleming, Allan] Allan R. Fleming: Designer. Foreword by Luc Rombout. Introduction by William Withrow. Essays by Robert Fulford, George Elliott, and Richard Outram. [Vancouver: Vancouver Art Gallery, 1976].

_____ Fulford, Robert. "Allan R. Fleming," in Canadian Art, Autumn 1959; pp. 266-73.

_____ Fulford, Robert. "Allan Robb Fleming. Canada's Design World Loses a Unique Figure," in The Toronto Star, 2 January 1978.

_____ Fulford, Robert. "The Symbolist," in Weekend Magazine, 6 August 1977.

_____ McCarthy, Pearl. "1-Man Design Show Brings Out an Issue," in The Globe and Mail, 15 November 1958.

[Gottschalk and Ash Ltd.] Stermer, Dugald. "Gottschalk and Ash Ltd.," in "Canada, Ltd.," in C.A. The Magazine of Communication Arts, Vol. 15, No. 1, 1973.

[Grip Printing and Publishing Co., Toronto] "The Art of Illustrating," in The Printer and Publisher, October 1894; pp. 10-11.

_____ Day, Norman. "The Art of Imitating Art," in artscanada, Issue No. 134/135, August 1969; pp. 21-3. Re Grip Ltd. and Rapid Grip and Batten.

_____ The Time to Strike. Toronto: The Grip Printing and Publishing Co., n.d.

[Harder, Rolf] Leblond, Jean-Claude. "Rolf Harder: du Graphisme à la Peintre," in Via des Arts, Vol. VXII, No. 74, Printemps, 1974; pp. 64-5.

[Harrison, Allan] Doyon, Paul. "Allan Harrison, Publiste et Peintre," in Le Jour (Montreal), 15 October 1975.

†_____ "The Graphic Art of Allan Harrison." Montreal: The Dufferin Press [1962].

[Hill, James] Drohan, Madelaine. "Classic Illustrator," in *The City* (Toronto), Vol. 3, No. 4, 28 January 1979; pp. 12-15, 21.

_____ "Hill in Oils . . . Hill in Plastic," in *Maclean's magazine*, 1 March 1954; p. 63.

_____ "James Hill," in *Quest* (Toronto), November 1974.

_____ "The Legend of Jimmy Hill, One of America's Top Illustrators," in *Creativity. A Supplement to Marketing Magazine*, March 1978; pp. 4-5, 8, 122, 125.

[Keelor, Arthur] "Posters." Toronto: Rous and Mann Ltd. [c. 1918].

[Kelly, J. D.] Holmes, Robert. "Canadian Illustrators and Designers," in *The Printer and Publisher*, July 1895; pp. 11-12.

[Kilvert, David] "David Kilvert: Design in Profile," in *X-Height* (Society of Graphic Designers of Alberta), 1977.

[Klunder, Barbara] Mallovy, Naomi. "Illustrator Gets Paid for Fun," in *Sunday Star* (Toronto), 19 February 1978; p. D5.

_____ "3 Artists," in "What's New in Chatelaine," in *Chatelaine*, July 1977; p. 4.

[Kramer, Burton, Associates, Ltd.] "Burton Kramer Associates," in *Idea*, Vol. 22, No. 123, March 1974; pp. 10-23.

[Lee, Raymond, and Associates] Stermer, Dugald. "Raymond Lee and Associates," in "Canada, Ltd.," in *C.A. The Magazine of Communication Arts*, Vol. 15, No. 1, 1973.

[Marchiori, Carlos] "Artist," in *Imperial Oil Review* (Toronto), Vol. 52, No. 3, July 1968.

_____ "Carlos Marchiori: Toronto Old and New." Toronto: Art Gallery of Ontario ("Contact" programme), 1978. Abridged from "Carlos Has Painted Toronto," 1976.

[Maggs, Arnaud] "About an Artist Named Maggs," in *Mayfair*, February 1955.

_____ Rockman, Arnold. "Goodbye, Arnaud Maggs," in *The Toronto Daily Star*, 19 January 1963.

[Michaleski, Bernard R. J.] "Bernard R. J. Michaleski," in *Canadian Design* (Ottawa: Department of Industry, Trade and Commerce), No. 11, May 1975; pp. 9-10.

[Rolph-Clark-Stone Ltd., Montreal and Toronto] *Catalogue of the Rolf-Clark-Stone Heritage Collection*. Toronto: Rolph-Clark-Stone Ltd. [1967].

[Ross, Oscar] Craig, Sheri. "Creativity Portfolio," in *Creativity. A Supplement to Marketing Magazine*, March 1978; p. 12.

[Salon des Artistes, Toronto] Blazer, Fred. "Poster Group Out to Prove that Chickens Do Have Lips," in *The Globe and Mail*, 1 December 1978.

_____ Freedman, Adele. "A Good Idea Was Not Enough," in *The Globe and Mail*, 5 December 1978.

_____ Guettel, Alan. "Poster Art Up for Plunder," in *The Toronto Star*, 4 December 1978.

[Sampson, J. Ernest] "The Late J. Ernest Sampson," in *Canadian Review of Music and Art*, Vol. 5, Nos. 4 and 5, October-November 1946.

[Sevier, Gerald] Patterson, Sheena. "Fondness for the Forties," in *Weekend Magazine*, Vol. 23, No. 20, 19 May 1973.

[Some Group Studio, Ottawa] Bergin, Jenny. "Some Group, Some Recognition, But Not at Home," in *The Ottawa Citizen*, 2 November 1972.

_____ Guerette, Parise. "Some Group Studio," in *Interim* (Ottawa), 16 November 1972.

[Tazewell, Samuel Oliver] Gundy, H. Pearson. "Samuel Oliver Tazewell First Lithographer of Upper Canada," in *Amphora 33* (Richmond, B.C.: The Alcuin Society) No. 3, 1978; pp. 15-30.

[Trier, Walter] Englesmith, George. "Walter Trier—In Memoriam," in *Canadian Art*, Autumn Number, Vol. IX, No. 1, October 1951; pp. 14-16.

[Weir, John S.] Teskey, Frank. "History of Long-Hair Hippies Project for Poster Artist," in *The Toronto Star*, 29 May 1974.

[Yaneff, Chris, Ltd.] *Trademarks by Chris Yaneff Ltd*. Toronto: Chris Yaneff Ltd., n.d.

[Zaid, Barry] "Barry Zaid, the Quixotic Eye," in *Advertising Techniques*, November 1971.

†_____ *The Push Pin Style*. An exhibition of design and illustration by present and former members of the Push Pin Studios. Foreword by Henry Wolf. Introduction by Jerome Snyder. Palo Alto, California: Communication Arts Magazine, 1970.

Section V: Canadian Periodicals and Annuals

†Art Directors' Club of Montreal. *Annual Exhibition of Advertising*, Vol. 1, 1952- Vol. 13, 1964. Sourced by *Graphica*, q.v.

†Art Directors' Club of Toronto. *Annual Exhibition*, Vol. 1, 1949 — Vol. 9, 1957.

†Art Directors' Club of Toronto. *Annual of Advertising and Editorial Art*, Vol. 1, 1949 — Vol. 16, 1964; 1972/3; 1973/4; 1977. Ceased publication with Vol. 16, 1964. Superceded by *Graphica* (q.v.) in 1965. Resumed publication 1972/3. No catalogue published 1974/5. Resumed publication as special section of *Creativity. A Supplement of Marketing Magazine*, March 1978.

†Art Directors' Club of Winnipeg. *Exhibition of Advertising and Editorial Art and Design*. 1969. Also published in other years.

Canadian Design. (Ottawa: Office of Design, Department of Industry, Trade and Commerce) September 1972 - January 1976.

Economical Advertising. (Toronto: Poster Advertising Association) 1929, 1930. Also published in other years.

†*Graphica*. (Annual sponsored jointly by The Art Directors' Clubs of Montreal, Toronto, Winnipeg, and Vancouver) 1964-68. (Publication dates: 1965 or 1966 - 1970).

Marketing Magazine. (Toronto: Maclean-Hunter Ltd.) Vol. 1, No. 1, 1908 - to date. Includes occasional supplement, *Creativity*.

Provincial's Paper. (Toronto: Provincial Paper Co. Ltd.) 1939-67. Superceded by *Impressions*, 1968-70.

Société des Graphistes du Québec. *Bulletin*. (Montreal: Société des Graphistes du Québec Inc.) Current.

†Society of Typographic Designers of Canada. *Typography '58 - '64*. (Catalogues of annual exhibitions of the S.G.D.C., sponsored by Rolland Paper Co., Montreal) 1958-64.

Society of Graphic Designers of Alberta. *X-Height*. (Edmonton: Society of Graphic Designers of Alberta) 1977 - to date.

Section VI: Biographical Dictionaries

Amstutz, Walter, editor. *Who's Who in Graphic Art*. Zurich: Amstutz and Herder, Graphis Press, 1962. "Canada" section: introduction by Paul Arthur, entries on Theo Dimson, Allan Fleming, Norman McLaren, and Ernst Roch.

Creative Canada. A Biographical Dictionary of Twentieth-Century Creative and Performing Artists. Compiled by Reference Division, McPherson Library, University of Victoria, B.C. Toronto: University of Toronto Press, 1971-2. Two volumes.

Harper, Dr. J. Russell. *Early Painters and Engravers in Canada*. Toronto: University of Toronto Press, 1970.

Hughes, Margaret, editor. *Who's Who in Ontario Art*. Reprinted from *The Ontario Library Review*. Toronto: King's and Queen's Printers, 1947-62. Parts 1 - 22.

MacDonald, Colin S. *A Dictionary of Canadian Artists*. Ottawa: Canadian Paperbacks, 1967-77. Five volumes to date.

McLean, T. W., and Association of Canadian Advertisers. *A List of Commercial Artists*. Toronto: Association of Canadian Advertisers, 1931.

"Qui Sont Les Designers Québecois," in *Décormag* (Montreal), Vol. 5, No. 3, November 1976.

Rous and Mann Ltd., Toronto. *Biographies of Artists Contributing to "The Canadian Artists Series" Cards*. Toronto: Rous and Mann Ltd., 1927-28.

Société des Graphistes du Québec Inc. *Repertoire des Membres*. Avant-propos par Georges Beaupré. Montréal: Société des Graphistes du Québec Inc., 1975.

Wolff, Hennie, editor. *The Index of Ontario Artists*. A Publication of Visual Arts Ontario and The Ontario Association of Art Galleries. Toronto: Visual Arts Ontario, 1978.

Collections

Photography Credits

Tom Moore, of T. E. Moore Photography, Toronto, took the majority of photographs of posters for this book. Photographs were also supplied by the following individuals and institutions.

Burns, Cooper, Hynes Ltd., Toronto: p. 63 (no. 32)
Canadian Pacific Archives, Montreal: pp. 2 (Fig. 5), 12 (nos. 4, 5, 6, 7), 13 (nos. 8, 9), 14 (no. 13)
A. Corsillo, Montreal: pp. ii (no. 8), 19 (no. 7), 20 (no. 12), 24 (no. 21), 25 (nos. 27, 28), 36 (no. 6), 59 (no. 6), 65 (no. 2)
Claude Neon Ltd., Toronto: p. 79 (no. 11)
Paul Gilbert: p. vi
Glenbow-Alberta Institute, Calgary: p. 7 (no. 4)
Greg Greason (for Claude Neon Archives, Toronto): pp. 27 (nos. 36, 40, 42), 30 (no. 8), 39 (no. 18), 77 (no. 12), 79 (nos. 3, 4, 5, 6, 7 11)

Allan Harrison: pp. 55 (no. 48), 79 (no. 10)
Hayward Studios Inc., Montreal: pp. vii (Fig. 2), 1 (no. 2)
Guy Lalumière et Associés, Montréal: p. 32 (no. 4)
McGill University Rare Book Library, Montreal (Lawrence Lande Collection): p. 1 (no. 3)
Marlborough Graphics, Ottawa: pp. iii (no. 6), xiv (Fig. 19), 14 (no. 15), 33 (nos. 13a, 13b), 55 (nos. 45, 46, 47, 49, 50), 61 (nos. 19, 20)
Massey-Ferguson Ltd., Toronto: 66 (no. 3)
Metropolitan Toronto Library: pp. ix (Fig. 5), xi (Fig. 13), xii (Fig. 14), xiii (Fig. 16), xiv (Fig. 18), 10 (no. 1), 27 (no. 33), 28 (no. 1), 34 (no. 1), 48 (no. 1), 49 (no. 13), 57 (no. 1), 58 (no. 2), 71 (nos. 28, 29), 76 (no. 5)
Willi Mitschka: p. 53 (no. 42)
National Film Archives, Ottawa: p. 23 (no. 18)
Michael Neill, Ottawa: p. 26 (no. 31)

Archives of Ontario: pp. 3 (no. 6), 10 (no. 1), 31 (nos. 1, 2), 43 (no. 8), 47 (no. 11)
Art Gallery of Ontario Library: pp. 21 (no. 14), 22 (no. 15) (i.e. photos in A.G.O. Library artist files)
Art Gallery of Ontario Photographic Services: front cover (no. 10), pp. vi (no. 2), 16 (no. 2) 17 (nos. 3, 5), 18 (no. 6), 19 (no. 8), 20 (no. 9), 22 (no. 15), 24 (nos. 22, 23, 24), 25 (no. 29), 41 (nos. 1, 2), 42 (no. 3), 43 (no. 9), 50 (no. 5), 54 (nos. 43, 44)
Gérard Péstiaux, Montréal: front cover (no. 4), pp. viii (Fig. 4) 40 (no. 26), 46 (no. 4)
Public Archives of Canada, Ottawa: pp. 1 (nos. 1, 2), 6 (no. 3), 8 (no. 6), 17 (no. 4), 20 (no. 10, 21 (no. 12), 25 (nos. 28, 30), 33 (no. 7), 34 (no. 2), 35 (no. 5), 36 (nos. 8, 9), 37 (nos. 10, 11, 12), 38 (nos. 13, 14, 15, 16), 39 (nos. 17, 19), 40 (no. 23), 45 (no. 1), 46 (no. 6), 47 (no. 12), 65 (no. 1), 75 (no. 1)

Saltmarche Visual Communications, Toronto: p. 21 (no. 13) (original photo owned by A.J. Casson)
Bruce Stapleton: p. 24 (no. 25)
City of Toronto Archives (James Collection): pp. x (Fig. 9), 77 (no. 1)
University of Toronto Library Photo Services: pp. xii (no. 15), xiii (no. 17), 6 (no. 2), 49 (no. 2), 74 (no. 50), 79 (no. 8)

Thanks also to Lawrence Wallrich for developing of photos taken by the author from printed sources.

Index